Matthi Forrer

HOKUSAI

Prints and Drawings

Prestel

Munich · Berlin · London · New York

First published on the occasion of the exhibition 'Hokusai: Prints and Drawings'
held at the Royal Academy of Arts, London, 15 November 1991 – 9 February 1992

Cover: *Mount Fuji seen above Mist on the Tama River, c.* 1831 (cat.14)
Frontispiece: A Sudden Gust of Wind at Ejiri, c.1831 (detail of cat.21)

The Library of Congress Cataloguing-in-Publication data is available;
British Library Cataloguing-in-Publication Data: a catalogue record for this book is available from the British Library;
Deutsche Bibliothek holds a record of this publication in the Deutsche Nationalbibliografie;
detailed bibliographical data can be found under: http://dnb.ddb.de

Prestel books are available worldwide.
Please contact your nearest bookseller or one of the following Prestel offices
for information concerning your local distributor:

Prestel Verlag
Königinstrasse 9, 80539 Munich
Tel. +49 (89) 38 17 09-0; Fax +49 (89) 38 17 09-35

Prestel Publishing Ltd.
4 Bloomsbury Place, London WC1A 2QA
Tel. +44 (020) 7323-5004; Fax +44 (020) 7636-8004

Prestel Publishing
900 Broadway, Suite 603, New York, NY 10003
Tel. +1 (212) 995-2720; Fax +1 (212) 995-2733

www.prestel.com

Catalouge edited by Robert Willams
Map by Astrid Fischer, Munich
Typeset by Max Vornehm, Munich
Color separations by Repro Karl Dörfel GmbH, Munich
Printed and bound by Print Consult, Munich

Printed in Slovakia on acid-free paper

ISBN 3-7913-2490-X

Contents

Foreword

Ten years ago the Royal Academy of Arts celebrated the artistic achievements of the Edo Period of Japan in its 'Great Japan Exhibition'. While this show included fine examples of prints by Katsushika Hokusai (1760–1849), their presence formed part of a larger story. It is therefore timely that, a decade later, an exhibition should be devoted to this most distinguished of Japanese print designers. It has been selected to enlarge a modern audience's understanding both of the esteem in which he is held in Japan and of the reasons for his continued popularity outside that country over the past 150 years.

Knowledge of Hokusai's art in the West derives from the fact that his prints were among the first to reach Europe from Japan in the mid-nineteenth century. All too frequently this familiarity is, however, confined to such memorable images as *The Great Wave*, one of the prints in his series *Thirty-six Views of Mount Fuji*. Yet the range of his work created over a lifetime that spanned nearly ninety years encompassed a breadth of images and types of art created within the context of the 'Floating World' of popular Edo urban culture — from its celebrated kabuki actors, and its beautiful courtesans, to the varied landscapes of Japan with its plains, seashores, precipitous waterfalls and steep-sloped mountains. While colour woodblock prints created for a burgeoning popular market remained his primary means of visual expression, Hokusai also created de-luxe single prints, albums and illustrated books of poetry for the cultural élite.

Quality of printed image and paper are central to our understanding of those specific features that set Hokusai beside Utamaro and Hiroshige. We are greatly indebted to Dr Matthi Forrer of the National Museum of Ethnology, Leiden, who has painstakingly searched through public and private collections throughout the world to assemble this exhibition. His selection has been made with the aim of showing how Hokusai treated the principal themes in his *œuvre* in different designs and at various stages in his career. Although this approach alone would distinguish the present exhibition from all previous ones of Hokusai's work, the artist is represented here with what is probably the finest selection — in terms of the quality of the impressions and state of preservation — ever shown. We are greatly indebted to all those who have lent works for this special occasion. We extend also our deep gratitude to our sponsors, BT and the Industrial Bank of Japan, whose support has made possible this exhibition. Given the commitment of the Royal Academy to education, we are also pleased to welcome support for this specific aspect of the Hokusai Exhibition from the Sasakawa Foundation. We trust that our public will make the journey from the familiar to the unfamiliar, and enter Hokusai's world of transparent beauty.

Roger de Grey
President, Royal Academy of Arts

Author's Acknowledgments

I would like to express my thanks to all of the following, who gave me invaluable assistance during my preparation of this catalogue and its accompanying exhibition, and to the individuals, institutions and private collectors who showed me their prized possessions in the course of my tour of selection:

The Rijksprentenkabinet of the Rijksmuseum, Amsterdam; the Museum für Ostasiatische Kunst, Berlin; Dr Money Hickman of the Museum of Fine Arts, Boston; Mrs Amy G. Poster of The Brooklyn Museum, Brooklyn, New York; Professor Dr John Rosenfield and Mrs Fumiko Cranston of the Harvard University Art Museums, Cambridge, Mass.; Mr James T. Ulak of the Art Institute of Chicago; Mr H. George Mann, Highland Park, Illinois; Mrs Jan Chapman and Mrs Yoshiko Ushioda of The Chester Beatty Library, Dublin; Mr Peter Morse, Honolulu; Dr Stephen Little of the Honolulu Academy of Arts; Professor Dr Gerhard Pulverer, Cologne; Dr J. J. Witkam of the Universiteitsbibliotheek, Leiden; Dr Timothy Clark of the British Museum, London; Mr Rupert Faulkner and Louise Hoffman of the Victoria and Albert Museum, London; Mrs Hollis Goodall of the Los Angeles County Museum of Art; Mrs Barbara Ford of the Metropolitan Museum of Art, New York; Dr Jean-François Jarrige and Mme Christine Shimizu of the Musée National des Arts Asiatiques-Guimet, Paris; Mmes Huguette and Anisabelle Berès, Paris; Mme Janette Ostier, Paris; Dr David Kamansky of the Pacific Asia Museum, Pasadena, Cal.; Mr Hollister Sturges and Ms Anne Schroeder of the Museum of Fine Arts, Springfield, Mass.; and Dr William Rathbun of the Museum of Fine Arts, Seattle.

For their advice and assistance of various sorts I would like to thank M. Georges Leroux, Brussels; Professor Kano, Kyōto; Dr Joe Earle, London; Dr Lawrence R. H. Smith of the British Museum, London; Robert G. Sawers, London; David Newman, London; Professor Dr Gian Carlo Calza, Milan; Dr Sebastian Izzard of Christie's, New York; Professor Dr Robert Raviez, Pacific Palisades, Cal.; Mr Hata Shinji, Tokyo; Professor Kobayashi Tadashi, Tokyo; and Mr David Caplan, Tokyo.

Without the enthusiastic support and characteristic efficiency of the staff of the Royal Academy of Arts this exhibition would not have been possible. That my task was made so pleasurable had much to do with the confidence shown in me by Norman Rosenthal and Annette Bradshaw, and the discussions I had with MaryAnne Stevens, with my collaborator on the design of the exhibition, Ivor Heal, with Jane Martineau and Robert Williams on planning and editing the catalogue, and with others not singled out here but certainly not forgotten. A special word of thanks is due to the project's ever reliable and always efficient assistant, Emeline Wick.

A word of thanks should also be addressed to my good friends Peter Morse and Roger Keyes, who always supported me enthusiastically and on many occasions provided invaluable advice.

Editor's Note

Each entry has a descriptive title against the catalogue number. Where this is followed by a further title, this title is a translation of the Japanese that follows it in parentheses, which, in turn, is the title as it appears on the print. All Japanese terms and names are transliterated according to the Hepburn system of romanisation, with the usual modifications.

Datings for Japanese prints are not normally indicated on the works themselves. *Surimono* are an exception, in that they can often be dated approximately on the basis of references to the animals of the zodiac calendar that appear in the designs or in the accompanying poetry. Most albums and books — but not all — are dated in the colophon. Dates given for other prints are based on current research on Hokusai's *œuvre*.

Signatures are transcribed as they appear on the prints unless otherwise specified, as, for example, in the case of some albums. The words *ga*, *hitsu* and, less frequently, *egaku* following the signature should all be interpreted to mean 'drawn by'. *Zen* preceding the signature means 'the former', since Hokusai changed his name frequently in the course of his career. For the signatures of blockcutters, [?kura] means a doubtful reading, and [_] a missing or undeciphered part of the name.

Most prints bear a seal or mark that identifies the publisher. Their absence does not necessarily mean that the print is a spurious publication. Since *surimono* were privately published they do not bear a publisher's seal.

From 1790 all commercially issued prints were subject to Government censorhip (*surimono* fall outside this category); from about 1791, therefore, a circular seal that reads *kiwame* ('approved') appears on nearly all commercial prints.

Most prints and books were published in standardised formats, such as *ōban*, *chūban*, *hosoban* and so forth. Where applicable, these formats are cited by their Japanese names. In the case of *surimono*, for which hardly any Japanese names are generally accepted, the more common Western indications of the formats are used.

Dimensions are given in millimetres, height before width.

The presence of one or more margins on a print is indicated in parentheses following the dimensions (an explanation of the significance of margins is given in the Glossary).

Where known, the names of former owners of works are included; this information, which is preceded by 'ex-', appears in parentheses following the name of the present owner.

The references to published research that follow some catalogue entries are intended to direct the reader to further discussion, not to other reproductions. References are given in an abbreviated form — surname, followed by year of publication and, usually, by page or illustration number; full details are to be found in the Select Bibliography.

Verse translations from the Japanese that appear in catalogue entries 74–83 are taken from Clay MacCauley, *Hyakunin isshu* (*Single Songs of a Hundred Poems*) (Yokohama: Kelly & Walsh, 1917), an anthology that was first published in *The Transactions of the Asiatic Society of Japan* (1899). All other translations from the Japanese that appear in the introductory essay and in the texts of the entries are by Matthi Forrer.

The following prints are not shown at the exhibition in London: cat. 1b, 47, 63, 71, 77, 88, 94 and 118.

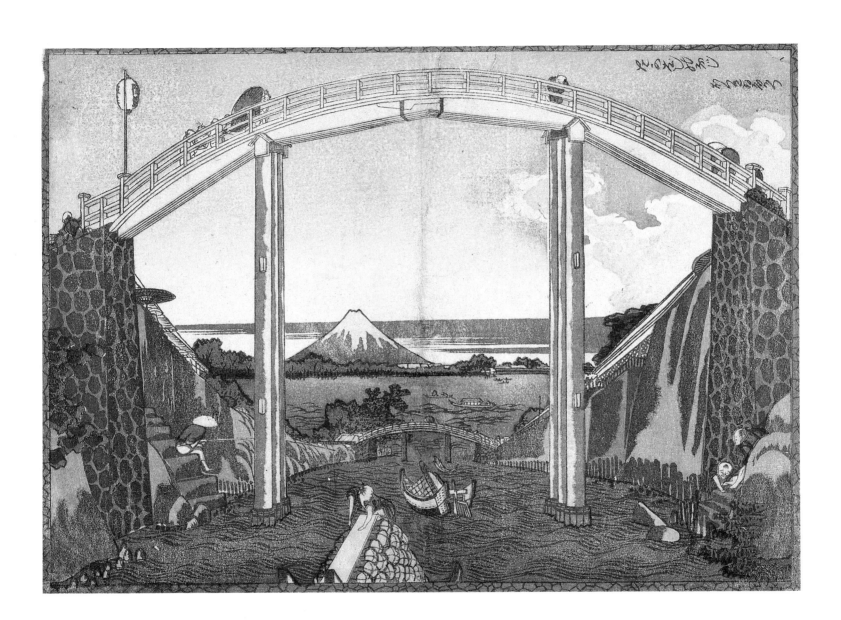

The Art of Hokusai

Hokusai, Japan's most famous artist, holds an assured place in the history of world art. His best-known print, *The Great Wave* (cat. 11), has been used so often for a variety of purposes that it is familiar to people almost everywhere, even though relatively few of them would be able to name the artist. For those in Japan and the West who are better acquainted with Hokusai's work, his reputation is based first and foremost on his landscape designs; these include waterfalls, bridges and, above all, Mount Fuji. What is seldom realised is that Hokusai's most famous works — some two hundred or so designs — all date from the time when he was already in his seventies.

Hokusai, in the romantic imagination, is the artist who changed his name more than thirty times and his address more than ninety times, and who left us a total *œuvre* of more than thirty thousand designs and lived to the age of eighty-nine (or ninety, if one follows the Japanese system, which considers a person to be one-year old at birth). He was a strict judge of his own work and on one occasion claimed that 'Although I had produced numerous designs by my fiftieth year, none of my works done before my seventieth is really worth counting . . .'. This comment comes from his own short autobiography, written at the age of seventy-four; it should probably be interpreted as an indication that, even then, he still wished to accomplish greater things, rather than that he seriously rejected everything he had designed hitherto. Hokusai applied himself to the same themes and subjects time and again in the course of his career; it is hoped that the works shown here will demonstrate that the masterpieces upon which his fame rests could have been realised only after many years of exploration and experiment.

EARLY CAREER

Hokusai was born in 1760 in the Katsushika ward of the Honjō district of Edo (present-day Tokyo). Edo, originally a small fishing village, had developed rapidly after the shōgun Tokugawa Ieyasu (1542–1616) had made it the seat of government in 1603. Ieyasu's hegemony in Japan followed the decisive battle of Sekigahara in 1600, after which he moved the capital to Edo, far from the Imperial court's traditional home in Kyōto. The Emperor, deprived of all influence on state matters, remained at Kyōto, only undertaking ceremonial duties connected with Shinto and official ritual. The shōgun, as supreme military commander, had complete control over the country, with the various daimyō, or feudal lords, ruling the provinces in his name. The shōgun's control was all the more effective since his daimyō were forced to leave their families as hostages in Edo each time they

Fig. 1 *A View of Mount Fuji through the Piers of a High-arched Bridge*, c. 1800–5. Boston, Museum of Fine Arts, J. T. Spaulding Collection (21.6675)

returned to their territories on administrative business. Their movements, as well as those of all other Japanese, were monitored by police, spies and informers.

Although the Portuguese, Spanish and Dutch had all established trading missions in Japan during the sixteenth century, fear of foreign influence, Christianity in particular, led the Tokugawa shōgunate to expel the Spanish in 1624 and the Portuguese in 1639. Thereafter, the country existed in self-imposed isolation, permitting only the Dutch and Chinese to continue a severely restricted trade through the port of Nagasaki.

The sudden arrival of all the daimyō families and their various retainers as new inhabitants of Edo — some 500,000 samurai alone were needed to serve the shōgun — created a huge demand for housing, furniture, goods and food, which, in turn, attracted large numbers of craftsmen and artisans to the city. By the end of the seventeenth century Edo probably had around one million inhabitants. Most of the daimyō mansions were grouped around the shōgun's castle, while officials, tradesmen licensed to serve the military classes, merchants and craftsmen all chose to live in their own particular districts. Edo's rapid expansion did not seriously affect the surrounding villages, however: they merged into a conglomerate of distinct districts, which included rice-fields, rather than forming into a single metropolis.

As a young boy Hokusai seems to have been adopted into the Nakajima family, Nakajima Ise being a mirror-polisher at the shōgun's court. The adoption of young children was a fairly normal practice among commoners in pre-modern Japan. As a youth Hokusai was called first Tokitarō and later Tetsuzō. If we are to believe the claim he makes in his autobiography, he 'was in the habit of drawing all kinds of things' from the age of six. He must have received some education since he could both read and write — Japan probably having the highest rate of literacy in all Asia at the time — as is witnessed by a number of popular novellas Hokusai wrote in the 1780s and '90s and some two hundred poems of his that survive from the 1820s.

After working in his mid-teens as an assistant in a bookshop, Hokusai was trained as a block-cutter. This does not mean, however, that he ever cut the blocks for his designs himself. In the first place, with only two or three years of training, he would not have been qualified to do so, nor would it have been in accordance with the usual division of labour. A designer of prints only provided the design, after which a professional copyist prepared a detailed worked-out version, from which specialised block-cutters made the various blocks needed to create each print, including the colour blocks and the blocks with the outlines of the figures, the scenery and the inscriptions that were to appear on the print. The actual printing was done by another group of specialised craftsmen. This traditional division of labour was to continue until 1904, when Yamamoto Kanae, inspired by Western practice, decided to cut the blocks for his own designs and pull the prints himself.

Publishing books on a commercial basis had developed in Japan in the early seventeenth century. Initially, printed illustrations were made for literary works, and only towards the end of the seventeenth century did single prints begin to be issued. Whereas book publishing had originally been centred in Kyōto and Ōsaka (Edo only became important in this field from around the mid-eighteenth century), Edo was always the centre for the production of single prints. The emergence of single prints was closely related to the requirements of the population of this rapidly developing city. Since the

townspeople were denied access to the entertainments enjoyed by the aristocracy and the samurai class, they created their own amusements and demanded images of celebrities with whom they could identify — the actors of the kabuki theatre and the beautiful court-esans of the Yoshiwara pleasure quarter.

Although prints of these popular idols were bought chiefly by wealthy merchants for much of the eighteenth century, by the nineteenth they were within the reach of a consid-erably larger audience. The increased demand gave rise to many more publishers and designers. Whereas only some two hundred designers and about thirty to fifty publishers had been active in the eighteenth century, probably more than six hundred designers of prints and more than four hundred publishers were active in the field during the nineteenth century. It should not surprise us to learn that, in such a competitive field, some publishing firms were short-lived enterprises. And although there was some over-lap, book publishing, as well as the production of fan prints, was largely a separate, and much larger, trade.

When Hokusai began his training as a print designer, probably at the age of nineteen, he was taken on by Katsukawa Shunshō (1726–92), then the foremost designer of actor prints. Hokusai's earliest prints, signed with his artist's name of Katsukawa Shunrō, were of actors of the popular kabuki theatre dressed in costume for specific roles. These were crudely printed portraits aimed at a mass audience that could not afford the more de-luxe works by established artists such as his teacher Shunshō and Shunshō's leading pupils, Katsukawa Shunkō (1743–1812) and Katsukawa Shunei (1762–1819). The majority of these early works by Hokusai survives only in single copies, many others, no doubt, having been lost forever.

There were only two leading themes in Japanese prints: actors and fashionable courtesans. Several schools of printmakers specialised either in one or the other of them. Within the field of actor portraiture, there was the traditional Torii School, which had originated in the seventeenth century and by this time was in decline, and the more fash-ionable, even avant-garde, school of the Katsukawa artists. Real success as a designer could only be expected in the latter.

By the late 1780s Hokusai was trying his hand at other subjects than actors. Designs based on legends and on Chinese themes, and a number of pictures of women, were pub-lished by the firm of Nishimuraya Yohachi. Perhaps it was these prints that in 1791 per-suaded Tsutaya Jūsaburō, Edo's foremost publisher, to commission from Hokusai a number of actor prints; Tsutaya ensured that they were very well printed, the first time Hokusai's designs were afforded such treatment (cat. 1). Tsutaya published a number of other subjects by Hokusai in 1791 and 1792. After this, however, apart from some illus-trations to popular novellas of the time, this collaboration was interrupted. Whether it was Hokusai or his publisher who ended the relationship is unclear. Yet, it had served to introduce Hokusai to a number of other artists, both of *ukiyoe* and other traditions, as well as writers, poets and scientists, in short, Edo's cultural élite, for which Tsutaya's shop seems to have served as a meeting-place. Around 1793 Hokusai began to take lessons with artists outside the Katsukawa School, and made a particular study of the works of the Sōtatsu painter Tawaraya Sōri (*fl. c.* 1764–80); when this was discovered, he was expelled from the Katsukawa School.

From around the mid-1790s, the artist's name of Shunrō seems to have been used by someone other than Hokusai, and Hokusai adopted the name of Sōri. His style appears to have changed radically too.

THE WORLD OF POETS

The 1790s is a particularly important decade for the history of Japanese prints, for new developments were made in many areas. This was the period when Kitagawa Utamaro (1754–1806) made his portraits of courtesans of the Yoshiwara, produced in competition with works of the same subject by Hosoda Eishi (1756–1829) and his followers. By this date the dominant role of Torii Kiyonaga (1752–1815) was over; the Katsukawa School still had a number of successes but it was being challenged by gifted newcomers in the field of actor prints, such as Utagawa Toyokuni (1769–1825) and Utagawa Kunimasa (1773–1810); independent masters, such as Momokawa Chōki (*fl. c.* 1780–*c.* 1810) and Tōshūsai Sharaku (*fl.* 1794–5), were also active. Printing techniques had reached their zenith and were exploited to the full by publishers such as Tsutaya Jūsaburō, Nishimuraya Yohachi, Uemura Yohei and an extremely active group of wealthy merchants who commissioned de-luxe private publications.

These well-to-do merchants indulged in writing poetry; they also organised poetry clubs. They made it a habit to have their best poems printed in poetry albums or on single-sheet prints, known as *surimono*; in either case, one or more artists would be commissioned to provide an illustration. These albums and *surimono* were distributed privately; they were not, as a rule, offered for sale in book or print shops. Since there were no financial constraints, there was almost no limit to the quality of the printing or of the paper or pigments that were used. Generally, the size of the editions of such works was considerably smaller than that of commercial prints and books.

From about 1795 Hokusai regularly contributed designs for both single prints — the *surimono* (cat. 85–99) — and for albums of *kyōka* poetry (cat. 112–21). By this time he was, as mentioned above, using the artist's name of Sōri, which suggests a link with Tawaraya Sōri. Followers of Sōri's Sōtatsu School were involved in a number of major *kyōka* publications in the 1790s. Hokusai's first designs for plates in the most prestigious albums date from 1797, the year in which both *The Threads of the Willow* (cat. 8) and *The Mist of Sandara* (cat. 113) appeared. In these albums, as well as in the plates for two similar works of the following year, *The Stamping Song of Men* (cat. 116) and a second album entitled *The Mist of Sandara* (cat. 114), it is evident that Hokusai had radically changed his style. His bold work in the field of actor portraits belonged to the past; now he concentrated on scenes with delicate figures in a style almost completely alien to the *ukiyoe* tradition. For the settings of his scenes he chose to depict the countryside in and around Edo, rather than the well-known scenic spots that had sometimes served as a background for fashionable ladies in the work of Kiyonaga, Shunchō and Utamaro.

After the new name that appears on these designs by Hokusai, this style is sometimes called the 'Sōri style'. From 1796 he started to add another name to that of Sōri, signing his works *Hokusai Sōri*. In 1798 he definitively changed his name to Hokusai, signing his works *Sōri aratame Hokusai*, or 'Sōri changing his name to Hokusai'.

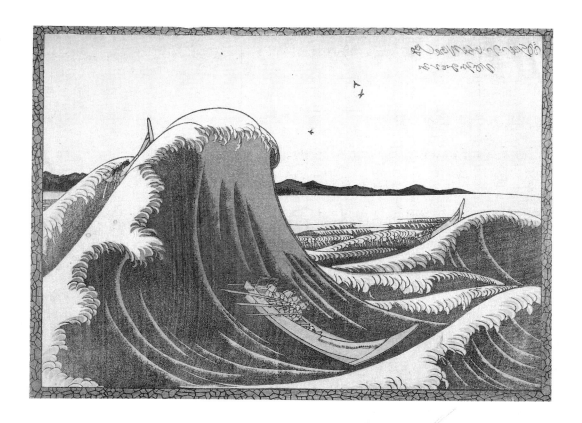

Fig. 2 *A Boat in a Great Wave at Oshiokuri, c.* 1800–5. Boston, Museum of Fine Arts, J. T. Spaulding Collection (21.6678)

Included in these designs that Hokusai made in the late 1790s is the first working of the theme that later gained him worldwide renown: the Wave. As early as 1797, when he was in his late thirties, Hokusai depicted a particularly large wave in one of the plates in *The Threads of the Willow* (cat. 8). It reappeared two years later, in a *surimono* for the New Year of 1799 (cat. 9), in a composition quite reminiscent of the *Threads of the Willow* plate, though the proportions appear more natural in the later design. It is, however, important to realise that both were almost certainly inspired by *The Seven League Beach at Shichirigahama* (fig. 3), an oil painting by Shiba Kōkan (1747–1818). Kōkan, a strong advocate of Western art, painted this scene in the sixth month of 1796; it was then publicly exhibited in the Atagoyama shrine in Edo until 1811. One cannot imagine that Hokusai was unfamiliar with this strikingly novel Western-style work, which must have aroused great public interest.

The tradition of issuing de-luxe *kyōka* albums hardly, and possibly not coincidentally, survived the death of Hokusai's former publisher Tsutaya Jūsaburō in 1797. Later, *kyōka* albums were still produced with colour plates, yet in their outer appearance looked similar to better-quality commercial publications. By then, Hokusai apparently had established himself with the amateur poets well enough to be invited to be the sole contributor of designs for a number of publications, mostly illustrating scenic landscapes and townscapes in and around Edo. The most important are the *Amusements of the Eastern Capital* (1799), *Famous Places of the Capital in One View* (1800), *Birds of the Capital* (*c.* 1802; cat. 118–20), *Both Banks of the Sumida River in One View* (*c.* 1803) and *Range upon Range of Mountains* (1804). Unlike the albums of the 1790s, with the possible exception of *Birds of the*

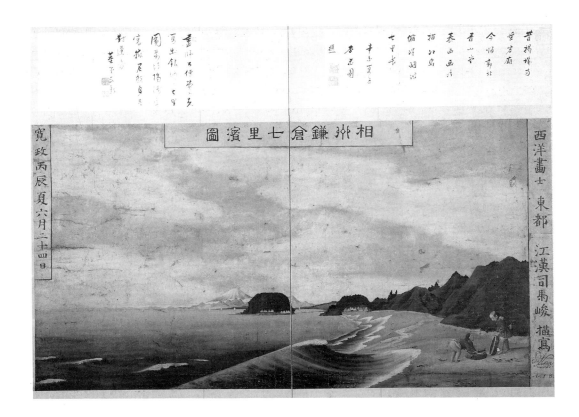

Fig. 3 Shiba Kōkan (1747–1818),
The Seven League Beach at Shichirigahama,
oil on paper, 1796. Kōbe, City Museum

Capital, these works were also distributed commercially through bookshops. Some were even reprinted several times, a sure indication that they had met with success. This must have stemmed from the novelty of the illustrations, which showed people engaged in mundane occupations at recognisable places, and which were printed in colour and in a larger format. Such 'townscapes', as this genre of print may be called, did figure occasionally in the work of earlier artists, notably Kiyonaga, Shunchō and Utamaro in the 1780s and '90s, but the main focus had always been on the fashionable ladies, not the setting.

It is open to question to what extent the ideas for designs for *surimono* and *kyōka* albums were suggested by the poet-patrons or left to the artist's invention; the conspicuous place given to townscapes in these albums may have originated with Hokusai or been suggested by the poets. Since place names also figure frequently in the poems in the earliest of these albums, the idea may, in some way or other, have originated with the poets, but was adopted more widely when the genre proved to be a success.

The so-called long *surimono* are broad horizontal designs printed on a paper that was afterwards folded into two, with one half occupied by the design and the other by programmes for theatrical or musical performances; sometimes they are also inscribed with poetry. In composition they are related to Hokusai's designs for the *kyōka* albums. Prints in this format had been introduced in the 1790s, as can be seen in one of Utamaro's best-known designs showing the extremely popular geisha Tomimoto Toyohina looking at such a *surimono*. These long *surimono* were usually issued as de-luxe invitations for the performances that were described on them. The designs were commissioned from the same artists responsible for *surimono* in other formats, mostly smaller. Hokusai, however, par-

ticularly between 1800 and 1810, seems to have designed literally hundreds of these long *surimono*, a far greater number than any by his contemporaries. Often the patterns on the clothing of the figures in the design would be based on the badges or devices of the companies organising the performances announced in the programmes. In later impressions these patterns were omitted. No less than three or four different states have been identified for some of these designs, which testifies to their great popularity at the time. Indeed, they were a unique art form, using highly novel compositions exquisitely printed in a format otherwise not in use at the time. As late as *c.* 1820 many of Hokusai's designs in this format dating from the early years of the century were reprinted, but heavily cropped, which makes them look rather like standard *ōban* prints. The same was done with several of Hokusai's plates to the *kyōka* albums of the 1790s. Given their format, it is not surprising that landscapes were considered a suitable subject for long *surimono*.

THE TURN TO LANDSCAPE

At the beginning of the nineteenth century Hokusai continued to design *surimono* and plates for *kyōka* albums, some of which, like *The Thirty-six Women Poets in Brocade Prints* (1801) and *Mount Fuji in Spring* (*c.* 1803; cat. 121), were de-luxe publications reminiscent of his work in the 1790s. Of even greater consequence for Hokusai's career, however, were two groups of landscape prints of *c.* 1800–5 that were clearly influenced by Western art (cat. 4–6 and 10). They have decorative borders in imitation of Western frames around oil paintings; the titles and signatures on the prints are written horizontally — as is Western writing — and, above all, their printing creates the effect of *chiaroscuro* and even cast shadows are incorporated in the designs; both were innovations in Japanese art. In some of the designs Hokusai cautiously applied a Western-style perspective. No publisher is named on these prints; perhaps they were originally issued privately or possibly sold in a wrapper, as was the case with at least two similar contemporary sets by Hokusai in a much smaller format, *Eight Views in Edo* and *Eight Views on Lake Biwa*, both of which imitate copperplate engravings.

During the last decades of the eighteenth century the study of Western painting techniques had been undertaken by various groups, all closely related to the Rangaku, or 'Dutch studies movement'. Although Japan had been closed to foreigners since 1639, trade was maintained on a modest scale with the Chinese and the Dutch. It was through this severely controlled contact that some Western technology and science reached the otherwise isolated country. Until 1720 there was a strict ban on the import of any books in Chinese or European languages. The shōgun Yoshimune (1684–1751), however, was interested in mathematics and astronomy, and wanted to perfect the calendar then in use in Japan; in consequence he lifted the ban and in 1740, at his instigation, some scholars began studying the Dutch language in order to benefit from European works on science. Thereafter, especially between 1760 and 1790, the study of Western learning flourished.

As illustrated Dutch books and prints were imported, knowledge of copperplate engraving, oil painting and other techniques was diffused. The realism of European illustrations fascinated artists such as Hiraga Gennai (1729–79) and Shiba Kōkan. Gennai

played a crucial role in developing a school of Western-influenced painting in Akita, a remote provincial town in the far north, which flourished for some time after Gennai's stay there in 1773. The artists of this school worked with traditional Japanese materials — pigments and silk — producing an interesting combination of naturalistic detail within fantastic compositions, often with unexpectedly large foreground subjects and *chiaroscuro* modelling. The painters of this school benefited from the active support of Akita's daimyō, Satake Shozan (1748–85), who was a talented painter and author of the first treatise on Western-style painting, the *Gahō kōryō* ('The Essentials of Painting'). In this work Shozan stressed that the classic Chinese adage, 'A painting is of value when it resembles the portrayed object' (from the *Li-tai ming-hua-chi* of 847), was more important than the viewpoint of Chinese literati, who held that 'the main function of painting was representation' and that 'whether a painting captures the essential spirit is what matters'. For two of his other theoretical works Shozan made extensive use of his copy of Gerard de Lairesse's *Groot schilderboek* ('Great Painter's Book') of 1707 for his discussions of linear perspective and the composition of Western pigments.

In Edo, the foremost promoter of Western painting was Shiba Kōkan. In 1788 he undertook a journey to Nagasaki in west Japan in order to study the techniques of Western art. Kōkan, however, was not impressed with the works of the official art inspectors and painters in that town, although the trip was probably one of the greatest events in his life. Kōkan owned several Dutch books and studied works in the possession of others. He seems to have acquired a copy of the *Groot schilderboek* as well as a volume of moral precepts in Dutch, *Iets voor allen* ('Something for Everyone'); this was profusely illustrated with plates, of which he was to make ample use in his later career, especially in his oil paintings. He also studied an eighteenth-century handbook of practical advice on various subjects — it was later translated into Japanese by Gentaku and his assistants — which provided sufficiently clear instructions for Kōkan to have mastered the art of copperplate etching by 1783. His first plate was a view of Sumida River with crosshatching used to indicate depth, light and shadow, which was a characteristic of the plates in Western books that by then had reached Japan. In designs executed in the same technique a year later, Kōkan, following Dutch examples of landscape illustration, reserved almost half of each composition for the sky, which was scattered with clouds in the Western manner. He also employed linear perspective, drew exaggerated cast shadows and even, probably to show he was aware that the earth is round, added curved horizons. Kōkan did not publish extensively on Western art techniques — a thorough treatise was projected but never realised — but in some of his publications he at least gave examples of Western perspective, realism and anatomy. There is an uncorroborated story that Hokusai took lessons from Kōkan. This may be true, but even without such lessons it would not have been too difficult for Hokusai to have learned something of the principles of Western art.

The great importance of this series of Western-style landscape prints for Hokusai's career is even more obvious when we realise that several of the themes treated in these scenes were to recur some decades later in the great landscape series of the 1830s. For example, the composition of Takahashi (fig. 1) is not only repeated in a somewhat different form in the plate of the Sumida River seen through Azuma Bridge (cat. 6) from the same groups of prints, but also in the Mannenbashi plate (cat. 15) from the *Thirty-six Views of*

Mount Fuji and again in the second volume of *One Hundred Views of Mount Fuji* (cat. 132). Both groups of prints included a plate showing a 'great wave' (fig. 2 and cat. 10), a theme Hokusai had already experimented with and was to repeat in the *Thirty-six Views* (cat. 11) and *One Hundred Views* (cat. 131).

Compared with the perspective views of the 1780s and '90s by Utagawa Toyaharu (1735–1814), Hokusai's designs strike us as far more natural. The perspective prints of the nineteenth century — including some by Hokusai from his Shunrō period — were designed to be viewed by means of instruments known as *nozoki karakuri*, in which a convex lens and a mirror were used to present an impression of great visual depth. Hokusai's prints of the early nineteenth century, however, were meant to be enjoyed as such in their own right. With their use of perspective and other Western elements they must have seemed very advanced at the time: none of his contemporaries was making similar works. Compared to Hokusai's later landscape prints these have an unmistakable Western bias; Western elements are more naturally incorporated into his later designs, and he abandoned the use of decorative borders, horizontal writing and cast shadows.

Although these early landscapes were successful enough to be reprinted several times, they were obviously aimed at a more cultivated and discerning public than Hokusai's earliest prints had been. From 1805 to 1810 Hokusai was to design numerous series of landscape prints for a much larger audience; these were cheap productions, often crudely printed and of little artistic value. From 1803 to 1815 he devoted much of his energy to illustrating some of the many novellas that were appearing at the rate of two hundred new titles annually. In these illustrations, mostly executed in line only, Hokusai produced fantastic designs of great dramatic power and compositional skill. In 1802 the well-known writer Shikitei Sanba (1776–1822) praised Hokusai as an artist of great individuality; and Hokusai's illustrations to popular novellas, along with his landscape prints, must have made his name known to a large public.

This fame attracted an increasing number of pupils and followers, for Hokusai had been teaching young artists since the late 1790s. As he was mainly active as a designer for *surimono* and poetry albums, his early pupils also made these genres their speciality. At various times later in his career he took on quite large numbers of pupils, many of whom — as was common practice in Japan — added part of their master's name, in this case 'Hoku', to their own. Among the artists he trained were Totoya Hokkei (1780–1850) and Katsushika Taito II (*fl.* 1810–50), both of whom designed prints and book illustrations. Because Hokusai changed his own style so frequently, work by his pupils and followers varies considerably; it is not possible, therefore, to speak of a Hokusai 'School' as such.

In 1812 Hokusai issued the first in a series of works in which he provided instruction in drawing in the Katsushika style, 'Katsushika Hokusai' being his usual signature at the time. The early volumes have humorous touches, including, for example, demonstrations of how to draw objects by breaking them up into circles, squares and rectangles or even into the Japanese characters that make up their names.

In 1814 he published the first volume of the *Hokusai manga*. Ten volumes were published under this title over the next five years, providing a compendium of Japanese life and society that included numerous legendary and historical figures. Altogether, these

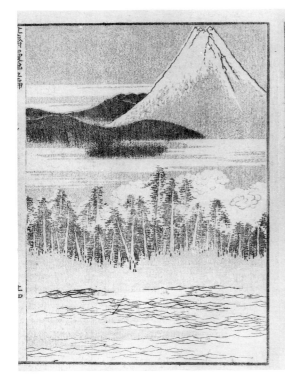

Fig. 4 *Mount Fuji seen from the Pine Beach of Shio*, from the *Hokusai manga*, v (1816). Leiden, National Museum of Ethnology (1-4442)

first ten volumes contain almost six hundred pages, sometimes with just one or two designs per page, although some pages have as many as ten to fifteen smaller ones. Both the title's prefix — *denshin kaishū*, or 'transmitting the essence' — and the introduction to each volume, mostly supplied by well-known authors, stress that the works were specifically made for followers who wanted to copy examples of the master's style of drawing. These albums of designs, to which the *Hokusai gashiki* (1819) and *Hokusai sōga* (1820) may be added, provide a good definition of the Katsushika style of drawing. Five further *Manga* volumes were published later at irregular intervals; the last two, based only partially on Hokusai's designs, appeared posthumously.

Several landscapes included in the first ten volumes reappear in far more elaborate versions in Hokusai's later series of great landscape prints. For example, there is a double-page illustration in the fifth volume of 1816 (fig. 4) that combines the pine trees of *A Shower Below the Summit* (cat. 13) and *Mount Fuji in Clear Weather* (cat. 12). In volume seven (1817), there is a view of Mishimagoe (fig. 5) that is reminiscent of a later plate in the series *Thirty-six Views of Mount Fuji* (cat. 20), and a view of travellers caught in a sudden gust of wind among the reeds in Shimōsa province that immediately recalls the Ejiri plate (cat. 21) in the *Thirty-six Views*. Volume seven also contains a precursor (fig. 8) of the print of Ono waterfall (cat. 40), though seen from a slightly different angle.

The popularity of the *Manga* volumes must have been tremendous. Probably no other serial picture album of the nineteenth century went through so many reprints. As late as the 1870s they were still being reprinted, needless to say from blocks that had become severely worn.

20

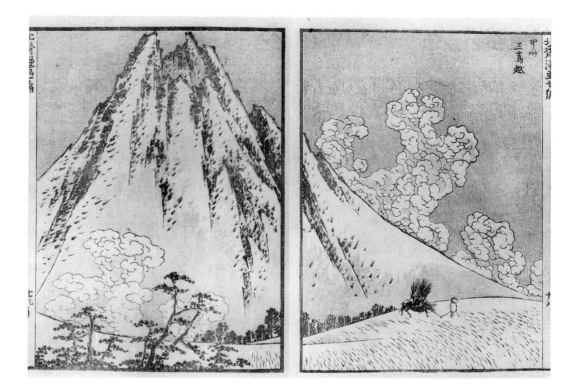

Fig. 5 *Mishima Pass in Kai Province*, from the *Hokusai manga*, VII (1817). Leiden, National Museum of Ethnology (1-4442)

THE RETURN TO THE WORLD OF POETS

Although Hokusai had never quite given up designing *surimono*, his production in this genre was considerably smaller between 1810 and 1820 than it had been hitherto. From *c.* 1820, however, he renewed contact with the *kyōka* poets, obviously with success, for in 1821 he was commissioned to design a series of thirty-six square *surimono* (then the usual format), probably the largest number ever produced in that format. Both the designs and the poetry in this large series, *A Matching Game with the Genroku Poem Shells*, allude to, or play with, the names of various shells. For example, the *Sudaregai*, or 'bamboo-blind' shell, is illustrated by a design of three women making bamboo blinds, the *Hanagai*, or 'flower' shell, by an *ikebana* arrangement, and the *Makuragai*, or 'pillow' shell, by a pillow and a picture of the so-called Treasure Ship (cat. 97).

In 1822 Hokusai was commissioned, probably by the same group of poets, to design a similar series of twenty-eight designs on the theme of horses, 1822 being a Year of the Horse in the traditional Japanese calendar. The words for 'horse' and 'colt' figure in the titles. In the print entitled *Sangenkoma*, the 'three-stringed colt', for example, a dismantled *shamisen*, a musical instrument rather like a banjo, is shown with some song-books. A 'triptych' — three linked prints — is devoted to a scene on a bank of the Onmaya River — '*uma*' or '*ma*' being the Japanese word for 'horse' — that includes the Komagatadō, the 'Colt-shaped Hall', that also appears in the album *Birds of the Capital* (cat. 120). Hokusai's *surimono* of this period differed considerably from his works of the 1790s and early 1800s. Not only had the techniques for printing developed substantially, his designs had undergone important changes, with still-lifes widely featured.

Fig. 6 *A Sudden Wind*, from the *Hokusai manga*, XII (*c.* 1834). Gerhard Pulverer Collection

It is, perhaps, surprising that Hokusai made his comeback in the world of amateur poets so effortlessly; he shared his position with several of his pupils, especially Totoya Hokkei (1780–1850) and Yashima Gakutei (*c.* 1786–1868), who were responsible for an enormous number of designs in this genre. This return to the world of non-commercial prints more or less coincided with Hokusai's sixty-first birthday. Since the zodiacal cycle was composed of a combination of the five elements and the twelve animals of the zodiac, a full cycle lasted sixty years. Thus Hokusai himself began a new cycle on his sixty-first birthday and, to commemorate this, he adopted the name of Iitsu, 'One year again'. It is with this name, or rather with the signature *zen Hokusai Iitsu*, that much of his best-known work is signed.

THE THIRTY-SIX VIEWS OF MOUNT FUJI

Towards the end of the 1820s Hokusai returned to the world of commercial publishing. He decided to devote a series of single prints exclusively to landscapes, each of which was to include a view of Mount Fuji. This mountain, a volcano 3,776 metres above sea level, was visible from Edo on clear days, although almost one hundred kilometres away. Because of its beauty, Mount Fuji had always been a favourite subject for poets and painters. Hokusai managed to interest the publisher Nishimuraya Yohachi in his plan. The prestigious project that Nishimuraya launched — the famous series of *Thirty-six Views of Mount Fuji* — was to consist of a series of *ōban* prints, each depicting Mount Fuji from a different viewpoint and under different circumstances. Never before had such a series of

large-format prints been planned in the field of landscape prints. Earlier in his career Hokusai had experimented with landscapes. He had produced single prints — he designed at least four, possibly seven, series of scenes along the Tōkaidō Road as well as many others of traditional views of Edo and of particular landscapes — and he had also depicted landscapes in his illustrated books, especially in the *kyōka* albums of the early 1800s and in some of the *Manga* volumes. Now, because his publisher was willing to invest heavily in the undertaking, he had the chance to elaborate on some of the themes that had fascinated him for so long. Soon after the series was begun Nishimuraya advertised that it was to be printed exclusively in shades of Prussian blue, a pigment recently introduced into Japan from the West that was both expensive and rare.

At this point a brief digression is necessary in order to set the novelty of the *Thirty-six Views* in the context of Japanese print production of that time. Keisai Eisen (1790–1848) and Kikugawa Eizan (1787–1867) had continued the tradition of making prints of fashionable courtesans from the Yoshiwara. But unlike the refined portraits of Utamaro and other artists working in the 1790s, Eisen and Eizan were attempting to satisfy the taste of the much larger audience for prints that had grown up in the early nineteenth century. Eisen excelled at depicting single courtesans in boldly patterned kimonos: the pattern seems to have been the primary *raison d'être* of the print. Eizan, on the other hand, favoured multiple-figure compositions, usually of one or two courtesans with maid-servants and girls in training. There was a declining interest for these sorts of print, however: Eizan virtually retired in about 1830, while Eisen turned to different subjects around the same time.

In the field of actor prints the foremost artist was Utagawa Kunisada (1786–1864). His output was enormous, and he designed large numbers of prints of actors from the

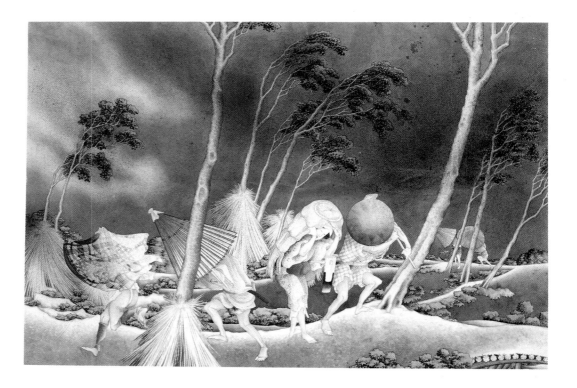

Fig. 7 *Peasants Surprised by a Sudden Rainstorm*, ink and colours on Dutch paper, *c.* 1826. Leiden, National Museum of Ethnology (1-4482A)

kabuki theatre in costume; these are bold figures in colourful dress with the stage setting indicated in the background. Utagawa Kuniyoshi (1797–1861), a fellow pupil with Kunisada of Utagawa Toyokuni, had been working in the same genre for a long time. In 1828, however, Kuniyoshi discovered a new theme, the historical print, depicting Japanese heroes, mainly drawn from the eleventh to the fourteenth centuries, which he was to explore for the rest of his career. At this date landscape only appeared in prints as a setting for actors or fashionable women; pure landscape was restricted to a few isolated prints and did not count as a genre in its own right.

From the above, it is obvious how daring Nishimuraya's plan for the Fuji series was. At the time of his announcement, in the first month of 1831, an initial group of ten designs, executed in various colours, had probably already been printed. Among them are the three acknowledged masterpieces of the series: *Mount Fuji in Clear Weather* (cat. 12), *A Shower Below the Summit* (cat. 13) and *The Great Wave* (cat. 11). Later the same year another ten designs came out, most of them printed in shades of Prussian blue, as advertised. This new pigment must certainly have contributed greatly to the success of the series, the word 'new' then probably being as much a key word in advertising as it is today. However, in later impressions of the designs originally printed only in blue, other colours for the blocks were gradually introduced and single-colour prints were apparently abandoned for the rest of the series; only the outlines were printed in blue. But even the outlines were changed into the usual black for the ten supplementary designs that were subsequently added — which meant that the complete set comprised forty-six designs, not the thirty-six of the series' title. The prints in this series came out over a period of some five years, usually about ten annually. Hokusai's other major landscape series and his prints of flowers and other subjects taken from Nature were published in the same period.

The *Thirty-six Views of Mount Fuji* was the earliest series of large-scale production in the field of landscape in the history of the Japanese print. Unlike earlier landscape prints, which were often in an almost exaggerated Western style, Hokusai found a balance between Japanese tradition and Western influence, which make his prints appealing to Western eyes and yet seem very Japanese at the same time. When it was first published, the *Thirty-six Views* must have seemed quite revolutionary to the Japanese public and to have displayed an obvious Western bias, as can be gauged from contemporary reaction. The most conspicuous sign of Western influence is the variety of cloud formations Hokusai used, which differ considerably from the traditional bands of mist employed up to then. He also occasionally combined the two types of sky — Western and Japanese — in one design. Probably the dark blue strips of sky along the top of the prints, which have come to be identified with Japanese landscapes because of their frequent appearance in the work of Utagawa Hiroshige (1797–1858), have their origin in Western art. Such skies must have been derived from hand-coloured Western copperplate engravings introduced into Japan by the Dutch. Hokusai must have been familiar with such engravings. The other Western elements that appear in some of the prints in the series are shading, cast shadows and a type of perspective. But Hokusai never forced the suggestion of depth, as Hiroshige was to do in his designs of the 1850s. Hiroshige was, in fact, the first artist to respond to Hokusai's landscapes. His breakthrough came in the early 1830s with *The Fifty-three Stations of the Tōkaidō*, a series published from 1833 by the then minor publishing house of

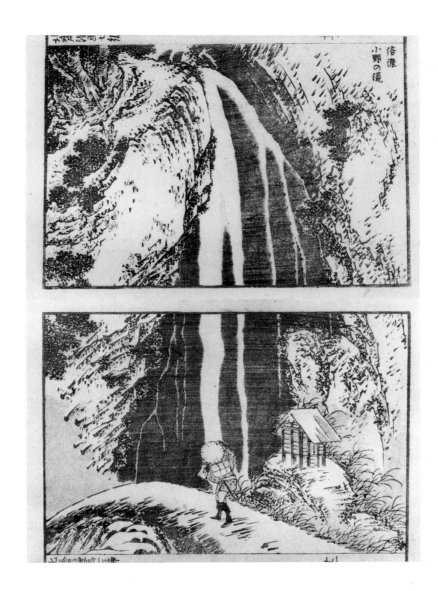

Takenouchi Magohachi. Both publisher and designer immediately became renowned, and thereafter Hiroshige designed landscape prints almost exclusively.

Utagawa Kunisada and Utagawa Kuniyoshi were also inspired to try their hand at landscapes, and Kuniyoshi in particular designed a number of very impressive prints. Unlike Hokusai, however, these two artists were less successful at incorporating Western influences into Japanese scenery. Strong perspective, wild skies, cast shadows and an imitation of *chiaroscuro* are much more pronounced in their prints and, indeed, seem to have been regarded as essential ingredients to any landscape — an indication of the response to Hokusai's innovative views of Fuji.

OTHER MAJOR WORKS OF THE 1830S

In 1831–2, the years in which the second group of ten designs belonging to the *Thirty-six Views of Mount Fuji* was published, Hokusai completed his designs for several other series:

Going the Round of the Waterfalls in All Provinces, *Eight Views of the Ryūkyū Islands* and *Large Flowers*. Nishimuraya Yohachi published the *Waterfalls* and *Large Flowers*, Moriya Jihei the *Ryūkyū Islands*.

The *Waterfalls* comprises eight designs, all of which are upright compositions. The subject had never been illustrated as a titled series in Japanese prints before, so the basis on which Hokusai selected his particular waterfalls is unknown. (In the 1840s Keisai Eisen made a series, doubtless inspired by Hokusai's work, that depicted waterfalls around Nikkō.) One connecting theme is that almost all the waterfalls are located on a pilgrimage route to a shrine or temple. However, since this may be true of most of Japan's waterfalls, the circumstance may not have been uppermost in Hokusai's mind. The theme provided Hokusai with an opportunity to draw water and cascading falls in a variety of forms; it was a theme he treated repeatedly in his painting manuals. Whereas the waterfalls of Ono (cat. 40) and Yōrō (cat. 41) pour straight down, another, in which two men are washing a horse (cat. 46), makes an elegant curve, while for the print of Kirifuri waterfall (cat. 39) Hokusai seems to have taken particular delight in breaking up the torrents. Although his compositions were taken from Nature, it is possible that Hokusai was guided as much by his brush and imagination as by his eyes. The *Waterfalls*, it must be said, show hardly any Western influence.

The series of *Large Flowers* (cat. 54–63) is striking for the realism it contains, but also for the unusual close-ups Hokusai presents. In this series an opposition is established between the flowers and leaves, which are often shown moving in the wind, and the insects that, though also affected by the wind, are rendered more as still-life objects. Although today the *Large Flowers* is appreciated for its realism, it was apparently not a very popular series. It survives only in small numbers and hardly any printing variations can be detected, from which it may be inferred that the series was rarely, if ever, reprinted. The same goes for the series of ten designs popularly known as the *Small Flowers*, probably published in 1833 (cat. 64). A facsimile reproduction of this latter series was made in the second half of the nineteenth century from newly cut blocks; it lacks the publisher's seal.

The series *Eight Views of the Ryūkyū Islands* (cat. 53) also dates from around 1832. The occasion for the sudden interest aroused in these Islands was the visit made by an official embassy from the Islands to the shōgun in 1832. Hokusai based his prints on amateurish line illustrations published in a contemporary official publication, adapted from a Chinese work of 1757, on the distant Islands; a comparison between the original illustrations and Hokusai's 'translations' into colour prints, in which soft blues predominate, is revealing, and poses the question of just how many of his other great landscape designs may have been based on simple illustrations in popular travel guides.

In 1833, in addition to a further group of ten prints for the *Thirty-six Views* and the *Small Flowers* series, Hokusai designed three landscape prints on the theme of *Snow, Moon and Flowers* (cat. 50–2). It is probable that the immediate success of Hiroshige's *Fifty-three Stations of the Tōkaidō*, which featured designs with changing seasons and different weather conditions, prompted Hokusai to design this set. But whereas Hiroshige's landscape prints — both his numerous Tōkaidō series and the many series of notable views in Edo that he made during the 1830s and '40s — were often aimed at visitors from outside

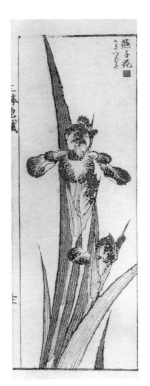

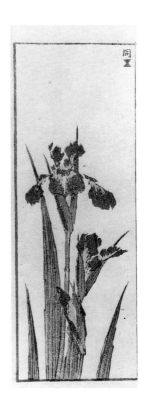

Fig. 9 Irises in the three styles of drawing, from *Santei gafu* (1816): straight (*top*), cursive (*bottom*) and running (*right*). Leiden, National Museum of Ethnology (1-4447)

26

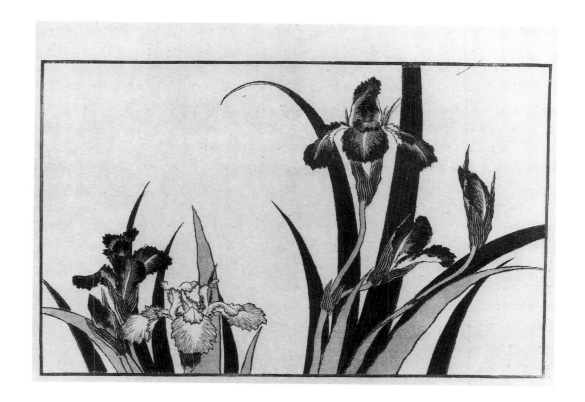

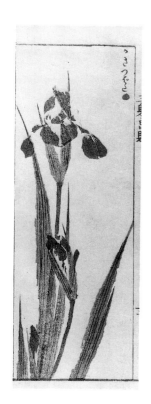

the capital (his publishers being located along the main roads), Hokusai's prints were destined for Edo's citizens, even though *Snow, Moon and Flowers* features views in Edo, Ōsaka and Kyōto respectively.

An untitled group of five large upright prints of nature studies probably dates from the same year. The designs include a hawk, two cranes (cat. 65), carp in a waterfall (cat. 66), turtles swimming and horses in a pasture. They are delicately printed works in which the elements, such as the water in which the turtles and carp swim, are rendered with great effect. Both their exquisite printing and their large format suggests that these prints were aimed at a more well-to-do audience. The publisher for this series was Moriya Jihei, who had also produced the *Eight Views of the Ryūkyū Islands*. His was an old established firm, mainly involved in publishing fiction, although in the 1790s it had published some sets of prints designed by Utamaro. Apart from the *Eight Views* and a few others by Hokusai, Moriya is known for series by Kunisada, Hiroshige and Utagawa Sadahide (1807–73). Although his firm had a reputation for making badly cut blocks, this certainly was never the case with those it published after Hokusai's designs.

The series *A True Mirror of Chinese and Japanese Poems*, dating from around 1833 and in the same format as the nature studies, was also published by Moriya Jihei. It comprises ten designs, in each one of which a classical poet is either depicted in a landscape that was known to him or in one for which a reference has been found in a poem. Thus the Japanese poet Abe no Nakamaro is portrayed on a terrace in China, where he was held captive, watching the moon above the sea (cat. 69), while the Chinese poet Li Po admires the waterfall of Lo-Shan (cat. 70), the subject of one of his poems. The series also contains a

design entitled *Shōnenkō* (cat. 71), the theme of the young man setting out from home, which has been the subject of hundreds of Chinese poems. In view of the often indirect allusions contained in these prints, which would only have been understood by a cultured élite, they were obviously only intended for limited circulation, which explains their comparative rarity.

The prints that make up *A True Mirror* are not only impressive because of their large format: all of them are masterly compositions with well-balanced colouring, ample gradation printing and — what was probably a novelty at the time — show the grain of the blocks clearly. Many regard this series as Hokusai's greatest achievement, in part because the designs form such a homogeneous group. The same, however, can also be said of the *Waterfalls*, the *Snow, Moon and Flowers* and the *Large Flowers*, among others; it is likely, then, that the impressive format and the relative scarcity of examples of this series have contributed much to the high esteem in which *A True Mirror* is held.

Hokusai also designed another series, *One Thousand Pictures of the Ocean*, for Moriya Jihei's firm. This comprises ten designs that illustrate various ways to catch fish. In addition to scenes that include anglers, men below a waterfall and a man in a boat with a large net, there is one of men fishing by torchlight at night (cat. 49) and even one of a whale hunt off the Gotō Islands (cat. 47). The best-known print of the series shows two fishing boats in a wild sea (cat. 48), an intricate composition in which the water seems to be running in two directions. The designs in this series are rather small in format, so *One Thousand Pictures* was printed with two designs to each block, with the publisher's mark and censorship seal often appearing on only one of the two designs in each pair.

In 1834, the year the *Thirty-six Views* was completed, Hokusai produced another landscape series, *Remarkable Views of the Bridges in All Provinces* (cat. 34–8), which consists of ten prints that depict a variety of types of bridge. An eleventh design, of a new bridge at Ōsaka, was probably added to the set only as an afterthought, since an addition to the signature states that it was designed 'on special request'. In view of Hokusai's lifelong fascination with bridges of all kinds, it can hardly be doubted that he responded to this request with great enthusiasm.

Most of Hokusai's works of these years are known in one impression only, an indication that the editions were very small, presumably because demand was limited. Their prices must have been high and they were never within the reach of a mass audience. The only exception to this was the *Thirty-six Views* series, which went through many reprints, often showing considerable variations. This seems to have been the case particularly with the earlier instalments, for examples of the group of ten supplementary designs are almost always good impressions printed from virtually unworn blocks. We have little information on which to base any estimation of the size of editions at that time. However, from a comparison with the print runs of works of popular fiction, for which some figures are known, a reasonable estimate of the size of most editions of Hokusai's landscape prints would be around five thousand impressions, a figure the blocks would easily have sustained. Colour blocks usually wore down faster than line-blocks and this may have been the publisher's chief reason for reverting from Prussian blue to black ink for the line-blocks used for the *Thirty-six Views* series after the initial impressions had been printed. The relative rarity today of Hokusai's prints — and those by other artists — can be

explained by a series of conflagrations and disasters in Edo: fires that regularly destroyed complete districts, the great earthquake of 1923 — which devastated more than two-thirds of the city — and bombs dropped by Allied forces during World War II.

Nishimuraya seems in part to have satisfied the continuing demand for the *Thirty-six View* series with new editions that were often unscrupulously modified. Some appeared in different colours or in simplified designs, others were printed from worn blocks that had been repaired. Since the well-to-do merchants and other serious collectors had by then been catered for, Nishimuraya seems to have decided that occasional print buyers could be satisfied with second-rate impressions. (Similar treatment, often worse, was meted out to Hiroshige's designs.) This demand probably explains Nishimuraya's decision to add an extra ten designs to the series, making a total number of forty-six. These additional designs were issued with a black line-block from the beginning; they may not have been reprinted as often as the original thirty-six were, possibly because of the serious economic recession of the late 1830s.

HOKUSAI'S LAST PRINTED WORKS

In 1833, five volumes of a translation of Chinese T'ang poetry were published with illustrations by Hokusai; the same year he also illustrated ten volumes of a translation of a Chinese novel, the *Shinpen Suikogaden*. The following year the twelfth volume of Hokusai's *Manga* and three volumes of Chinese classics were published, as well as the first volume of Hokusai's masterpiece in book illustration, *One Hundred Views of Mount Fuji*. The plates for this were cut by the foremost block-cutters of the time and exquisitely printed in line and in shades of grey; *One Hundred Views* is a landmark in the history of the illustrated book. Mount Fuji is once again the subject of Hokusai's wonderfully original compositions. *One Hundred Views* begins with plates depicting the gods that were identified with the sacred mountain. These plates are followed by views of Fuji itself, its stylised form repeated in many elements in a variety of ways. In this album Fuji's form serves as the starting-point for many of the compositions, whereas it was only occasionally used in this way in the *Thirty-six Views*.

In *One Hundred Views* Hokusai returned to several of the themes that had fascinated him for years: the Wave (cat. 131), for example, or Fuji seen through the piers of a bridge, as in the plate *Seven Bridges in One View* (cat. 132). It did not occur to him that this would be his last opportunity to treat such subjects, for as a postscript to the first volume he added the short autobiography, here given in full, in which he expressed his aspiration to live to the age of 110:

> From the age of six I was in the habit of drawing all kinds of things. Although I had produced numerous designs by my fiftieth year, none of my works done before my seventieth is really worth counting. At the age of seventy-three I have come to understand the true form of animals, insects and fish and the nature of plants and trees. Consequently, by the age of eighty-six I will have made more and more progress, and at ninety I will have got closer to the essence of art. At the age of one hundred I will have reached a magnificent level and at one hundred and ten each dot and each line will be alive. I would like to ask those who outlive me to observe that I have not spoken without reason.
> Gakyōrōjin Manji

That he chose to include an autobiography as a postscript to the first volume of *One Hundred Views* suggests that this was a period in which Hokusai was reassessing his life and work. He saw the *One Hundred Views* as the beginning of a new phase in his career, and thus the time to adopt a new artist's name, that of Manji. His signature in the volume's colophon reads *zen Hokusai Iitsu aratame Gakyōrōjin Manji*, or 'the former Hokusai Iitsu changing into Gakyōrōjin [the old man mad with drawing] Manji'. The postscript and the same signature also appear in the second volume, published the following year.

Publication of the third, and final, volume appears to have been postponed until the early 1840s because of the Tenpō crisis. This crisis, the result of a series of bad harvests in the mid-1830s, was blamed on mismanagement by a corrupt administration. About 100,000 people died of starvation and there were peasant uprisings in numerous provinces. Many people who lived in Edo, Hokusai among them, fled to the countryside; cultural life in the cities almost came to a complete standstill. There were only occasional performances in the kabuki theatres, hardly any of which were new productions. Both print and book production became increasingly difficult, with many serial publications either interrupted or cancelled altogether.

It appears that this crisis meant bankruptcy even for a large and long-established publishing house like that of Nishimuraya Yohachi. Having collaborated on the first two volumes of the *One Hundred Views* Nishimuraya was now forced to sell the blocks for all three volumes, those for the third volume apparently having already been cut. Eirakuya Tōshirō (Hokusai's publisher for the *Manga* volumes) bought the blocks. Eirakuya thus not only became the sole publisher for volume three, but also for all subsequent impressions of the first two volumes.

Hokusai's last series of single prints, *One Hundred Poems Explained by the Nurse*, was begun with Nishimuraya, who published five of them. The remainder (of which twenty-two are known) was published by the obscure Iseya Sanjirō. In this series Hokusai illustrated a popular classical anthology of poems, the *Hyakunin isshu*, compiled in 1235 by Fujiwara no Teika (1162–1241), which was even the subject of popular card- and shell-games. In *One Hundred Poems* Hokusai played freely with word associations and combinations of words; some words he deliberately misunderstood or misinterpreted. These associations and misunderstandings should, however, be attributed to the simple-minded wet-nurse of the title. The presentation by this nurse of the hundred best-known poems in Japan involved a very diverse group of prints, including beautiful landscapes and some moving and intimate scenes; many are printed in brilliant, daring colour schemes. Some of the prints feature open and almost empty landscapes, such as those for the poems by the Empress Jitō (cat. 75) and Abe no Nakamaro (cat. 79 and fig. 12); others concentrate on human activities, such as the illustration to the poem by Minamoto no Muneyuki that shows hunters in the mountains warming themselves by a large fire (cat. 80). Some, like the prints to poems by Kakinomoto no Hitomaro (cat. 76) and Yamabe no Akahito (cat. 74), combine people and landscape in a manner that is reminiscent of his works of the early 1830s.

It is interesting to note that except for the ubiquitous, so-called *Homo Hokusaiensis* — who is easily recognised by his clearly bracketed limbs, round face and idiosyncratic features — hardly any of Hokusai's earlier favoured themes recur in this series, though a man

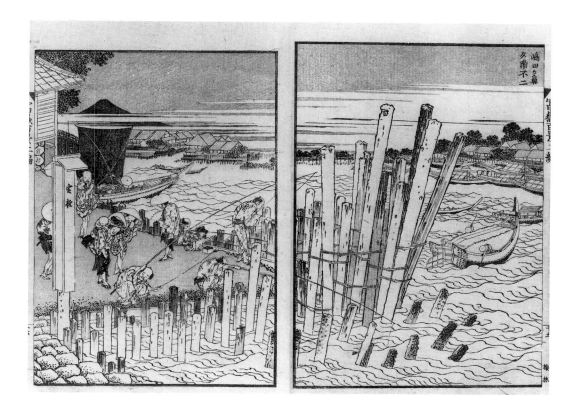

is washing a plate in *Pleasure Boats on Sumida River* (cat. 81), a subject that had been included in many previous book illustrations. In another plate men are shown sawing up a large log, which had also been treated in the *Thirty-six Views*.

The twenty-seven designs seem to have been published between the spring of 1835 (their publication was announced in a popular novel of that year) and the summer of 1836; further printings were probably interrupted by the Tenpō crisis. However, Hokusai seems to have completed all his designs for the remaining prints. Of the sixty-four that are known, fifty-five are drawings in the form of copies prepared for the block-cutter. Although these are in line only, they nevertheless provide a good idea of how the complete series would have looked.

PAINTINGS AND DRAWINGS

Between 1830 and 1836 Hokusai made almost 250 designs, of which nearly two hundred were realised as prints. In addition, there were the numerous book illustrations, including those for the *One Hundred Views*. But it is reported that during the worst of the Tenpō crisis, Hokusai wandered through the streets trying to sell his drawings. And once the crisis was over, apparently he did not return to his former level of production—Hokusai was, after all, in his early eighties by then and, apart from some book illustrations, he began to devote most of his energy to painting. He seems to have been quite successful in this field: many of the paintings were executed on silk and, therefore, appear to have been

commissioned by rich clients. There is still considerable controversy over the extent of his painted *œuvre*, one of the problems being that the paintings differ so markedly in style from his prints.

For drawings, however, the situation is very different. Fourteen original designs, plus a few details, have survived for the plates that relate to the *One Hundred Views*. In addition, there are four designs for prints from the *One Hundred Poems* series that date from about the same time (fig. 12), and a group of over one hundred designs of mythological *shishi*, Chinese lion-dogs, which Hokusai drew as daily exorcisms from the eleventh month of 1842 until the twelfth month of 1843.

From this broadly accepted corpus of drawings, it is possible to develop a clear idea of Hokusai's approach to drawing. Apparently he started only after careful deliberation, having first made clear in his own mind exactly what it was he wished to draw, and in order to avoid having to make corrections he used his brush with great care. As can be seen in the preparatory drawing (cat. 108) for the print of *People Crossing an Arched Bridge* (cat. 78), the figures in his designs were apparently drawn separately; a copy was carefully made, which was then pasted in position. Sometimes further corrections were made in red ink or on extra pieces of paper. Hokusai's careful brushwork can also be seen in surviving examples of his handwriting, mostly letters addressed to his publishers (cat. 111). Although his hesitant brushwork traits are most conspicuous in works of the 1830s and '40s, they are evident to some degree in works dating from much earlier. In a series of drawings that probably dates from the late 1780s (Victoria and Albert Museum, London), his cautious brushwork is already recognisable. An exception to his usual style can be seen in the sketches belonging to the so-called *Day and Night Albums* (cat. 101, 102) and in a few other works made around the same time (cat. 103). The *Day and Night* sketches were probably not made with printed works in mind and generally exhibit a much looser style than is usually to be found.

It is probably correct to assume that Hokusai lived entirely for his art. His production was enormous, amounting to over 3,500 designs for prints alone, plus illustrations to over 250 books (many in more than one volume) and a considerable number of paintings; he must have worked ceaselessly. He seems to have spent his money easily (more than once he even had to pay his grandson's gambling debts): in the winter of 1830 he wrote to his publisher Hanabusaya Heikichi claiming that, 'This month, I have no money, no clothing, nor food. If this continues for another month, I will not live to see the spring . . .'.

In his time, Hokusai was highly valued as an artist, not only by the patrons of his numerous *surimono*, but also as an illustrator of popular novels, working with the foremost writers of his day, including Takizawa Bakin (1767–1848), Ryūtei Tanehiko (1783–1842) and Takai Ranzan (1762–1838). His picture books, the *Manga* for example, could only have been reprinted so often — sometimes over a period of more than sixty years — thanks to a continuous demand by a diverse public. His landscape prints of the 1830s were influential, regularly imitated, sometimes even simply copied by other artists and integrated into their own designs. The popular annuals that were published at the time as guides to the relative status of Edo's most fashionable courtesans and actors, and also occasionally writers and artists, reveal that Hokusai was ranked among the top *ukiyoe* artists.

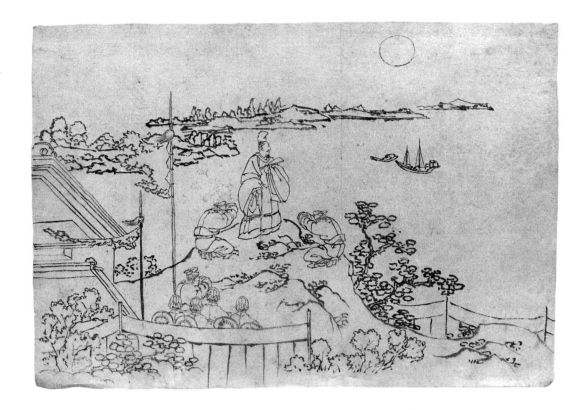

Fig. 12 *Abe no Nakamaro Watching the Moon from a Hill*, preparatory sketch (273 × 384 mm) for the print of this subject in *One Hundred Poems Explained by the Nurse* (*c.* 1835–6). Huguette Berès Collection

Hokusai was himself responsible for the somewhat distorted view that people have of him as an artist. On several occasions he seems to have organised public demonstrations of his art. In the summer of 1804, for example, he painted a figure of Daruma, the founder of the Zen sect of Buddhism, that is said to have measured some 120 *tatami* mattings (about 216 x 108 metres); a tenth of the size would have been more likely and still impressive enough in scale. In 1817, probably as part of an advertising campaign by Eirakuya Tōshirō to promote Hokusai's *Manga* volumes, Hokusai repeated his performance in Nagoya. The eyes of the Daruma in this painting were said to have measured 1.8 metres, the nose 2.7 metres and the mouth 2.1 metres. For brushes, he used brooms. The finished painting was suspended from scaffolding erected on the Nishikakesho, near the Nishi Honganji temple at Nagoya.

RECEPTION IN THE WEST

When Hokusai's works began to arrive in the West in the mid-nineteenth century, his *Manga* and the *Thirty-six Views of Mount Fuji* were hailed as great discoveries; the prints in the *Manga*, in particular, were more popular than anything else that had arrived from Japan. Numerous designs taken from the *Manga* volumes began to figure in all kinds of publications, the earliest examples of which are probably the copperplate engravings after Hokusai's illustrations included in Philipp Franz von Siebold's *Nippon* (1832–58). Among the more notable subsequent publications that include works after Hokusai are Sherard Osborn's *Japanese Fragments*, the third volume of the *Recueil de dessins pour l'art et l'industrie*

and Charles de Chassiron's *Notes sur le Japon, la Chine et l'Inde* (all published in 1861). By the early 1860s Hokusai's French admirers included the brothers Edmond and Jules de Goncourt and the Barbizon School painters Jean-François Millet and Théodore Rousseau. And once artists and collectors in Paris, Amsterdam, London and elsewhere had begun to decorate their homes with Japanese prints and various oriental *objets d'art*, this very fashionable form of decoration was rapidly reflected in contemporary portraits and interior scenes. James McNeill Whistler, for example, showed two such paintings, *The Scarf* (untraced) and *The Golden Screen* (Freer Gallery of Art, Washington, D.C.), in London at the Royal Academy's summer exhibition in 1865, while Edouard Manet's portrait of *Emile Zola* (Louvre, Paris) of three years later includes a Japanese print pinned to the wall next to the sitter.

By the 1870s Japanese art had become an object of serious study for numerous Western scholars and critics, including Théodore Duret, whose two articles largely devoted to Hokusai's book illustrations appeared in the *Gazette des Beaux-Arts* in 1882. In 1896—only five years after Iijima Kyōshin's *Katsushika Hokusai den*, the first book on Hokusai in Japanese, was published in Tokyo—Edmond de Goncourt published his monograph *Hokousaï*, Michel Revon his *Etude sur Hok'sai* and Siegfried Bing his series of articles on 'La Vie et l'œuvre d'Hok'sai' in *La Revue Blanche*.

In Japan in the second half of the nineteenth century, interest in Hokusai's work lagged far behind that of the West. The first major exhibition of his work to be held there was, in fact, organised by Ernest Fenollosa, an American admirer. Inevitably, this exhibition, held in 1900, concentrated on the paintings, for prints were then still regarded as a relatively vulgar form of art. This attitude probably explains why the next serious monograph on Hokusai to be published in Japan did not appear until 1944, by which time numerous studies, admittedly uneven in quality, had appeared in Britain and Germany as well as in France. If the number of books, articles and exhibitions is a reliable means of measuring popularity, France can justly claim to have shown the greatest interest in Hokusai over the past century.

Impressive collections of Hokusai's illustrated books and landscape prints were first formed in France, England and the USA. His *surimono* were first appreciated by collectors in The Netherlands, Belgium and Germany, though important collections of them are now also to be found in Ireland and the USA. His preparatory drawings were also admired from the outset in The Netherlands, where they have even been exhibited in combination with drawings by Rembrandt and Van Gogh. Of Hokusai's paintings, the finest collection is undoubtedly to be found in the Freer Gallery of Art in Washington, D.C. In recent years in Japan, enthusiasm for Hokusai's works has expanded enormously, as is shown by the almost annual large exhibitions devoted to them as well as by the recently founded Hokusai museums in the towns of Ōbuse and Tsuwano. Today, no other Japanese artist's works are so well-known around the world by such a large, non-specialist public.

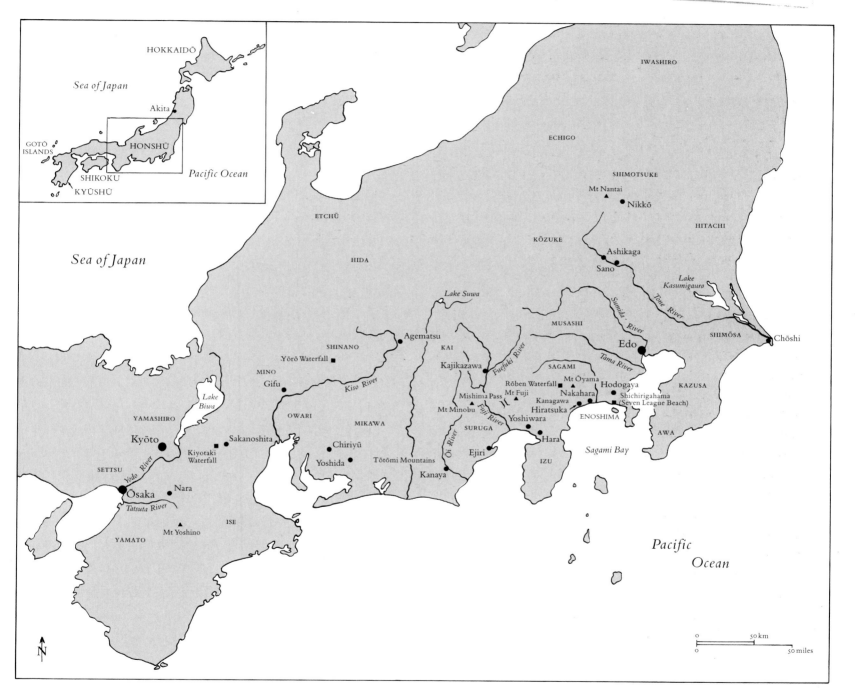

HOKKAIDŌ

Sea of Japan

Akita

GOTŌ
ISLANDS

HONSHŪ

Pacific Ocean

SHIKOKU

KYŪSHŪ

IWASHIRO

ECHIGO

Sea of Japan

SHIMOTSUKE

Mt Nantai

Nikkō

ETCHŪ

KŌZUKE

HITACHI

HIDA

Ashikaga

Sano

*Lake
Kasumigaura*

Lake Suwa

MUSASHI

Sumida River

Tone River

Agematsu

SHINANO

KAI

Fuefuki River

Edo

SHIMŌSA

Chōshi

Yōrō Waterfall

Kajikazawa

Tama River

MINO

Gifu

Kiso River

SAGAMI

Rōben Waterfall Mt Ōyama

Hodogaya

KAZUSA

Mishima Pass Mt Fuji

Nakahara Shichirigahama
(Seven League Beach)

*Lake
Biwa*

OWARI

Mt Minobu

Kanagawa

Hiratsuka

ENOSHIMA

YAMASHIRO

MIKAWA

SURUGA

Fuji River

Yoshiwara

AWA

Kyōto

Chiriyū

Ōi River

Hara

Kiyotaki
Waterfall

Sakanoshita

Yoshida

Tōtōmi Mountains

Ejiri

Sagami Bay

*Pacific
Ocean*

SETTSU

Yodo River

IZU

Kanaya

Ōsaka Nara

Tatsuta River

ISE

Mt Yoshino

YAMATO

N

0 50 km
0 50 miles

35

CHRONOLOGY

	HOKUSAI'S CAREER	CONTEMPORARY EVENTS
1760	Born in the Honjō district of Edo (present-day Tokyo)	
1765		First large group of full-colour prints produced
1770s		Flowering of the Katsukawa School of actor portraits
1775	Begins a three-year apprenticeship to a woodblock-cutter	
1778	Enters the studio of Katsukawa Shunshō, the leading designer of actor prints	
1779	Issues his first prints (signed Shunrō)	
1780s	Designs numerous actor prints in the style of the Katsukawa School	Flowering of portrait prints of beauties, designed by Torii Kiyonaga
1783		Shiba Kōkan produces the first copperplate etchings to be made in Japan
1790s	Studies the styles of painting of various schools	Portraits by Kitagawa Utamaro of famous courtesans published
1791	Begins working for the publisher Tsutaya Jūsaburō	Censorship seals become obligatory on all prints
1792		Death of Shunshō, Hokusai's teacher
1794		Tōshūsai Sharaku designs numerous bust portraits of actors
1795	Adopts the name Sōri. Over the next decade designs numerous *surimono* and plates for poetry albums	
1796	First use of the name Hokusai	
1797	Begins to experiment with his 'wave' motif	Death of the publisher Tsutaya Jūsaburō
1799	Announces his change of name to Hokusai	
1800s	Begins producing various series of Western-style prints as well as major albums of views of Edo	Landscapes begin to be integrated into prints of actors and courtesans, generally in the form of small insets
1805	Illustrates many popular novels by Bakin and other authors from now on	
1806		Death of Utamaro
1814	First volume of *Hokusai manga* published. Designs hardly any *surimono* during the next few years	Utagawa Kuniyoshi and Utagawa Kunisada begin their careers
1815		Torii Kiyonaga dies. Prints of courtesans and beauties of a rather coarse type by designers that include Kikugawa Eizan and Keisai Eisen begin to appear

1817	Drawings in the so-called *Day and Night Albums* made about this time	
1820	Changes name to Iitsu, though retaining the name Hokusai	
1820s	Returns to the world of the poets: designs many *surimono*, including some large series	Flowering of *surimono* in a square paper format; designers include Hokusai's pupil Totoya Hokkei, and Yashima Gakutei
1823		The physician Philipp Franz von Siebold arrives at Deshima, where he spends the next six years
1825		Death of Utagawa Toyokuni
1830s	Publication *c.* 1830–5 of the series *Thirty-six Views of Mount Fuji*, forty-six prints published by Nishimuraya Yohachi	Kunisada dominates the field of actor prints; Kuniyoshi establishes a new genre of prints on historical subjects. Full landscapes become common as settings for figure prints
1832	Publication of the series *Going the Round of the Waterfalls in All Provinces*, *Large Flowers* and *Eight Views of the Ryūkyū Islands*	
1833	Publication of the series *Snow, Moon and Flowers*, *One Thousand Pictures of the Ocean* and *A True Mirror of Chinese and Japanese Poems*	Utagawa Hiroshige establishes his reputation as a designer of landscapes with his series *The Fifty-three Stations of the Tōkaidō*
1834	Publication of the series *Remarkable Views of the Bridges in All Provinces*, *Small Flowers* and the first volume of the album *One Hundred Views of Mount Fuji*	
1835	Publication of the second volume of *One Hundred Views of Mount Fuji* and the series *One Hundred Poems Explained by the Nurse*	
1836–8	Reduced to penury, he is reported to be hawking his drawings in the streets	The Tenpō crisis causes widespread hardship and a collapse in print and book publishing
1840s	Designs few prints or illustrations for books, turning to painting instead	
1842–3	Draws a *shishi*, a Chinese lion-dog, each day as a ritual exorcism; these designs later become known as *The Daily Exorcisms*. Third volume of *One Hundred Views of Mount Fuji* published *c.* 1842	Restrictions imposed on print publishing: actor prints are banned and censorship is tightened
1845		Many prints published from now on carry lengthy explanatory inscriptions provided by well-known authors
1848	Publishes his *Picture Book on Colouring* in two volumes	Death of Eisen
1849	Dies on the eighteenth day of the fourth month and is buried at Seikyōji Temple in Asakusa, Edo	
1858		Death of Hiroshige
1868		Shōgunate rule overthrown; imperial rule restored in the person of the Emperor Meiji

CATALOGUE

1 a/b THE ACTORS ICHIKAWA EBIZŌ IV AND
SAKATA HANGORŌ III

published by Tsutaya Jūsaburō, 1791

signed: *Shunrō ga*
censorship seal: *kiwame*
woodblock, *hosoban*, 314 x 135 mm (each)
The British Museum, London (1904.1.10.02) (1a)
Museum of Fine Arts, Boston (11.19925) (1b)

The print of the kabuki theatre actor Ichikawa Ebizō IV (1a) in the role of the monk Mongaku is one of a pair published shortly after his performance in *Kin no. menuki Genke no kakutsuba* ('The Golden Sword Decoration and the Square Swordguard of the Minamoto Family') at the Ichimura theatre in Edo in 1791. The play consisted of a familiar plot specially adapted for the occasion; such adaptations were customary for the opening of each new theatrical season, which took place in the eleventh month.

The matching print (1b) depicts Sakata Hangorō III, who appeared in the same performance in the role of Chinzei Hachirō no Tametomo. Both actors strike a *mie*, a characteristic of kabuki theatre, in which its performers freeze into a rigid pose at climactic moments: the head is first rolled in a circular motion to finish up twisted over one shoulder, the eyes glare horribly and one corner of the mouth is pulled down. These *mie* were considered the highlights of a play and, consequently, were frequently represented in prints. As is so often the case with kabuki plots, the characters spend much of the performance in disguise, only to reveal their true identities — and discover those of others — at a late stage. Here Mongaku masquerades as a bandit, while Tametomo pretends to be an itinerant monk.

These two prints, which were available individually or as a pair, are good examples of Hokusai's skills as a designer in the genre of actor prints. They have all the dramatic power that was the speciality of the Katsukawa School, in which he was first trained.

2 A WOMAN WITH A TEACUP

c. 1816–17

signed: *zen Hokusai Taito hitsu*
fan print, line-block proof impression with corrections in ink,
261 x 310 mm
Society of Friends of Asiatic Art, Amsterdam (Rijksprenten-
kabinet, Rijksmuseum, Amsterdam) (W. 785)

A tea-house waitress, who carries a cup on a tray, is adjusting
one of her hairpins. Over her shoulder is a towel. Her shaven
eyebrows and blackened teeth indicate she is married. The
tray and the comb she wears in her hair share an identical
plum-blossom pattern, which Hokusai probably intended
to look like lacquerwork. This proof impression of a fan
design has Hokusai's own corrections in ink on the waitress's
collar. Once these changes had been made on the block by
the cutter, a number of additional proofs were pulled.
Hokusai would then indicate on these proofs the colour that
was to be used for each area. The registration marks for the
colour blocks can be seen in the corner bottom left, though
no colour print version of this design is known.

Although quite a number of Hokusai's paintings on fans
have survived — most of which were done for the folding
type, although this particular design is for a rigid fan — only
a few prints in this format are known; this, with the possible
exception of one other print, which again is known only in
proof, is the earliest. It is also the only fan print of a bust por-
trait of an individual. Hokusai's other fan prints all date from
the 1830s. A number of them are nature studies (see cat. 67);
the remainder comprise a series of landscapes entitled *Shōkei
kiran* ('Strange Sceneries'), some of which are printed
entirely, or almost entirely, in shades of blue.

Fans traditionally were discarded at the end of summer
when they were no longer needed; it is, of course, impos-
sible to estimate how many examples of Hokusai's designs
in this format have been lost in this way.

3 KINTARŌ AND THE WILD ANIMALS

published by Nishimuraya Yohachi, late 1780s

signed: *Shunrō ga*
woodblock, *ōban*, 372 x 248 mm
Staatliche Museen Preussischer Kulturbesitz, Museum für
Ostasiatische Kunst, Berlin (6200.09.198)
(ex-Hayashi Tadamasa Collection)

Kintarō sits at the foot of an oak tree in the company of two
wild animals. While resting his left hand on the neck of a
rather feline-looking bear, he grips one leg of an eagle in his
right. His kimono is adorned with *kotobuki* ('long life') in
repeated seal script.

Kintarō, who is sometimes known by his youth name of
Kintoki, was allegedly the posthumous son of Sakata
Kurando, an officer in the bodyguard of the tenth-century
Emperor Suzaku, and Yaegiri, a girl from Kyōto. After
Kurando was forced to leave the Emperor's court in disgrace
over his relationship with the girl, he began the life of a wan-
derer, earning his living by selling tobacco. Yaegiri set out to
find him, but soon after having done so Kurando killed him-
self. Yaegiri then lived alone on Mount Ashigara, where in
time she gave birth to Kintarō. He thus grew up in the wild,
with the animals he tamed as his only companions. He was
finally discovered, during a hunt, by the courtier Minamoto
no Yorimitsu (d. 1021), who persuaded Yaegiri to allow him
to bring up the boy. Kintarō eventually became one of
Yorimitsu's generals.

This early design by Hokusai clearly shows the influence
of Torii Kiyonaga (1752–1815). The bold outlines are typical
of contemporary portrayals of Kintaro, and are not to be
found in any other work by Hokusai of this period.

Ushigafuchi at Kudan (Kudan Ushigafuchi)

from a group of Western-style landscapes, *c.* 1800–5

signed: *Hokusai egaku*
woodblock, *chūban*, 180 x 245 mm
Bibliothèque Nationale, Paris (JB. 740)

It is a sunny day, and people are walking up Ushigafuchi street in Kudan (present-day Chiyoda ward), Edo. Descending this steep road are a samurai and his servants. On the left, two men gaze down into the pool from which Ushigafuchi, literally 'ox pool', takes its name. Apparently, this derives from an incident in which an ox-cart tumbled into the dike by Kudansaka Hill, after which ox-carts were banned from the area. In the distance are some houses backed by trees, beyond which is a fire watch-tower.

There is a marked Western influence in this print. It is probably one of the earliest — and one of a very small number — in which Hokusai used cast shadows for his figures. This *chiaroscuro* effect, probably made in imitation of Western oil paintings, is the result of printing darker pigments over lighter shades in such a way that the outlines appear slightly blurred. The effect, especially in the foliage of the trees, is fairly convincing. The realistically rendered clouds and sky are also unmistakably influenced by Western art: traditionally in Japanese prints, skies are composed of horizontal bands of mist. In order further to emphasise his debt to the art of the West Hokusai added a decorative border, and wrote both his signature and the title of the print in horizontal, syllabic script.

In a later reprint of this design, both the decorative border and the shadows are omitted.

REFERENCE: Lane, 1989, p. 74

5 A COASTAL VIEW

Viewing Noboto Beach at Low Tide
from the Salt Coast at Gyōtoku
(Gyōtoku shiohama yori Noboto higata wo nozomu)

from a group of Western-style landscapes, *c.* 1800–5
signed: *Hokusai egaku*
woodblock, *aiban*, 196 x 257 mm
Museum of Fine Arts, Boston, Nellie P. Carter Collection (34.331)
(ex-P. Blondeau Collection)

A broad view of the beach at Gyōtoku, in Shimōsa province to the east of Edo, which was famous for its salt production. A man on horseback is travelling on the coastal road; *torii*, or 'entrance gates', to Shinto sacred places can be seen in the water beyond the rocks. Above the rider is a flock of birds.

This print contains a curious mix of Western and traditional Japanese elements. The overprinting of various shades to render depth and shading betrays Western influence, as does the overall composition, in which the thatched roofs and high trees in the foreground convey a sense of perspective. This type of sky, however, is purely Japanese.

The coast at Noboto also appears in Hokusai's series *One Thousand Pictures of the Ocean*, though seen from a different viewpoint and as the setting of a scene depicting people on the beach gathering shellfish.

There are various distinctly different impressions of this print. In the earliest examples, there is a rainbow in the sky, while a later state (Musée Guimet, Eo 178) not only omits the decorative border, but also the print's title and the artist's signature.

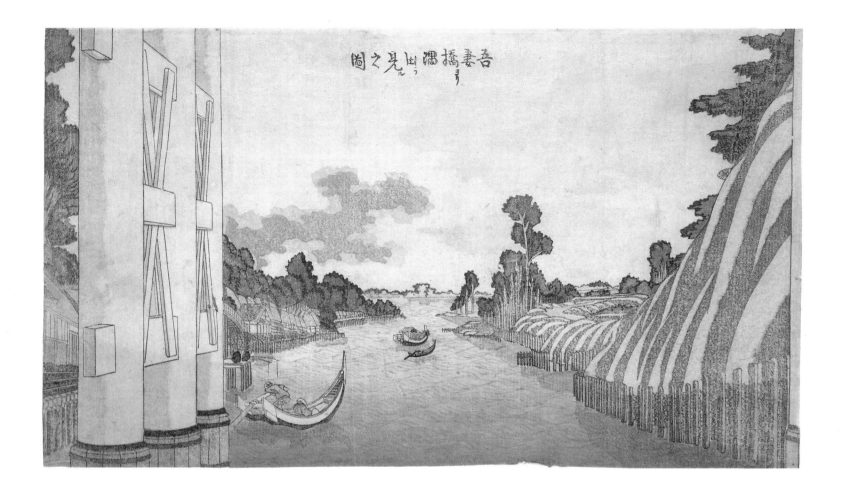

吾妻橋淵川見之圖

6 A VIEW OF SUMIDA RIVER

Sumida River Seen from Azuma Bridge
(*Azumabashi yori Sumida wo miru no zu*)

from a group of Western-style landscapes, *c.* 1800–5

unsigned
woodblock, *aiban*, 188 x 314 mm
The Art Institute of Chicago, The Clarence Buckingham
Collection (1928.1106)

A view of Sumida River in Edo and several boats, with the piers of Azuma bridge conspicuous in the foreground. To the left are the houses along Hanakawadō, a popular riverside street. There are cherry trees on both sides and, to the right, the high embankment behind which, a little further upstream, the famous Mimeguri Inari shrine is situated.

There are obvious Western influences in this design. The overprinting of various shades in both the trees and the embankment to the right is meant to suggest shading, or the effect of *chiaroscuro*. The clouds, which are also printed in various tones, are in a marked Western-style form. In addition, the piers of the bridge are shaded, and both the right-hand bank of the Sumida and the boats cast their shadows on the water. The print's decorative border was intended to suggest a Western-style frame, although in this example it has been trimmed off completely. The Sumida's stylised waves, depicted in a typically Japanese manner, contrast sharply with these Western elements.

REFERENCES: *Ukiyoe taikei*, VIII, 15; Lane, 1989, p. 72

The Famous Places on the Tōkaidō Road in One View
(*Tōkaidō meisho ichiran*)

published by Kadomaruya Jinsuke, 1818

signed on wrapper: *Katsushika zen Hokusai Taito rōjin* ['old man'] *ga*
woodblock, 430 x 580 mm
Bibliotheek der Rijksuniversiteit, Leiden (373)
(ex-Philipp Franz von Siebold Collection)

In pre-modern Japan, the numerous major roads that connected the main cities were not only meant for travellers and as a means of transporting all kinds of merchandise, they also had a strategic purpose — to provide speedy routes for troops of samurai should any daimyō, or feudal lord, attempt to oppose the shōgun. The most popular road for those who journeyed solely for pleasure, however, was the Tōkaidō, which connected the capital, Edo, and the old imperial city of Kyōto, where the Emperor continued to reside, although deprived of all real power.

The distance from Edo to Kyōto on this coastal road is about 550 kilometres, which most travellers would have covered in approximately three weeks. At intervals — generally between six to ten kilometres — towns, or stations as they were known, served to lodge travellers, provide restaurants and fresh horses and, of course, offer various amusements. Following the appearance of Jippensha Ikku's comic travelogue, *Tōkaidōchū hizakurige* ('A Shanks's Mare'), a serial published from 1802 onwards, prints of scenes on the Tōkaidō Road were designed by a great many artists.

Shortly after 1800, for example, Hokusai designed some seven or so different series of landscapes of the Tōkaidō — which comprised fifty-three stations in all — some of which also included plates of the starting-point and terminal station.

In this map Hokusai has laid out the whole route from Edo (with the Castle and Nihonbashi, the starting-point, seen at bottom right) to Kyōto, with Nijō Castle and Mount Atago at the top right. Top left is Mount Fuji, behind which the sun rises. Topographically, the whole country is represented as one long and winding road, with numerous inscriptions indicating the villages, temples and best-known sites, as well as the distances between stations. Originally this map was sold in a printed wrapper, on which the title and the year of publication were given. That it was a success may be inferred from Hokusai's publication the following year of a similar map depicting another, longer, route, the Kisokaidō, which connected Edo and Kyōto. Two others by him, of Shiogama and Matsushima in Mutsu province, appeared shortly after.

8 WOMEN ON THE BEACH AT ENOSHIMA

Spring at Enoshima (Enoshima shunbō)

from the *kyōka* album *The Threads of the Willow* (*Yanagi no ito*)
published by Tsutaya Jūsaburō, 1797

signed: *Sōri ga*, with seals: *Hokusai* and *Sōri*
woodblock, album plate, 254 x 380 mm
The British Museum, London (H. 177)

Two women are talking to a young girl at Shichirigahama, the 'Seven League Beach' near Enoshima, a rocky island to the south of Edo. A porter, who appears to want to join in the conversation, rests his load. In the background several people are gathering shells; beyond them is the sandbank that leads to Enoshima itself. Mount Fuji is on the horizon.

In the foreground, and taking up almost half of this album sheet, is a conspicuously large wave rolling towards the beach. This wave probably represents Hokusai's earliest experiment with what, more than thirty years later, was to become the Great Wave (cat. 11) in the series *Thirty-six Views of Mount Fuji*. Yet, although *The Great Wave* plate in that series has become virtually synonymous with the name of Hokusai, this initial version seems to have been directly inspired by a wave in Shiba Kōkan's oil painting of the Seven League Beach, made in 1796 (fig. 3).

Enoshima was one of the scenic spots that could be easily reached from Edo, and an excuse for going there was provided by the presence of a shrine devoted to Benten, who was popularly worshipped as a goddess of love and wealth. Benten's origins as a river god meant that shrines devoted to her were usually constructed near water, often on islands. As she is also identified with snakes, the inclusion of an island dominated by one of her shrines in this album issued for 1797, a Year of the Snake, is not surprising.

The other five plates in this de-luxe *kyōka* album were designed by Tsutsumi Tōrin (two designs), Suzuki Rinshō, Hosoda Eishi and Kitao Shigemasa (1739–1820).

REFERENCES: Forrer, 1982, pp. 53f.; Lane, 1989, p. 36

9 A VIEW OF THE ISLAND OF ENOSHIMA

privately issued by Rissetsuan Goshin, 1799

signed: *Sōri aratame Hokusai ga*
dated: *Kansei tsuchinoto hitsuji gantan shihitsu* ('Testing the brush
on New Year's morning of the year of the Goat'), i.e. 1799
woodblock, *surimono*, 199 x 273 mm
Arthur M. Sackler Museum, Harvard University, Cambridge,
Massachusetts, Gift of the Friends of Arthur B. Duel (1933.4.1813)

Scattered groups of people are on the seashore; some are
crossing the sandbank in order to reach the rocky island of
Enoshima. To the right, the cliffs and trees are partly
obscured by banks of mist.

The waves, though slightly smaller than those in some
of Hokusai's other prints, are prominent enough for us to
regard this design as yet another precursor of *The Great Wave*
(cat. 11). As a whole, the composition strongly resembles
the plate Hokusai contributed two years earlier to the *kyōka*
album *The Threads of the Willow* (cat. 8).

This design was commissioned by Rissetsuan Goshin,
author of the five haiku poems that appear in the upper half
of the sheet. The paper itself was initially blindprinted with
a pattern to make it resemble silk.

REFERENCE: Bowie, 1979, 97

A View of Honmoku off Kanagawa
(*Kanagawa oki Honmoku no zu*)

from a group of Western-style landscapes, *c.* 1800–5

unsigned
woodblock, *aiban*, 233 x 353 mm (margins on all sides)
David Caplan Collection

Although Hokusai had already been experimenting with his 'wave' in a plate for the *kyōka* album *The Threads of the Willow* (1797; see cat. 8) and in a *surimono* of a similar view of Enoshima (cat. 9), this *aiban* print, along with some other similar designs made during the same period, seems to be the first direct precursor of *The Great Wave* (cat. 11). Although reversed, both the shape of the most prominent waves and the positioning of one of the boats appear to have been established in this print of 1800–5, which predates the Fuji series by more than two decades. An even stronger resemblance to *The Great Wave* can be seen in a similar Western-style view of *A Boat in a Great Wave at Oshiokuri* (fig. 2), which has the waves rolling in the same direction and the boats in an almost identical position.

A comparison of the prints shows that this *aiban* is strongly marked by Western influence. This is particularly noticeable in the overprinting, where the indistinct outlines suggest the effect of *chiaroscuro*, while the print's title and artist's signature are both written in horizontal syllabic script, and the decorative border imitates a Western-style picture frame. In *The Great Wave*, however, Hokusai's representation engages a different Western influence — that of realism. *The Great Wave*, with its various shades of blue, white foam and the natural hollow of the wave itself, has all the characteristics of a true-to-life wave. This earlier *aiban* print has a wave shaped more like a mountain, probably because it is represented immediately before it collapses. Its shape was, however, imitated subsequently by several artists, notably Keisai Eisen (1790–1848) and Utagawa Kuniyoshi (1798–1861).

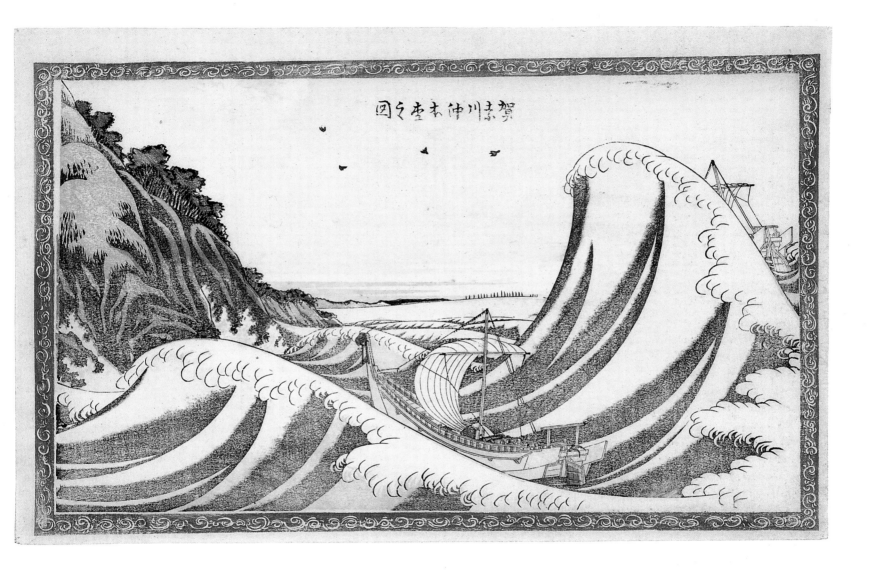

MOUNT FUJI

CAT. 11–32

From the series *Thirty-six Views of Mount Fuji (Fugaku sanjūrokkei)* published by Nishimuraya Yohachi (Eijūdō), *c.* 1830–5

censorship seal: *kiwame*

11 THE GREAT WAVE

In the Hollow of a Wave off the Coast at Kanagawa (Kanagawa oki nami ura)

c. 1830-1

signed: *Hokusai aratame Iitsu hitsu*
no seals
woodblock, *ōban*, 255 x 380 (margin at right)
The Metropolitan Museum of Art, New York, The
H. O. Havemeyer Collection, Bequest of Mrs H. O. Havemeyer
(JP 1847)

No other Japanese print is as widely celebrated as Hokusai's *Great Wave*. It figures frequently in all kinds of design, from comics to advertisements and from book-jacket illustrations to record-sleeves. This universal acclaim has transformed the Wave almost into an icon.

Hokusai's composition is perfectly balanced, but there must be something more to a design that has been accorded such a special status, for it would scarcely have become so popular in the West had the effect been seen as somehow forbidding. Whatever the effect upon Westerners, however, a Japanese audience in the early nineteenth century would probably have responded quite differently. In traditional Japanese painting, which originated in the illustrations added to sections of long horizontal hand-scrolls, pictures, like the text, were 'read' from right to left. The consequence of this was that the Japanese eye was accustomed to viewing images in this way, which implies that Hokusai's Great Wave was designed to tumble into the viewer's face, so to speak. For Western viewers, who were not disposed by tradition to 'read' pictures from any specific direction, the Wave would simply roll along from left to right, following the movement of the eye. A simple way to examine whether or not there is, indeed, any difference is to view *The Great Wave* in a mirror.

Impressions of this print vary only slightly. Early examples are characterised by fine crisp lines, the title cartouche is intact and the 'fingers' at the tip of the Wave show only small interruptions where two lines almost connect. Depending on the state of preservation, the pink cloud in the sky is more or less clearly visible. Almost all early impressions have the black sky behind Mount Fuji reaching up to, or going slightly above, its summit. The best examples have particularly subtle variations in the blues of the water.

In later impressions the black sky behind Fuji generally only reaches half-way up the mountain, and block breaks appear here and there. These begin on the left-hand side in the title cartouche. At first there is only a small break near the bottom, on the inner line. Next comes a much larger break, involving both lines of the cartouche, also to the left. In subsequent impressions further damage can be seen to the line of the wave at right, just behind the boat. This is followed by some damage to the top of what may be called the Great Wave's lower group of protruding fingers. Still later, various weak areas at the top line of the Wave show, and a new block for printing the light blue pattern in the white foam seems to have been cut. A restored worm-hole, bottom left, involved retouching some blue which should repeat the curve of the Wave and not, as here, make a band towards the left. There are also various nineteenth-century and modern facsimiles printed from new-cut blocks.

REFERENCES: *Ukiyoe taikei*, VIII, 29; XIII, 1; Forrer, 1988, p. 264; Lane, 1989, pp. 189, 192

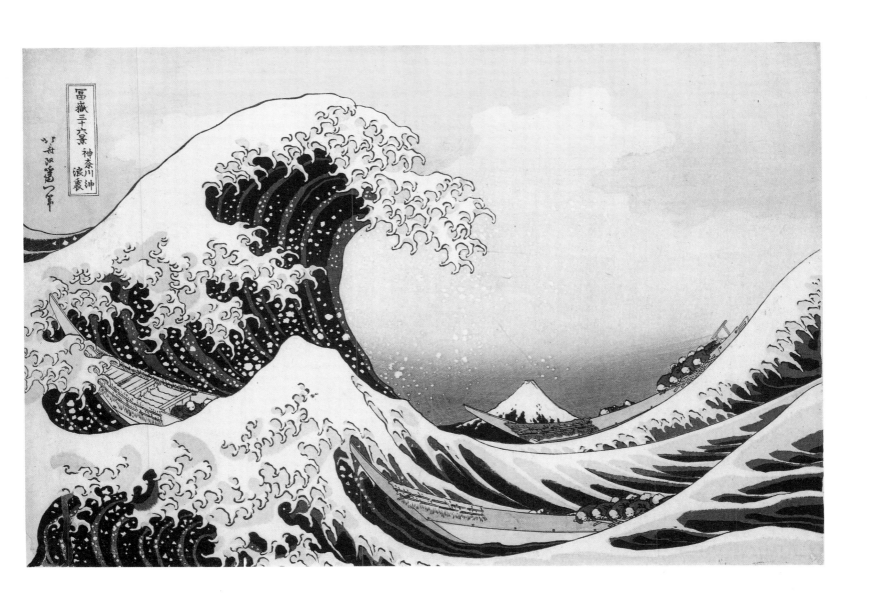

12 MOUNT FUJI IN CLEAR WEATHER

South Wind at Clear Dawn (Gaifū kaisei)

c. 1830–1

signed: *Hokusai aratame Iitsu hitsu*
no seals
woodblock, *ōban*, 260 x 381 mm (margins at right and bottom)
The British Museum, London (1906.12.20.525)

Commonly known as 'Red Fuji', no other print in Hokusai's *œuvre* takes Nature so uncompromisingly as its subject. Whereas in the majority of Hokusai's landscape designs Nature is used as the setting in which human life goes on, nothing in this print suggests man's presence: there is only Mount Fuji, towering against a blue sky patterned with white clouds.

The season is somewhere between late summer and early autumn, when Mount Fuji is said to have a reddish hue. The snow makes a sharp contrast to the almost black cone of the summit. The emphasis given to this, the darkest area of the design, is balanced by the woods at the foot of the mountain. The subdivision into a dark summit, reddish mass and a green, tree-covered base is in itself sufficient to make the mountain appear intriguing. Yet, Hokusai chose to set off Fuji with a blue sky that is almost completely filled with an intricate pattern of clouds, which demands equal attention. This type of cloud is unique in Japanese prints – and, for that matter, in Japanese art: it obviously emulates Western models, and probably derives from Dutch copperplate engravings.

That Hokusai chose to use these Western-style clouds in one of his first true landscape prints may have been, in part, the result of a desire to attract the public's attention to his art, although some fifteen years earlier, in the fifth volume of his picture book *Hokusai manga* (1816), he had included a similar design, with Mount Fuji seen from the pine beach of Shio (fig. 4). However, it was only printed in line and in tones of grey and pink, and in a much less prestigious format. Only when this large, *ōban* colour print was published did Hokusai's innovations in landscape design become apparent.

The colour variations in this print—the shading from black to red and from reddish-brown to green, depending on the printer's interpretation—which are probably greater than in any other of Hokusai's designs, are frequently commented on. Most of the early and the carefully graded impressions, however, feature particularly strong colouring, lending a quite dramatic sense of presence to the mountain. There is also a later, variant, reprint (*Ukiyoe taikei*, XIII, 2–2) from the original blocks, in which the blue outline of the mountain is omitted and the title cartouche and signature are printed in black. For that impression, a blue block was employed for both the sky and for Fuji, and a stronger blue for the mountain's slopes, while its base was printed in a light tone and the upper half left uncoloured.

REFERENCES: *Ukiyoe taikei*, XIII, 2; Lane, 1989, p. 189

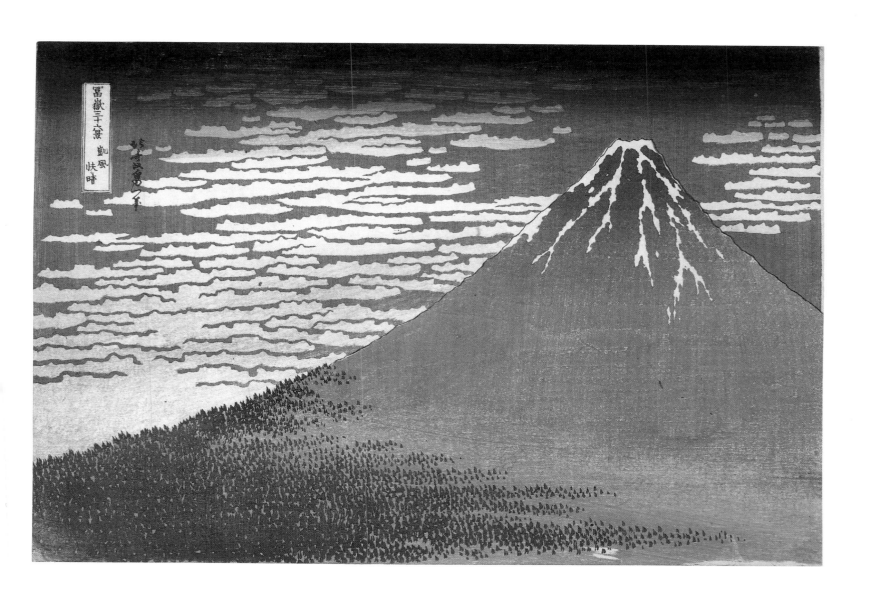

13 A SHOWER BELOW THE SUMMIT

Shower Below the Summit (Sanka hakuu)

c. 1830–1

signed: *Hokusai aratame Iitsu hitsu*
no seals
woodblock, *ōban*, 259 x 382 mm (margins at right and bottom)
Musée National des Arts Asiatiques-Guimet, Paris (Eo 173)

This print complements *Mount Fuji in Clear Weather* (cat. 12). Whereas in that print Fuji is seen by day and against a clear sky, here a sudden shower almost covers the mountain's foot and much of its slopes in dark clouds. Judging from the three peaks shown in this print the view is from Edo, although no precise location is indicated for either design.

Hokusai later included a plate of Mount Fuji with lightning in the second volume of his album *One Hundred Views of Mount Fuji* (1835). There, the lightning flashes down from the left, and a village swept by sudden winds and rain is included in the foreground.

The earliest impressions of this print can easily be recognised by two characteristic features. One is the pair of brown dots just below Fuji's summit; the right-hand dot must have been chipped off quite early on. Second, early impressions generally have sufficient blue in the sky to make the top of the white clouds visible, while later impressions vary considerably in the area of blue printed, sometimes showing only half of the clouds.

In both early and later impressions, much of the quality of the prints depends on the shade of reddish-brown at the top of the mountain and on the degree of care that was taken in printing the black at the bottom. A later, variant, impression (Lane, 1989, 250) features — apart from a black line-block — the outlines of pine trees against a white band, a light green having been printed along the foot of the mountain. In addition, the sky appears in a yellowish tone at the top, and in violet above the distant range of hills.

REFERENCE: Lane, 1989, pp. 192, 194

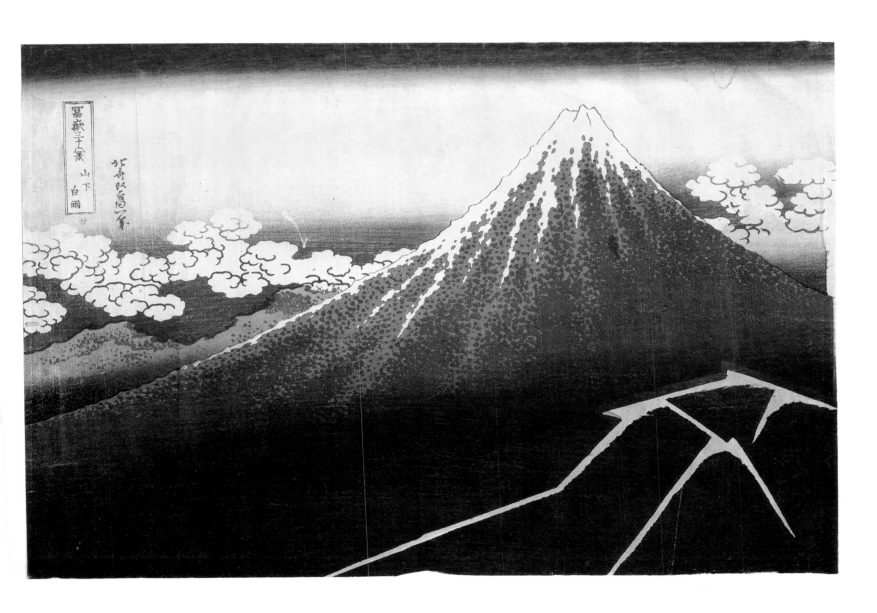

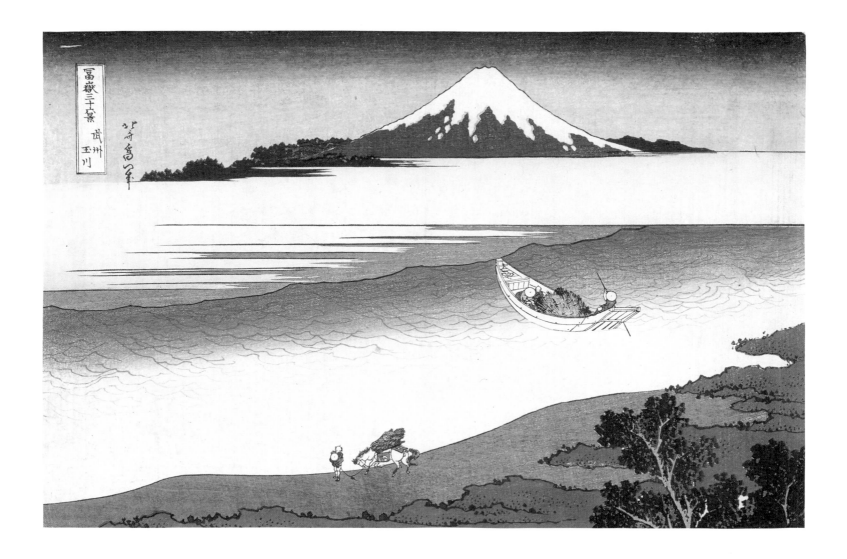

14 MOUNT FUJI SEEN ABOVE MIST ON THE TAMA RIVER

The Tama River in the Province of Musashi (Bushū Tamagawa)

c. 1831

signed: *Hokusai Iitsu hitsu*
no seals
woodblock, *ōban*, 247 x 367 mm
Peter Morse Collection

A boat is on the Tama River; Mount Fuji appears above a bank of mist that hangs over the water. In the foreground a man leads a horse along the bank. The Tama rises in the province of Kai and flows down through Musashi, finally entering Edo Bay near Kawasaki. In this design the colour is so faint that the effect is close to that of blindprinting — that is, by printing a pattern without having applied any pigment to the block. In a later impression from somewhat worn blocks, all of the Tama's waves are printed in a soft blue.

As with so many of the designs in this series, the effect depends to a large extent on the care exerted by the printer. Nicely gradated printing in well-balanced shades makes it easy to read the scene: in some impressions of this print the foreground is so dark that the legs of both the man and his horse are almost lost. Some impressions have the river-bank printed in two different colours. A defect in the woodblock used for the sky shows as a horizontal white stroke just above the title cartouche in even the earliest impressions. Sometimes this has been retouched.

There is also a later impression of this design printed with black outlines.

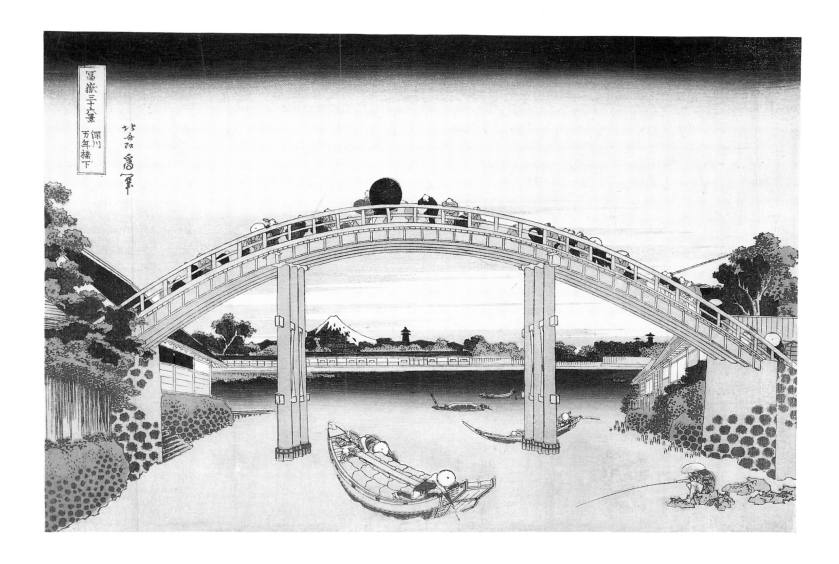

15 MOUNT FUJI SEEN THROUGH THE PIERS OF MANNENBASHI

Seen under Mannenbashi at Fukagawa
(Fukagawa Mannenbashi shita)

c. 1831

signed: *Hokusai aratame Iitsu hitsu*
no seals
woodblock, *ōban*, 256 x 374 mm
Honolulu Academy of Arts, The James A. Michener Collection
(L21.273)

Mount Fuji as seen through the supporting piers of Mannenbashi, an arched bridge over the Onaki River in the district of Fukagawa, Edo. The Mannen bridge is situated where the Onaki meets the Sumida River, which can be seen flowing from right to left beyond the bridge. The district of Fukagawa itself lies on the Sumida's eastern bank: on the right side of this print the houses of Fukagawa Tokiwa can be seen, and those of Fukagawa Kiyomizu on the left. Beyond the Sumida are the restaurants of Nakasu, an entertainment district, but one that more than once became the temporary home for courtesans and others from the neighbouring Shin Yoshiwara district, which frequently burnt down.

In early impressions of this print, the horizontal lines indicating the planks that form the wall of the house beneath the left side of the arch are all connected to the vertical timbers. In later impressions, however, probably as a result of a correction made by Hokusai, these lines were all trimmed in such a way that makes the planking less distinct.

REFERENCE: *Ukiyoe taikei*, XIII, 4

Kajikazawa in Kai Province (Kōshū Kajikazawa)

c. 1831

signed: *zen Hokusai Iitsu hitsu*
woodblock, *ōban*, 262 x 385 mm (margins at right and bottom)
The Metropolitan Museum of Art, New York, Henry L. Phillips
Collection, Bequest of Henry L. Phillips, 1929 (JP 2986)

A fisherman on a jutting rock holds the lines to which his cormorants are tied, while behind him is a young boy seated by a basket of fish. Beneath them, wild waves break on the rough shore. The triangular composition that is formed by the promontory, the fisherman and the lines he holds mirrors the distant outline of Mount Fuji. The scene is believed to be the point where two rivers, the Fuefuki and the Kamanashi, flow into a third, the Fuji, in the province of Kai, to the north-west of Edo.

This is the first impression of this print, executed in an *aizurie* version — that is to say, it is printed entirely in shades of blue. In addition, the right-hand and lower margins have been preserved intact. Later impressions feature an increased number of colours used, a green foreground being the first divergence from the original. Later still, yellow appears in the near foreground, the clothing is violet, and pinks and reds are incorporated, especially in the sky. In even later impressions, printed with a black line-block, the scheme is often in shades of blue, with only clothing and the basket printed in red.

REFERENCES: *Ukiyoe taikei*, VIII, 30; XIII, 15; Lane, 1989, pp. 194–5

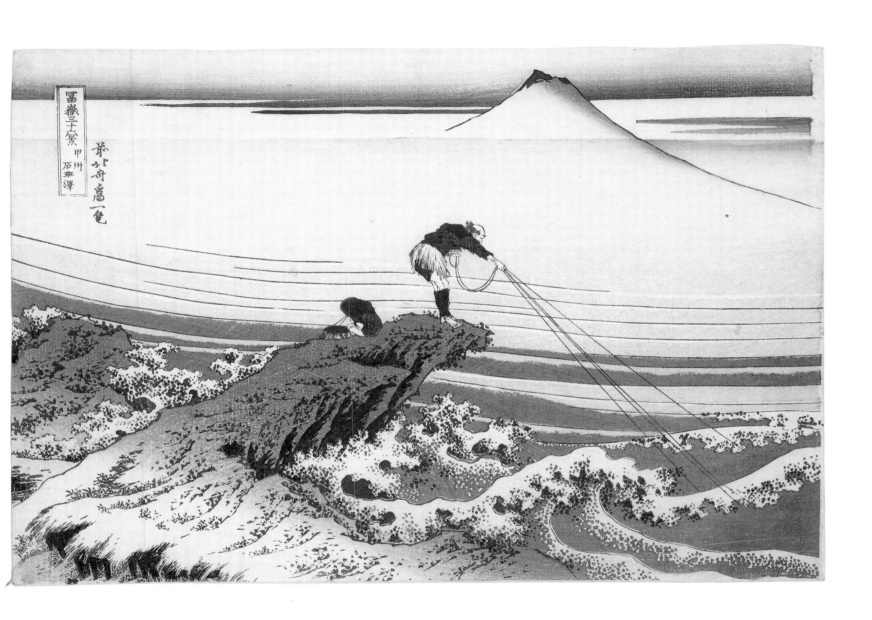

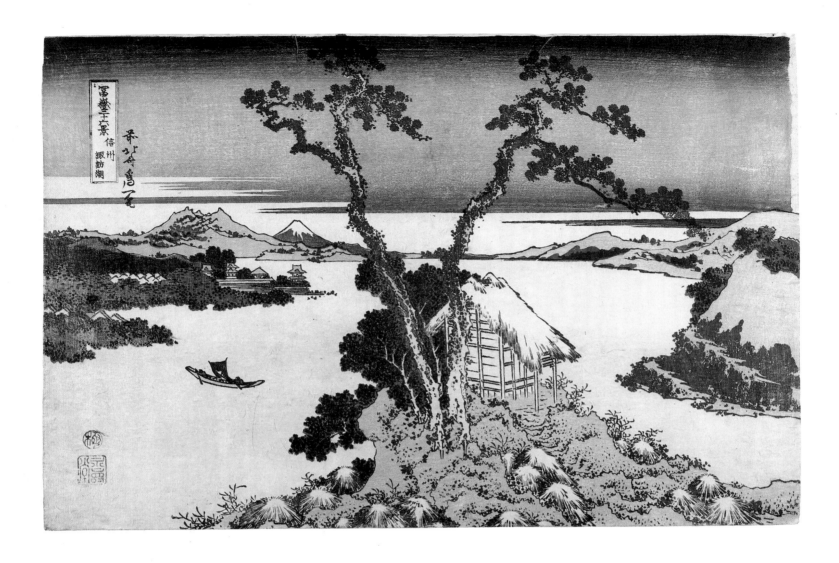

17 A VIEW OF MOUNT FUJI ACROSS LAKE SUWA

Lake Suwa in Shinano Province (Shinshū Suwako)

c. 1831

signed: *zen Hokusai Iitsu hitsu*
woodblock, *ōban*, 260 x 382 mm (margins at top, right and left)
The Brooklyn Museum, New York, Gift of Mr Frederic B. Pratt
(42.79)

Beneath two pines, a thatched hut stands on a promontory above Lake Suwa in present-day Nagano prefecture. Mount Fuji can be seen in the distance behind Takashima Castle, which belonged to the Suwa daimyō, or feudal lord. Except for some mist on the horizon, it is a clear day with a sheer blue sky. On the lake, one of the fishermen in the boat is hauling in a large net.

Here Hokusai has created a sense of depth in what is otherwise a traditional Japanese landscape by placing the pine trees and hut conspicuously in the foreground. Other than this, apart from printing some areas in a darker tone, little has been done to suggest distance. Only three shades of blue have, in fact, been used.

As in all later impressions of the designs originally issued in an *aizurie* edition, various colours were subsequently introduced. Mount Fuji and the trees in the foreground and on the more distant hills were printed in shades of green, with yellow used for the timber walls of the hut and for the branches of some of the trees, while the sky was printed in blue at the top and in an orange-red below, thus setting the scene in the early evening.

In still later impressions the blue outlines were replaced by a black line-block.

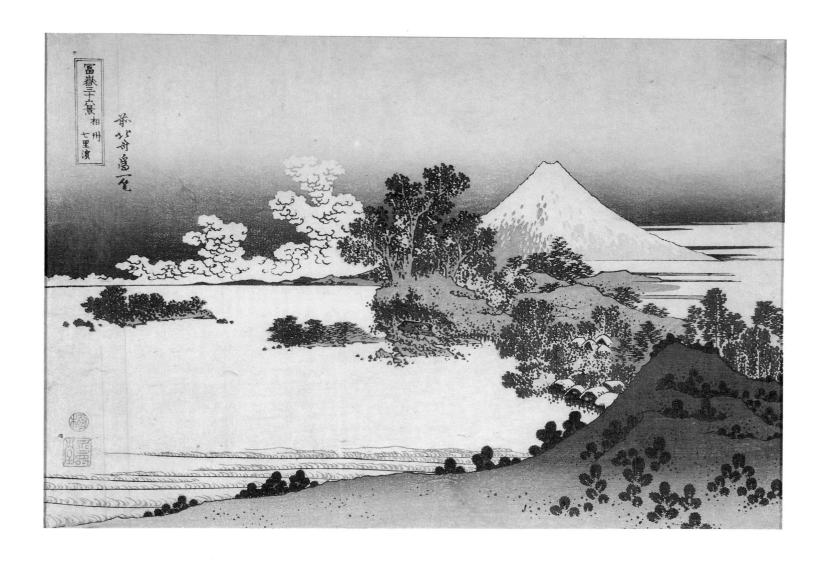

18 MOUNT FUJI SEEN FROM SHICHIRIGAHAMA BEACH

Shichirigahama in Sagami Province (Sōshū Shichirigahama)

c. 1831

signed: *zen Hokusai Iitsu hitsu*
woodblock, *ōban*, 261 x 386 mm (margins at right and bottom)
The Chester Beatty Library and Gallery of Oriental Art, Dublin
(Ac. 260)

A view of Fuji, partly covered in snow, from Shichirigahama, 'Seven League Beach', beyond the village of Koshigoe at Sagami Bay, south of Edo. To the left, and depicted here as farther off the coast than it really is, lies the island of Enoshima. The view is almost identical to that in the *surimono* print of *Women on the Beach at Enoshima* (cat. 99).

Only Mount Fuji, here conspicuously looming in the background, is missing in the *surimono*.

This print, which belongs to the second group of designs published in the *Thirty-six Views of Mount Fuji*, is executed exclusively in shades of blue. Though of a non-fugitive kind, the pigment used was apparently mixed with another component in order to achieve the different shades that can be seen in this impression and in a few others. In later impressions of this print, although the blue outlines were retained, green was introduced to print the young pines in the foreground, and the trees surrounding Koshigoe and those on the promontory and islands. In addition, the right side of Fuji's slopes was printed in green. The gradated blue of the sky on the horizon was then printed in an orange-yellow hue, and generally in a much narrower area, which rendered only part of the clouds visible. By contrast, a gradated blue sky was printed at the top.

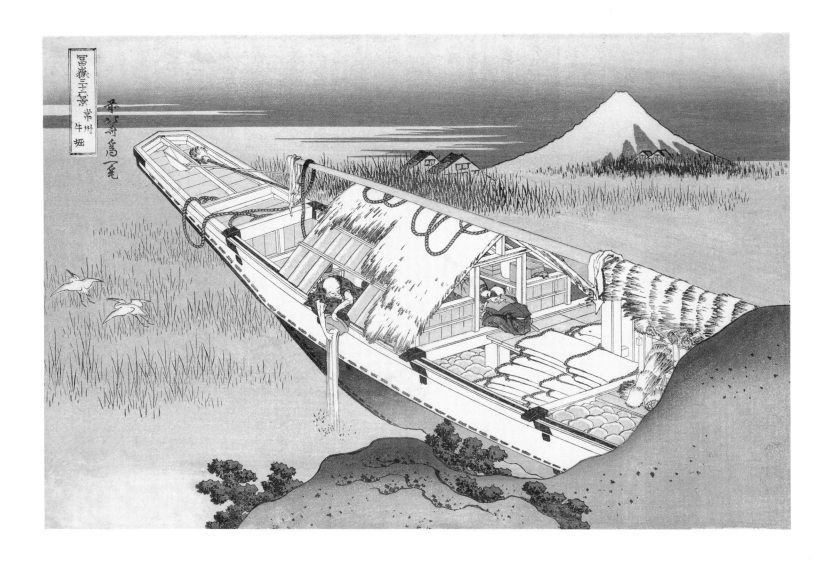

19 A BOAT MOORED AT USHIBORI

Ushibori in Hitachi Province (Jōshū Ushibori)

c. 1831

signed: *zen Hokusai Iitsu hitsu*
woodblock, *ōban*, 253 x 368 mm (margin at bottom)
Mann Collection, Highland Park, Illinois

A large boat of the type known as *takasebune*, generally used to transport harvested rice, is moored by the edge of a lake. At the sound of falling water poured by a man from his cooking pot, two white herons start into flight. The houses seen in the distance probably form part of the town of Ushibori in Namekata province (now Ibaraki prefecture), which lies on the edge of Lake Kasumigaura.

Early impressions of this design, printed entirely in shades of blue and from intact blocks, are extremely rare. Even the *aizurie* copy of this print in the Ledoux Collection, for example, shows some damage in the area of the reeds above the boat's mast. In later impressions green was used for the clothes of the figures, as well as for a few minor parts of the boat itself, the foreground shrubs, the slopes of Fuji and the roofs of the houses to its left. The timbers of the boat were then printed in yellow, while the reeds were given a violet tint. In a yet later version — with the damaged area of the reeds provisionally restored — the boat's mast and most of its deck, as well as its load and the roof and walls of the living-quarters, were printed in dark green, with pink applied to all of its timber frame, including the hull.

REFERENCE: *Ukiyoe taikei*, XIII, 20

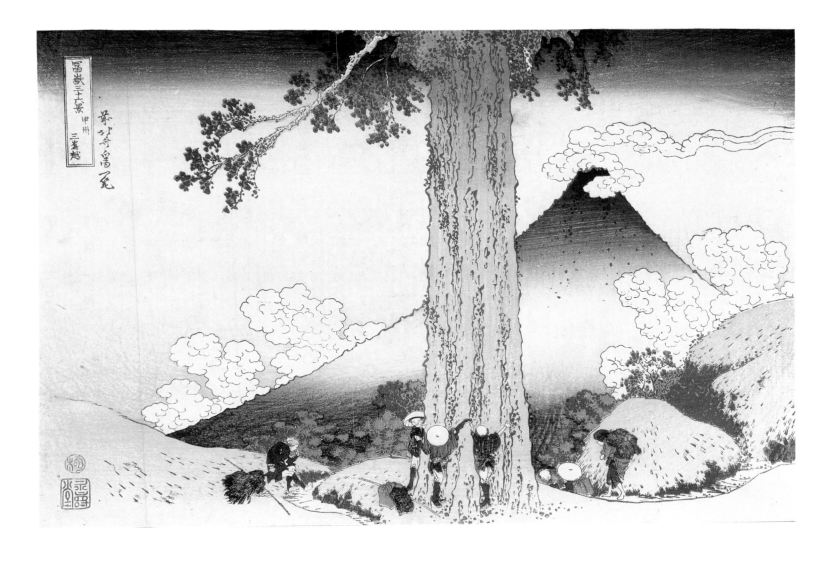

20 MEASURING A PINE TREE AT MISHIMA PASS

Mishima Pass in Kai Province (Kōshū Mishimagoe)

c. 1831

signed: *zen Hokusai Iitsu hitsu*
woodblock, *ōban*, 256 x 378 mm
Peter Morse Collection

A group of travellers are trying to measure the circumference of a huge pine tree at Mishima Pass in Kai province (present-day Yamanashi prefecture). Mishima Pass is in a mountainous area to the north of Mount Fuji, near the border of the provinces of Kai and Suruga.

In this design Hokusai incorporated two unmistakably Western elements. First, there is the sense of perspective or depth, implied by the conspicuous tall pine in the foreground; even Mount Fuji in the distance appears to be relatively small in comparison. This device had already been explored in the late eighteenth century by painters such as Shiba Kōkan (1747–1818) and Aōdō Denzen (1748–1822). In prints, however, there are few examples earlier than in Hokusai's. Hiroshige applied the device in his series *One Hundred Famous Views of Edo* (1856–8). The other Western element in this print concerns the very typical cloud forma-

tions, which appear in several designs in Hokusai's great landscape series. He had first experimented with such clouds earlier in his career, notably in two series of small prints that date from the early 1800s, made in imitation of Western copperplate engravings. In the seventh volume of his *Hokusai manga* (1817), Hokusai had included a view of Mishima Pass featuring similar clouds to these, although the foreground pine trees were drawn much smaller (fig. 5).

Much of the effect in this print is the result of the care exerted by the printer in softening the pigments on his blocks in order to achieve a good gradation. In some impressions Fuji is printed in three distinctly separated horizontal bands, almost as if it were a flag. Occasionally, the black at the foot of the mountain is so dark as to make the tops of the trees in the valley almost impossible to discern. The extraordinarily fine lines cut on the woodblocks for printing the clouds of mist were, as can be imagined, easily damaged, and many impressions show breaks in this part.

A proof impression of the line-block only is preserved in the Ōta Memorial Museum, Tokyo.

21 A SUDDEN GUST OF WIND AT EJIRI

Ejiri in Suruga Province (Sunshū Ejiri)

c. 1831

signed: *zen Hokusai Iitsu hitsu*
woodblock, *ōban*, 260 x 385 mm (margins at top and left)
Musée National des Arts Asiatiques-Guimet, Paris (Eo 3286)

Travellers at a bend on the Tōkaidō Road near Ejiri are caught by a sudden gust of wind, which scatters their papers, a hat and the leaves of the two foreground trees. Across the fields, which are overgrown with reeds, is Mount Fuji. To the right is a stretch of water, possibly the Ubagaike, a well-known pool just off the Tōkaidō Road.

The subject of people caught in a blast of wind always fascinated Hokusai. Both in earlier works, such as his albums *Famous Places in the Eastern Capital in One View* (1800), *Birds of the Capital* (*c.* 1802; see cat. 118), the seventh volume of *Hokusai manga* (1817) and *Hokusai soga* (1820), and later in the twelfth volume of *Hokusai manga* (*c.* 1834, fig. 6) and in *One Hundred Views of Mount Fuji* (see cat. 128) there are examples of this recurrent theme. Similar figures to those in this print can be found in these other designs. The effect of paper blown in the air also occurs in the twelfth volume of *Hokusai manga*, where five people involved in different occupations are all surprised by a sudden gust. In two sheets of drawings one reappears in a state of wild confusion, for which reason he has become known as 'the mad poet', even though there too 'wind' is inscribed next to the figure.

What is perhaps of greater interest is the relation between the design reproduced here and an earlier watercolour by Hokusai of 1826, which was commissioned by Philipp F. von Siebold of the Dutch East Indies Company and executed on Dutch paper (fig. 7).

Impressions of this print vary in tone from an almost *aizurie* version to one in which the blues and greens of the field alternate. Some impressions feature a distinct reddish shade at the top.

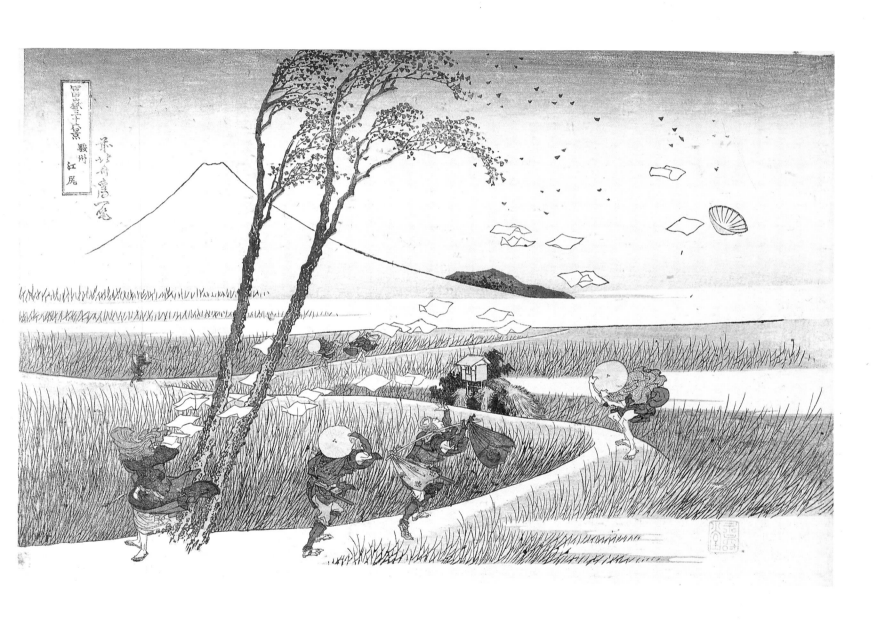

The Sazai Hall of the Temple of the Five-hundred Rakan
(*Gohyaku Rakanji Sazaidō*)

c. 1834

signed: *zen Hokusai Iitsu hitsu*
woodblock, *ōban*, 254 x 370 mm (margin at top)
National Museum of Ethnology, Leiden (4067–4)

From the balcony of the Sazaidō, which lies in an eastern district of Edo, a group of people are gazing across the marshes towards Mount Fuji, to the right of which a timber-yard can be made out. The Sazaidō itself is a three-storey tower that was built in 1741 as a temple to the Five-hundred Rakan, which became popularly known as the 'Sazaidō', or 'Turban-shell Tower', on account of its spiral staircase.

In two earlier albums of *kyōka* poetry Hokusai had included plates of the Sazaidō's balcony in which people are shown looking out over the surrounding land: in both the *Birds of the Capital* of 1802 (see cat. 119) and *Kyōka ehon – Yama mata yama* ('Range upon Range of Mountains') of 1804, Hokusai focused on various individuals on the balcony. Here, with the exception of the seated woman at the right, everyone seems to be absorbed in looking at Mount Fuji, which appears in neither of the earlier album plates. In this print Hokusai has sought to present the scene in accordance with the principles of Western perspective: the lines of the floorboards, the balcony railing and the roof are all aligned on Mount Fuji as the picture's vanishing point. As is so often the case in the *Thirty-six Views*, the trademark of the pub-

lisher can be found somewhere in the design. In this case, the bundle over the shoulders of the boy to the left bears that of Nishimuraya Yohachi.

In early impressions the area printed in black *bokashi* varies slightly. Sometimes the dark tone only reaches to the lower half of the railing, in other examples it reaches the top. The same goes for the sky. In a later state the shoulder-packs of the seated couple, which are printed in black in early impressions, are grey. In addition, probably in an attempt to make this more clear, a small area of black between the man leaning on the railing and its supporting post was gouged away, so as to appear grey. That this particular version is, in fact, a later impression is confirmed by a break—at the height of the suspended bell—in the roof's left-hand column. In these later impressions, the censorship seal and that of the publisher are usually lacking.

Only a few examples are intact at the right. In such cases, not only is the edge of the pillar shown, but a stripe of green as well.

REFERENCE: *Ukiyoe taikei*, XIII, 23

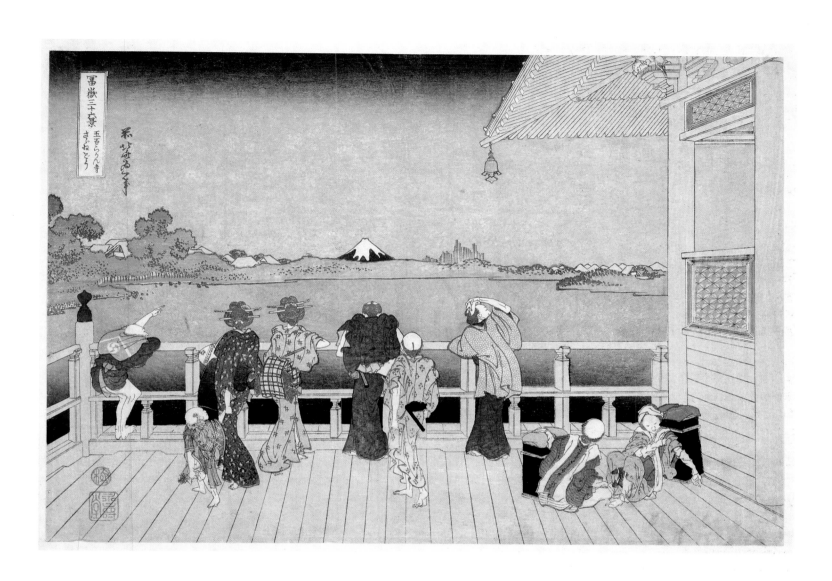

23 PEOPLE ADMIRING MOUNT FUJI FROM A TEA-HOUSE

Yoshida on the Tōkaidō Road (Tōkaidō Yoshida)

c. 1834

signed: *zen Hokusai Iitsu hitsu*
woodblock, *ōban*, 254 x 369 mm (margin at top)
National Museum of Ethnology, Leiden (4218–4)

The interior of a tea-house at Yoshida, one of the stations on the Tōkaidō Road between Edo and Kyōto. Because of its favourable location, the tea-house is appropriately called Fujimi *chaya*, 'the tea-house with a view of Mount Fuji', a name that appears in large horizontal script on the centre panel. On the right two further panels read *ocha tsuke* ('tea served') and *kongen Yoshida hokuchi* ('the original Yoshida tinder'), an advertisement for the local kindling-wood.

On a bench by the window are two ladies, one of whom is addressing the waitress. On a bench to the right are two travellers resting with their luggage. On their hats appear the trademark of the publisher of this series of prints and the character 'Ei', a reference to Eijūdō, the name of the publisher's firm. On the left are two coolies by a palanquin, which presumably belongs to one of the ladies by the window. One of the coolies is wiping the sweat from his head with a towel, while the other is repairing one of his straw sandals with the aid of a mallet.

This interior scene provided Hokusai, as did the view from Nihonbashi (cat. 24) and the balcony of the Sazaidō (cat. 22), with the opportunity to demonstrate his grasp of the laws of Western perspective.

REFERENCE: *Ukiyoe taikei*, XIII, 29

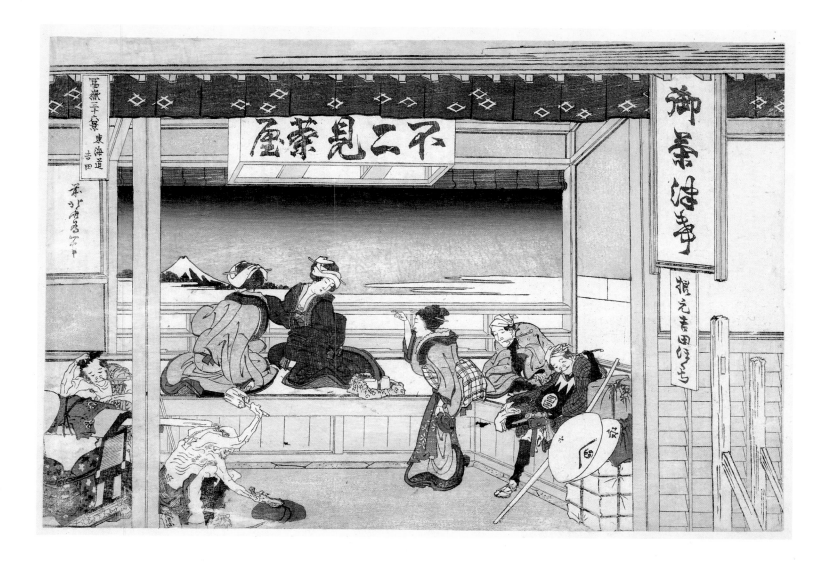

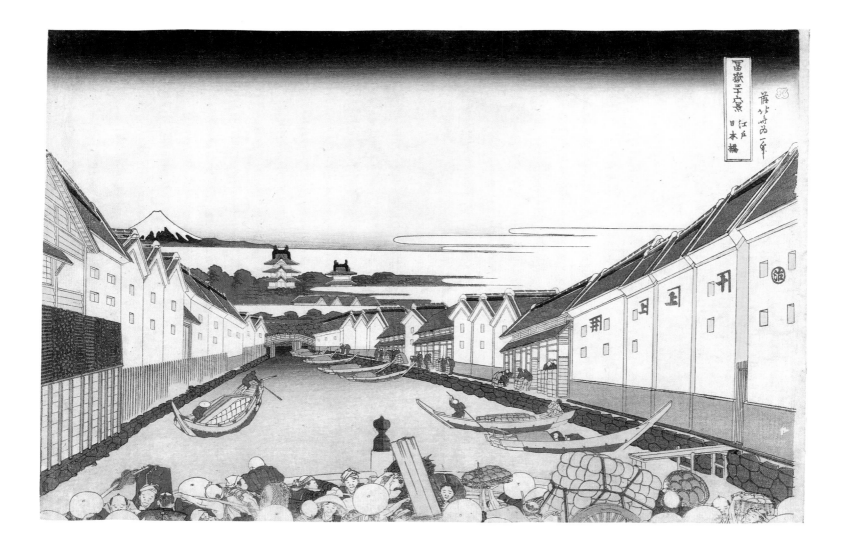

24 MOUNT FUJI AND EDO CASTLE
SEEN FROM NIHONBASHI

Nihonbashi in Edo (Edo Nihonbashi)

c. 1834

signed: *zen Hokusai Iitsu hitsu*
no seals
woodblock, *ōban*, 262 x 386 mm (margins at top and right)
Gerhard Pulverer Collection (ex-Hamilton Easter Field Collection)

Mount Fuji as seen from Nihonbashi, a canal bridge in the centre of Edo first built in 1603. Below Nihonbashi is the city's fish-market, although one would hardly be aware of that fact from this design, unless some of the porters crossing the bridge are indeed carrying baskets of fish or shells. In the middle distance is a smaller bridge, Ikkokubashi, and beyond that is Edo Castle, which belonged to the shōgun. Both sides of the canal are crowded with warehouses, on some of which can be seen the trademarks of the companies that owned them. It is interesting to note that the timber walls of those warehouses that appear in the plates of various albums of around 1800 were being rendered with plaster or encased in stone by the 1830s, when Hokusai made this view.

For this design Hokusai combined a traditional rendering of distant banks of mist with Western-style perspective, using the Castle to form his vanishing point.

In the course of his career Hokusai depicted Nihonbashi in a number of similar views. In addition to the various series he produced of *The Fifty-three Stations of the Tōkaidō*, it also appears in his albums of Edo topography of around 1800, such as the *Amusements of the Eastern Capital* (1799), the *Famous Places in the Eastern Capital in One View* (1800) and the *Birds of the Capital* (1802). With the exception of the design in *Amusements*, these album views exaggerate the bridge's span, while the canal below looks more like a broad river.

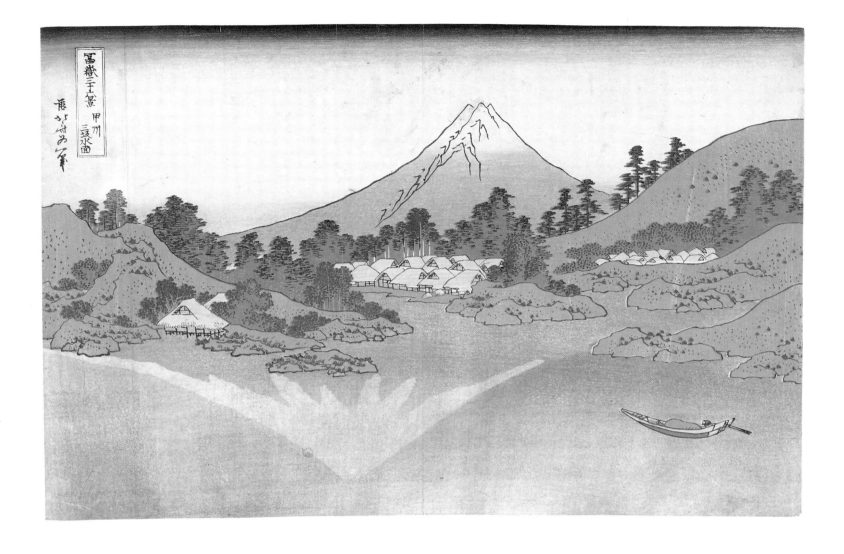

25 MOUNT FUJI REFLECTED IN A LAKE

The Surface of the Water at Misaka in Kai Province (*Kōshū Misaka suimen*)

c. 1834

signed: *zen Hokusai Iitsu hitsu*
no seals
woodblock, *ōban*, 248 x 369 mm
Peter Morse Collection

A view of Mount Fuji with its reflection in the water of a lake formed at the river mouth at Misaka Pass in Kai province (now Yamanashi prefecture). A laden boat on the lake points towards the village on the far bank.

Unlike cast shadows, reflections in water have always been rendered in Japanese prints. Usually, however, they are incidental or contribute an element of humour, as when children or monkeys are shown reacting to their reflections.

In a *surimono* of the 1820s by Hokusai's pupil Yashima Gakutei, for example, a cat is shown reacting angrily to seeing itself reflected in a lacquered black mirror-stand. The use of reflections in landscapes, however, had probably not been attempted before this design was published.

There seem to be two variants in early impressions of this print, either, as here, with only a small area of blue at the top and most of the sky left uncoloured, or with the blue continuing down to the tops of the hills and trees. A later impression, with black outlines, has the summit of Fuji uncoloured and all of the hills in light blue, while the trees stand out in a darker blue. The water is printed in a distinct blue and, to make the reflection of Fuji stand out more clearly, an extra block was added in order to print Fuji's slopes in a deep blue.

REFERENCE: *Ukiyoe taikei*, XIII, 35

Viewing the Evening Sun at Ryōgoku Bridge from Onmayagashi (Onmayagashi yori Ryōgokubashi no sekiyō o miru)

c. 1833

signed: *zen Hokusai Iitsu hitsu*
woodblock, *ōban*, 262 x 385 mm (margins on all sides)
The Metropolitan Museum of Art, New York, Rogers Fund, 1936
(JP 2554)

The Onmaya ferry on Sumida River in Edo is making the crossing from Onmayagashi to Honjō on the far bank. In the distance is Ryōgoku bridge, with Mount Fuji on the horizon. To the left, in a boat moored to the bank, a woman is washing a towel. On the bundle carried by one of the men standing on board the ferry is Nishimuraya Yohachi's trademark.

Onmayagashi, 'the Onmaya bank', is said to have derived its name from the shōgun's stables (*umaya*) located at Miyoshi Street in the Asakusa district, which runs along this part of the Sumida River.

In some impressions of this print the two boats have a somewhat more pinkish hue. There is also one impression in which the entire surface of the river, right up to the far bank, is printed in one continuous deep blue rather than in the lighter shade seen here just beyond the boat; the overall effect here is far more that of an evening scene, since the distant boats appear as mere shadows. In a much later impression the water is printed in a very light blue right up to the bottom edge of the print, thus omitting the intense blue seen here in the foreground. In addition, that impression has the roofs of the distant houses as well as that of the house in the left-hand foreground printed in brown.

REFERENCES: *Ukiyoe taikei*, XIII, 22; Lane, 1989, p. 194

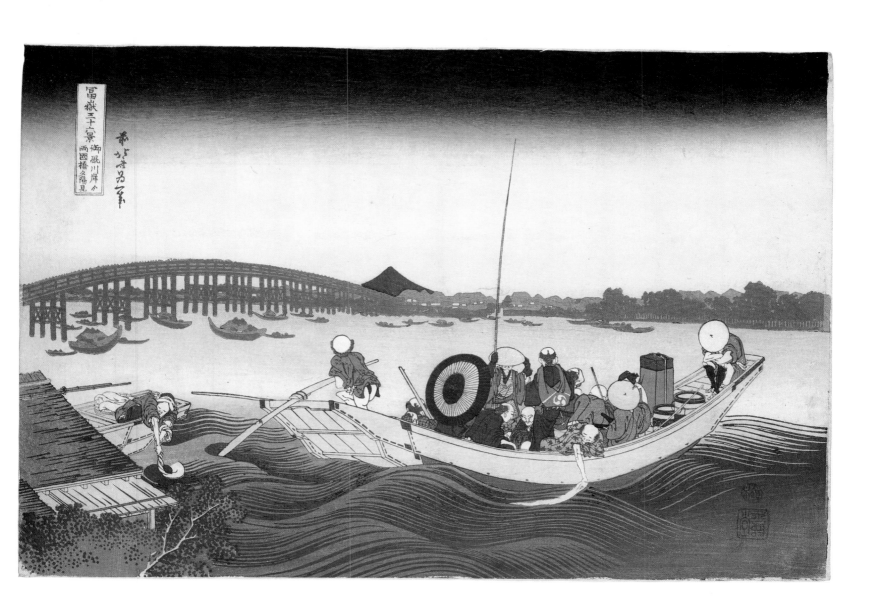

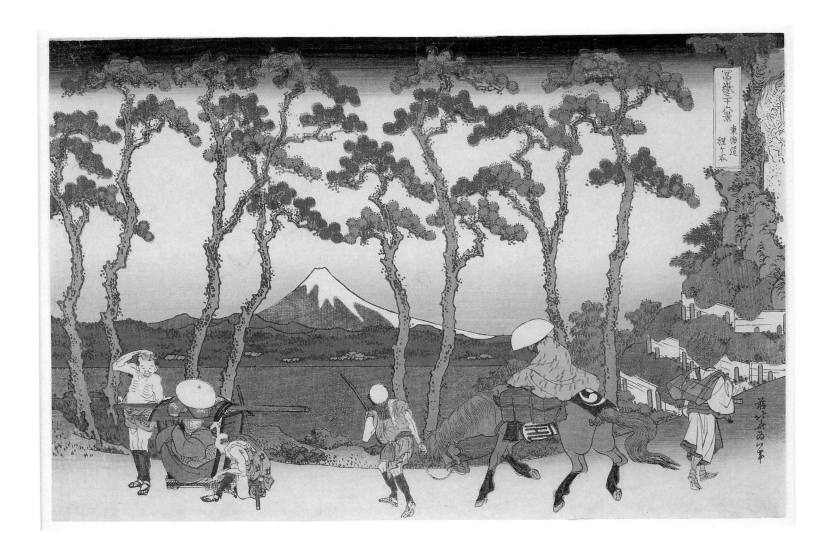

27 TRAVELLERS ON THE TŌKAIDŌ ROAD AT HODOGAYA

Hodogaya on the Tōkaidō Road (Tōkaidō Hodogaya)

c. 1834

signed: *zen Hokusai Iitsu hitsu*
no seals
woodblock, *ōban*, 255 x 374 mm (margin at top)
Honolulu Academy of Arts, The James A. Michener Collection
(L21.261)

Near the town of Hodogaya, travellers are making their way along the Tōkaidō Road. Mount Fuji can be seen through a screen of pine trees that flank the road. Beyond the rice fields, and below Fuji, are some houses among the trees. To the right of the travellers an itinerant monk — identifiable as such by his straw hat and bamboo flute — glances towards a stone image stopping up the hollow in a tree. On the saddle-cloth of the horse and rider he has just passed is the trademark of the publisher, as well as the character 'Jū' from the Eijūdō firm's name. The location of this scene is probably the Shinanozaka, a hill on the border of Musashi and Sagami provinces, about half-way between Hodogaya and Totsuka.

Various distinct printing variations for this design have been identified. Early impressions generally have most of the sky in a light gradated blue, except for a horizontal band where the pines show their leaves. The grass around the rocky monument, the monk's hat, the road, the large package carried by the horse, the small hills just off the road, the palanquin's roof and its carrying pole as well as the distant hills beyond the woods are all in a light green. In addition to a small break at the left side of the title cartouche, a later impression has the sky mostly white, with only blue *bokashi* at the top and a small area of light blue on the horizon, and with all those areas originally printed in light green now printed in blue. Only part of the road has been left blank.

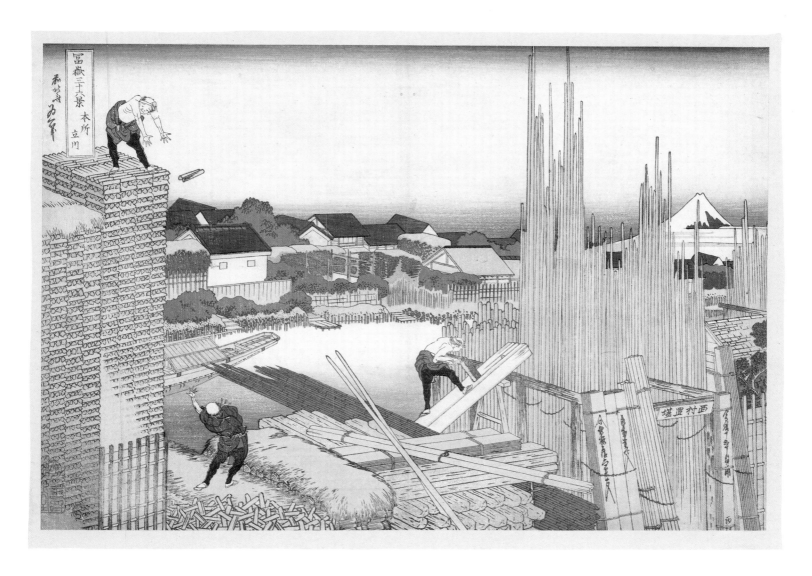

A still later impression, which incorporates a black line-block, features the originally light-green areas and the title cartouche in a clear blue colour, with the originally dark green woods and cones of the pine trees printed in a deep blue. The stems of the trees and the horse, both originally pink, are brown, and Fuji's slopes are in black. The road is printed in grey.

REFERENCES: *Ukiyoe taikei*, XIII, 36; Lane, 1989, pp. 195, 198

28 THE TIMBER-YARD BY THE TATE RIVER

Across the Tatekawa and Honjō District (Honjō Tatekawa)

c. 1835

signed: *zen Hokusai Iitsu hitsu*
woodblock, *ōban*, 256 x 381 mm
The Metropolitan Museum of Art, New York (1329)

Mount Fuji seen through the planks stacked up in a timber-yard next to the Tate River. Two men are building up a towering pile of firewood, while a third is sawing a large plank. To the right in the foreground are some planks of wood in a frame marked *Nishimura okiba*, the 'storehouse' of Nishimura, who published this series of prints. His address, *Bakurochō nichōme no kado*, and a note, 'the stock of Eijūdō', can be seen on other planks. The wood farthest to the left is inscribed *Shinpan sanjūroku Fuji shiire*, 'Stock for the new edition of the thirty-six views of Fuji', from which it is generally inferred that this print was the first to announce the ten supplementary prints that followed publication of the original *Thirty-six Views*.

The Tate is a small river that flows into Sumida River. The houses seen on its far bank are those of Aioi Street. The district of Honjō is more distant, on the Sumida's east bank.

REFERENCES: *Ukiyoe taikei*, VIII, 34; XIII, 37

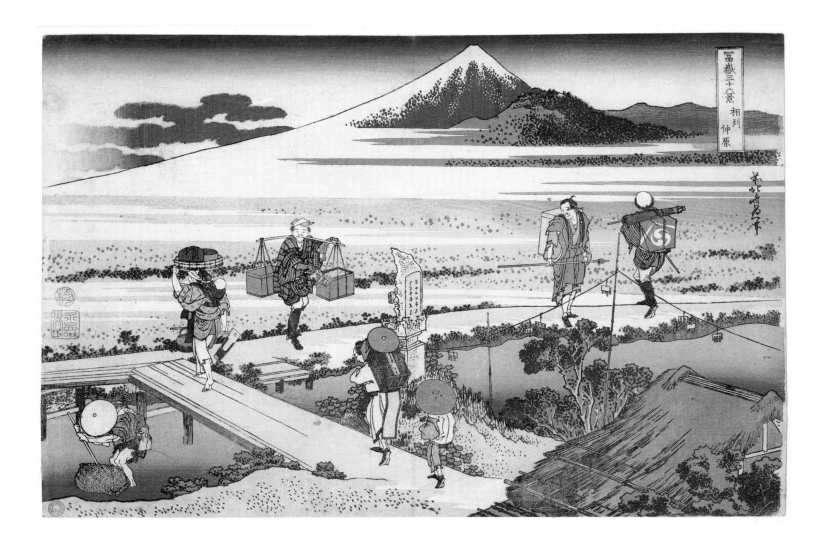

29 A VIEW OF MOUNT FUJI AND TRAVELLERS BY A BRIDGE

Nakahara in Sagami Province (Sōshū Nakahara)

c. 1835

signed: *zen Hokusai Iitsu hitsu*
woodblock, *ōban*, 253 x 376mm (margin at right)
The Metropolitan Museum of Art, New York, Rogers Fund, 1922
(JP 1325)

Here, Mount Fuji is seen across the fields known as Nakahara just off the Tōkaidō Road, near the town of Hiratsuka in present-day Kanagawa prefecture. In the foreground is the thatched roof of a shrine, with the stone statue of an unidentifiable god, on the bank of the stream. The two men approaching the plank bridge from the shrine are itinerant monks, while a third monk, identifiable as such by his staff

with bells, waits for them on the road. Crossing the bridge is a peasant woman, who carries a basket on her head and a hoe in her hand. Hanging from the lines to the right of the shrine are small clattering contraptions for scaring away birds. Beyond, the man to the right seen turning to view Mount Fuji carries a bundle that bears Nishimuraya Yohachi's trademark.

Earlier impressions of this design feature generally brighter colours, a lighter tone of green and brighter yellow and pink. The problematic area here seems to have been the insufficiently defined cloud to the left. Impressions vary considerably, especially at the left-hand side, and some have been gone over in *bokashi* several centimetres from the edge of the paper. Whether or not this was caused by bad cutting cannot be ascertained.

REFERENCE: *Ukiyoe taikei*, XIII, 40

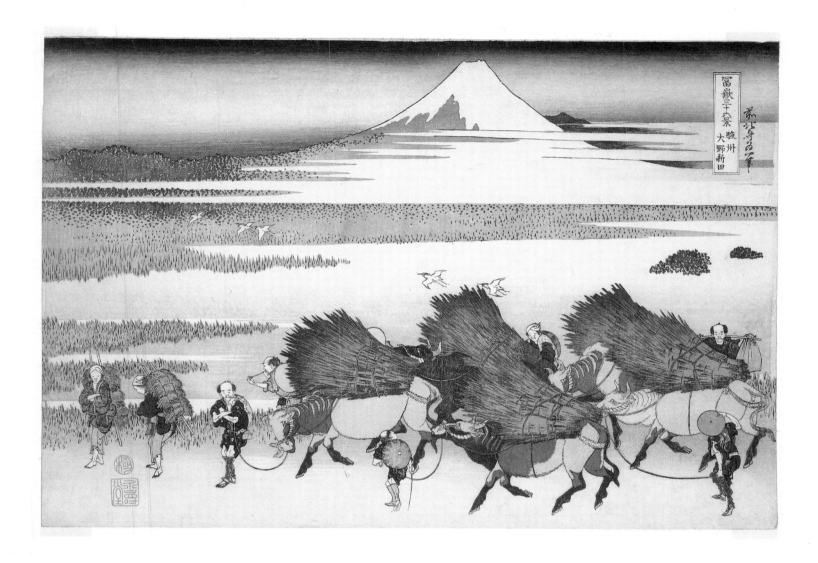

30 PEASANTS LEADING OXEN

The New Fields at Ōno in Suruga Province (Sunshū Ōno shinden)

c. 1835

signed: *zen Hokusai Iitsu hitsu*
woodblock, *ōban*, 265 x 383 mm (margins at top, right and left)
The Art Institute of Chicago, The Clarence Buckingham
Collection (1925.3286)

After a day of labour, peasants are returning home at dusk,
having gathered the bundles of reeds that are carried by their
oxen. Herons are flying over the marsh behind them, and
Mount Fuji rises above some conventionally stylised banks
of mist. To the right, the setting sun colours the sky. The
scene is the New Fields of Ōno, an area of reclaimed land
lying between Hara and Yoshiwara on the Tōkaidō Road.

Early impressions of this print feature a delicate blue
bokashi, both in the sky — from the top of the sheet down-
wards and from the distant woods upwards — and, only
faintly noticeable in this print, across the water in the fore-
ground. Green is also printed in *bokashi* — even between the
oxen and between their legs. In later impressions the *bokashi*
printing is far more restricted: the pink oxen, here shown
blackened by mud, are almost in a plain brown, and the bun-
dles of faggots are left uncoloured; the green slopes of Fuji
are generally black and the area beneath the flying herons is
printed in black and blue rather than in the uniform green of
the original.

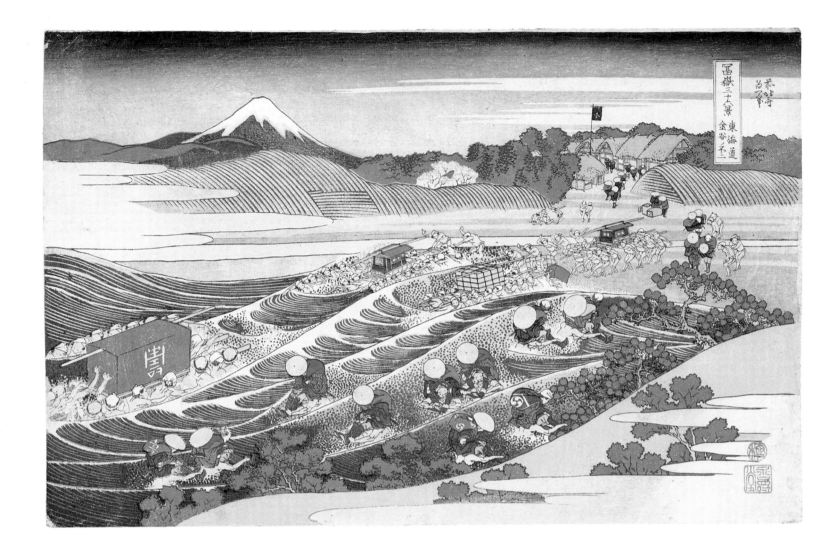

31 TRAVELLERS CROSSING THE ŌI RIVER

Mount Fuji from Kanaya on the Tōkaidō Road (Tōkaidō Kanaya no Fuji)

c. 1835

signed: *zen Hokusai Iitsu hitsu*
woodblock, *ōban*, 262 x 386 mm (margins at top and right)
Peter Morse Collection

Travellers are crossing the Ōi River at Kanaya on the Tōkaidō Road, with individuals as well as palanquins being carried above the torrent by 'river-waders'. To the right, some travellers seem to be haggling over the price charged for this service. Kanaya was the twenty-fourth station on the Tōkaidō Road and, from Shimada, it could only be reached by fording the Ōi River, as there was neither a bridge nor a ferry there. As can clearly be seen in Hokusai's print, the Ōi is a swift-flowing river.

Some of the travellers have the trademark of the publisher, Nishimuraya Yohachi, on their luggage, the character 'Jū' from the name of his firm appearing on the large palanquin with a green coverlet to the left.

Since this design belongs to the group of ten additional prints to the *Thirty-six Views* series, all impressions feature a black outline. Because of the economic recession in the later 1830s during the Tenpō crisis, there was little opportunity to reprint this design. The main difference between early impressions and the later ones seems to be the treatment of Mount Fuji, for whereas early impressions have its slopes in black, overprinting a brown block (of which only some edges are noticeable), in later impressions the black block is omitted.

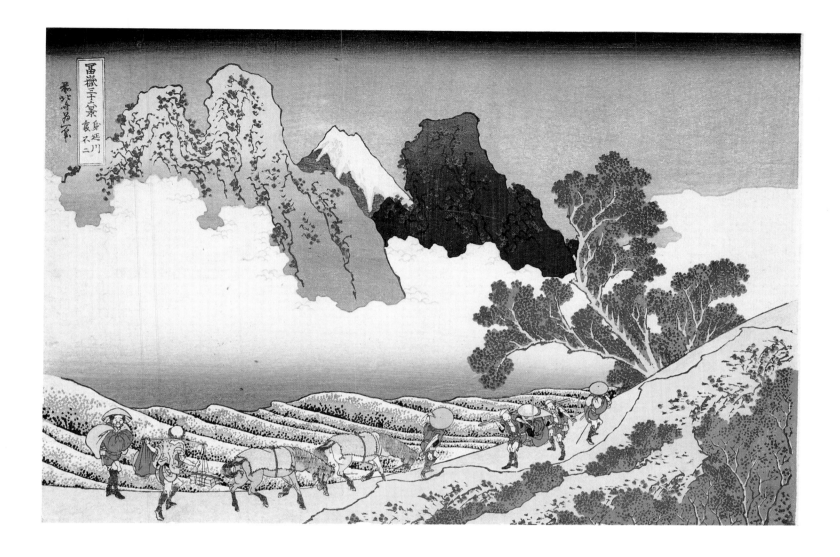

32 MOUNT FUJI SEEN FROM THE BANKS
OF MINOBU RIVER

The Back of Mount Fuji from Minobu River
(*Minobugawa ura Fuji*)

c. 1835

signed: *zen Hokusai Iitsu hitsu*
no seals
woodblock, *ōban*, 256 x 380 mm (margin at right)
Peter Morse Collection

A line of travellers and horses treks along a sloping road by
the side of the Minobu River, as that stretch of the Fuji River
near Mount Minobu is popularly known. The road is called
the Minobusandō, 'the Minobu mountain road'. Beyond the
bank of mist is Mount Minobu itself, with Mount Fuji in the
far distance seen from behind — that is, if we think of Edo as
the 'natural' viewpoint.

Impressions of this print, which is one of the group of ten
designs later added to the original *Thirty-six Views*, invari-
ably have the outlines printed in black. Major variations in
the printing can hardly be seen, except for the different qual-
ity of the gradation from yellow to brown in the rocks to the
left of Fuji and the green at the summit of the blue rock to the
right.

REFERENCE: *Ukiyoe taikei*, XIII, 42

published by Nishimuraya Yohachi, *c.* 1832

signed: *Hokusai aratame Iitsu hitsu*
woodblock, 413 x 564 mm
Peter Morse Collection

Throughout his career Hokusai displayed great enthusiasm for bridges. In his *surimono* and album plates of the 1790s and early 1800s, bridges of various kinds often figure conspicuously, while in the *kyōka* albums that focus on Edo topography, intricately constructed bridges have a prominent place. The best-known designs of bridges are, however, the plates for the series *Remarkable Views of the Bridges in All Provinces.*

This print depicts an imaginary autumnal landscape containing a hundred (probably to be understood as 'many') bridges, which Hokusai, in the long inscription at the top, claimed to have seen in a dream. After waking, he decided to make a picture of the dream landscape he had so much enjoyed.

A reprint of this design, entitled *Famous Bridges in All Provinces in One View* (*Shokoku meikyō Kiran*) and probably issued after the success of his *Remarkable Views* series, omits both the long inscription and the adjacent poem in Chinese.

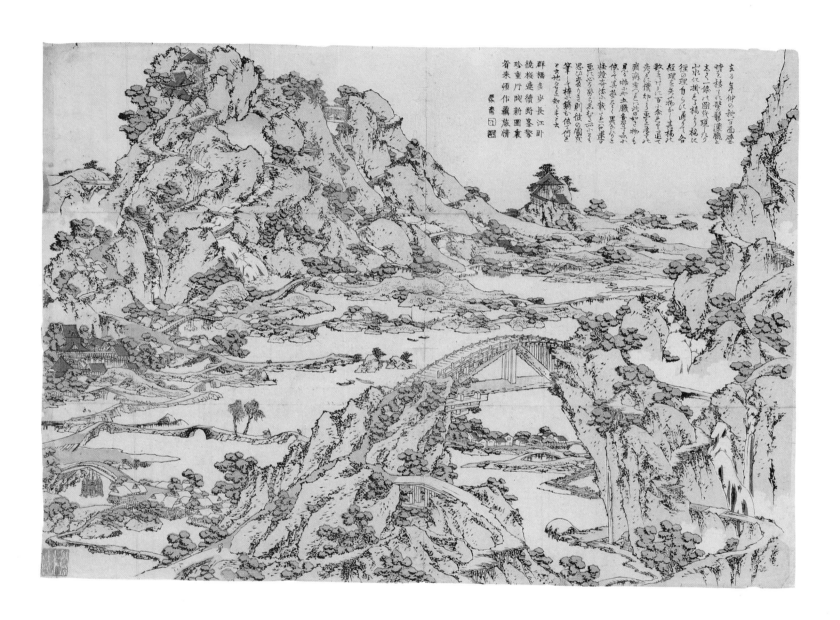

群橋多少長江町
繞様連續對峯響
珍重庁暇新圖裏
有来師作鷁旋情

From the series *Remarkable Views of the Bridges in All Provinces* (*Shokoku meikyō kiran*) published by Nishimuraya Yohachi (Eijūdō), *c.* 1834

signed: *zen Hokusai Iitsu hitsu*

censorship seal: *kiwame*

34 THE PONTOON BRIDGE AT SANO IN WINTER

View of the Old Boat-bridge at Sano in Kōzuke Province (Kōzuke Sano funabashi no kozu)

woodblock, *ōban*, 243 × 372 mm
Peter Morse Collection

It is winter, and travellers are crossing the boat-bridge over the Tone River at Sano in the province of Kōzuke (now Gumma prefecture), to the north-west of Edo. The hut in the foreground and the pine tree are covered with snow; distant hills are seen through banks of mist. In medieval times the pontoon bridge at Sano was a popular subject for poetry, and one poem, which describes a snowstorm at a ferry, may have been Hokusai's inspiration here, for in his day the bridge no longer existed. It is unclear whether Hokusai's design was based on an earlier representation, as the title leads us to believe, or was simply based on his own imaginative interpretation of a poem.

This is the only snow scene in the *Remarkable Views of the Bridges*. In the series of *Waterfalls* there are no winter scenes, and only one in the *Thirty-six Views of Mount Fuji*, that of Koishikawa. In comparison with the landscapes made by his contemporaries, such as Keisai Eisen or, more particularly, Hiroshige, snow scenes by Hokusai are rare. It is interesting that in Hokusai's *Landscape with a Hundred Bridges* (cat. 33), a pontoon bridge with a similar curve appears in the foreground.

Early impressions of this print have a yellow ochre title cartouche, with the sky printed in *bokashi* from black to grey, sometimes in a clear grey to the top of the distant hills. The water is printed in gradated blue, dark at the near shore and to the right of the bridge. A variant impression omits the deep blue to the right of the bridge, while the water near the far shore is in deep blue. Although the bank of mist in this impression is coloured red to the right, it is more usually yellow. A later impression has the title cartouche in red, and the water near both shores and in the foreground to the right of the bridge in a deep blue.

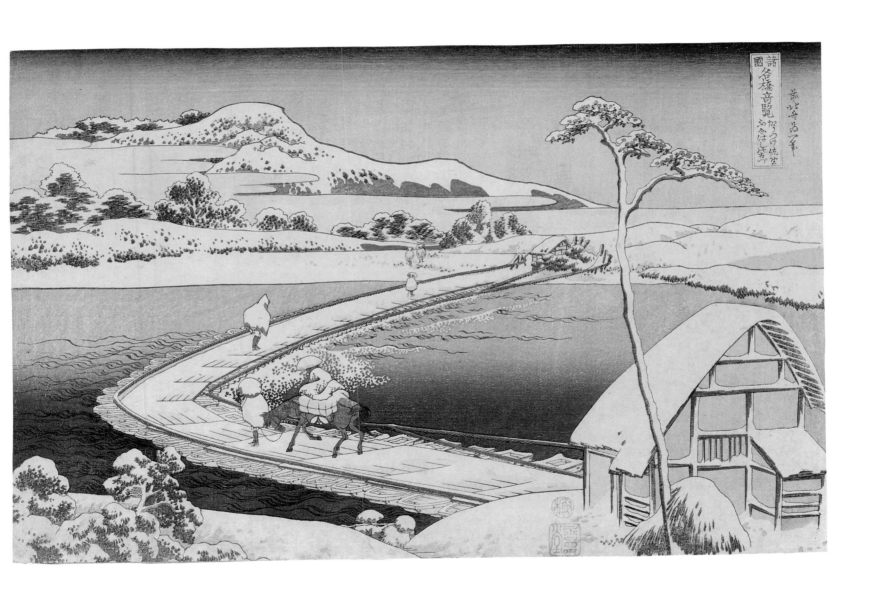

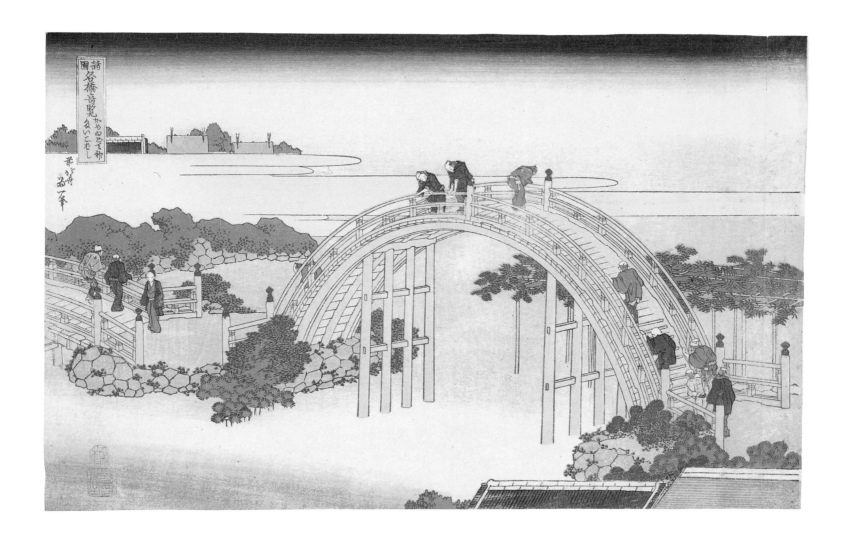

35 THE DRUM BRIDGE AT KAMEIDO

The Drum Bridge at Kameido Shrine (Kameido tenjin taikobashi)

woodblock, *ōban*, 248 x 378 mm (margin at right)
Honolulu Academy of Arts, The James A. Michener Collection
(15.936)

The Drum Bridge at Kameido, Edo, leads to the Tenmangū Shrine (far right), which was built on newly reclaimed land in 1662 (the present temple is a reconstruction of 1936) as a place to worship the learned statesman Sugawara no Michizane (845–903). A second, less steeply arched, bridge can be seen to the left.

The shrine, with its bridge and wistaria-covered pergola, was considered to be one of Edo's most scenic spots and attracted many visitors. On the twenty-fourth day of the eighth month a great annual festival was held in honour of

Sugawara no Michizane, which was of special interest not only to men of letters but to all those who sought to become skilled as writers. Needless to say, this festival coincided with the wistaria in full bloom.

Early impressions of this print have good gradation printing in blue along the top and, in a lighter shade, both above the band of mist and below it, roughly down to where the piers of the bridge meet the water, and in a diagonal strip in the left foreground. In later impressions the area above the band of mist and that beneath the bridge, which required much attention, are left blank, with the small strip in the foreground often printed rather crudely. A still later impression shows that a new block was cut for the few streaks of water that come from the foreground left and almost reach halfway to the bridge; the gradation in the sky is restricted to the very top. In an impression that followed, the title cartouche, as in all the later impressions of this series, is printed in red.

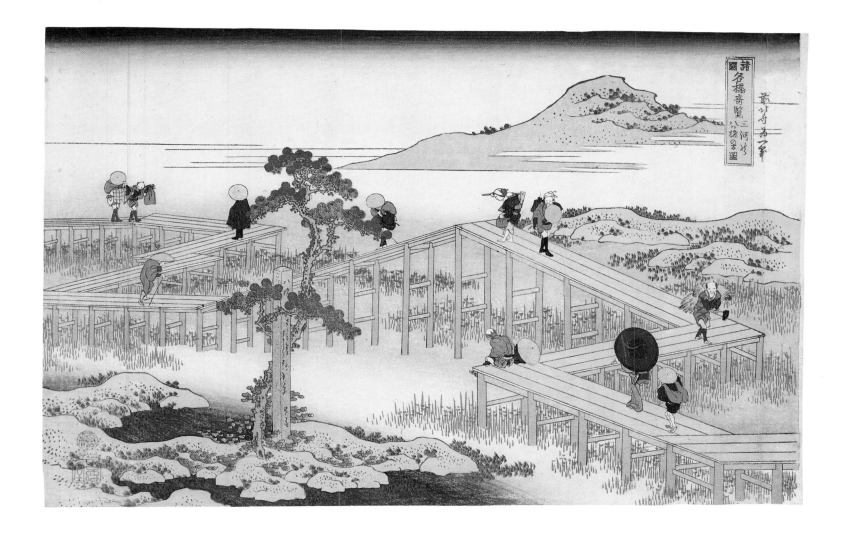

36 ADMIRING THE IRISES AT YATSUHASHI

Ancient View of Yatsuhashi in Mikawa Province (Mikawa no Yatsuhashi no kozu)

woodblock, *ōban*, 248 x 380 mm (margin at right)
Honolulu Academy of Arts, The James A. Michener Collection
(15.935)

Farmers and travellers at Yatsuhashi are admiring the irises in bloom. Yatsuhashi, which literally means 'Eight Bridges', is a place that was made famous through its description in *The Tales of Ise (Ise monogatari)*, a collection of verse and prose by Ariwara no Narihira (823-80). It is believed to have been near the town of Chiryū in Mikawa province (now Aichi prefecture), which was on the Tōkaidō Road. The bridge's complicated structure is explained by the fact that eight rivers came together there, the same number, it was noted, as the legs of a spider. The bridge was no longer to be seen in Hokusai's

day, so he must have based his design on an earlier image.

Early impressions are characterised by an overprinted blue at the top of the distant mountain; this is omitted in later impressions. The sky varies, with the blue gradation printing restricted to the top in some cases, and in others descending as far as the bank of mist. A still later impression differs considerably, with the mountain-top featuring the overprinting, but with the blue of the water continued to the top of the bank of mist. In addition, the blocks were extensively trimmed to the right and left, even cutting off the artist's signature. The title cartouche was then moved further left, thus covering a small mountain peak and necessitating an extra plug for the now blue mist, with the straight line of the break showing clearly. The same modifications appear in a still later impression, in which the title cartouche is printed in red. The sky is a pinkish-red along the top only, while the mountain and the piers of the bridge are in pink and yellow ochre respectively. A line has been added along all sides.

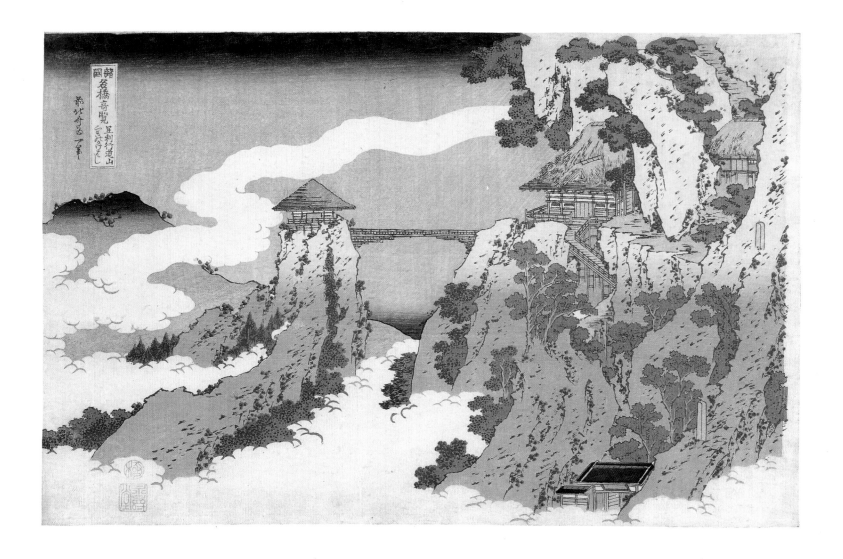

The Hanging-cloud Bridge at Mount Gyōdō near Ashikaga
(Ashikaga Gyōdōzan Kumo no kakehashi)

woodblock, ōban, 262 x 385 mm (margins at top and right)
Gerhard Pulverer Collection

A wooden bridge above a mountain pass at Gyōdōzan, north-west of the town of Ashikaga in Shimotsuke province (now Tochigi prefecture). It connects the Buddhist temple, the Jōinji (to the right), with the tea-room, a small pavilion at the summit of a rocky outcrop. Beneath, mist rises from the pass. The stones set up to the right of the footpath mark the temple's precincts.

The rising mist is another of Hokusai's experiments with Western-style cloud formations, although in this particular case the actual form it takes has no real equivalent in the West — nor, for that matter, in the East.

Early impressions clearly show the white band of mist against a good gradation-printed blue sky. In addition, the distant mountain-top to the left is overprinted in blue, and the rocks in the centre and to the right change from green at the bottom to a yellowish-brown at the top. A later impression, which has the title cartouche printed in red, is severely trimmed on all sides. The top of the sky is printed in a pinkish-red, with blue applied only in a small area below the bridge, thus rendering the band of mist almost invisible. The distant mountain is in grey and without the overprinting, while the rocks create a somewhat chaotic pattern, sometimes blueish at the bottom, ochre in the middle and brown at the top, but also, in some cases, the other way around, or even with dark grey at the bottom. A line has been printed on all sides.

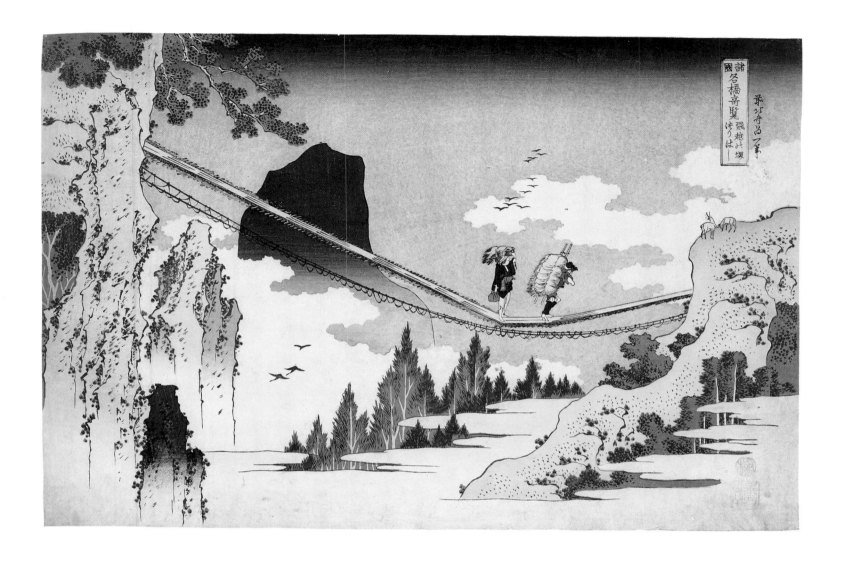

38 FARMERS CROSSING A SUSPENSION BRIDGE

The Suspension Bridge on the Border of Hida and Etchū Provinces (Hietsu no sakai tsuribashi)

woodblock, *ōban*, 258 x 380 mm
Mann Collection, Highland Park, Illinois

Two farmers carrying loads are crossing a suspension bridge on the border between the provinces of Hida and Etchū (now Gifu and Toyama prefectures). Below them, bands of mist partially obscure the trunks of the cryptomeria trees. In the distance is an odd-shaped mountain, which is printed entirely in a deep blue. For this design Hokusai combined the bands of mist that are typical of traditional Japanese painting and prints with an example of the kinds of cloud he discovered in Western art.

In early impressions of this print the blue of the mountain reaches down only as far as the white cloud that is stretched across it. In later impressions, however, the foot of the mountain is white, which makes the cloud less well defined. In a yet later impression the cloud is once again fully indicated where it obscures the mountain, but since the sky has been printed in blue only at the top of the print, no cloud can be distinguished above the trees. In addition, the right-hand side of the foot of the mountain has no outline.

REFERENCE: Lane, 1989, pp. 203, 206

WATERFALLS
CAT. 39–46

From the series *Going the Round of the Waterfalls in All Provinces* (*Shokoku taki meguri*) published by Nishimuraya Yohachi (Eijūdō), *c.* 1832
signed: *zen Hokusai Iitsu hitsu*
censorship seal: *kiwame*

39 PILGRIMS AT KIRIFURI WATERFALL

Kirifuri Waterfall at Mount Kurokami in Shimotsuke Province (*Shimotsuke Kurokamiyama Kirifuri no taki*)

woodblock, *ōban*, 380 x 258 mm (margins at top and bottom)
Mann Collection, Highland Park, Illinois

Pilgrims travelling to the Tōshōgū shrine at Nikkō stop to admire Kirifuri waterfall on Mount Kurokami (2,484 m) in Shimotsuke province (now Tochigi prefecture), north of Edo. Literally translated, Kurokamiyama means 'black-haired mountain', a name, though nowadays hardly used, for part of Nantaizan, a mountain to the north of Nikkō. Kirifuri means 'dropping mist', a suitable description for this waterfall, which tumbles more than thirty metres in two main torrents.

As is so often the case with the figures in Hokusai's landscape prints, there are references to his publisher Nishimuraya Yohachi. The man high up to one side of the waterfall holds a hat bearing the character 'Ei', which stands for Eijūdō, the name of the publisher's firm. The character 'Jū', from this same name, appears on the hat leant against the bundle belonging to the seated man. Nishimuraya's trademark figures on the bundle carried by one of the men standing at the foot of the waterfall.

Apart from differences in the shades of the yellows and greens in this print — probably the result of slight variations in the composition of the pigments used in the printing — no clearly distinguishable changes seem to have been made in successive impressions. Some, however, do show that a blackish shade has been overprinted on the reddish-brown rocks.

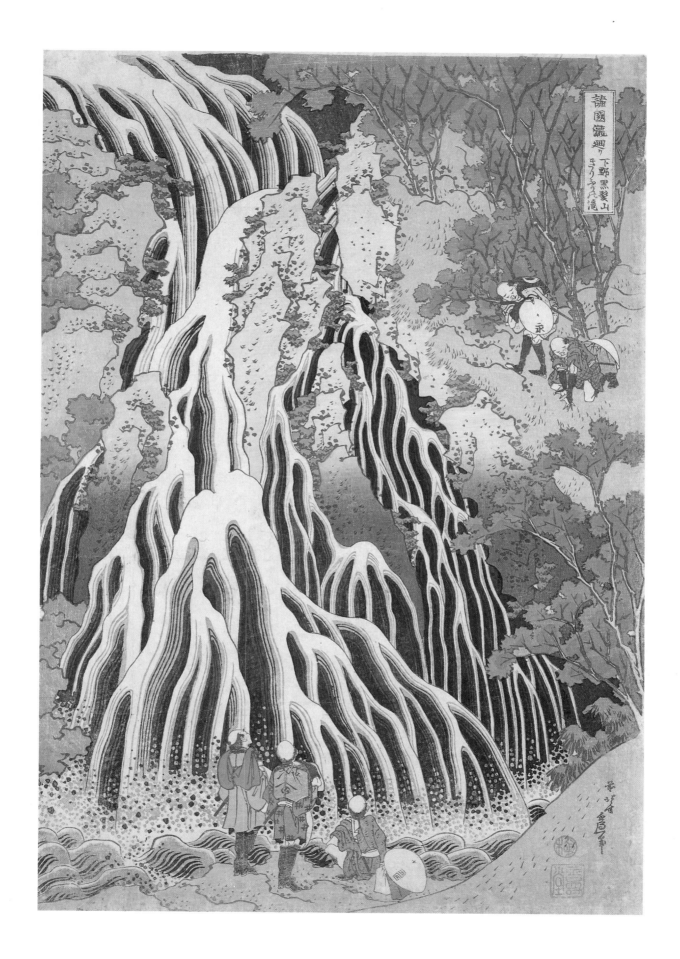

40 TRAVELLERS ON THE BRIDGE BY ONO WATERFALL

Ono Waterfall on the Kisokaidō Road (Kisokaidō Ono no bakufu)

woodblock, ōban, 381 x 260 mm (margin at left)
The Art Institute of Chicago, The Clarence Buckingham Collection (1925.3389)

A group of travellers below a small hut on a jutting rock are gazing up at Ono waterfall. Beyond, mist rises from the mountain pass. Ono, which has a fall of some nine metres, is a tributary of the Kiso River and was to be found near the village of Kagematsu, the thirty-ninth station on the Kisokaidō Road. Hokusai had already included a double-page view of Ono waterfall in the seventh volume of his *Manga* (1817; fig. 8) which, although taken from a slightly different viewpoint, is similar to this view, except that only one traveller is represented. The form this waterfall takes inspired two rascally characters in a novel of the time to remark that the district's 'local speciality was *soba*', Japanese vermicelli.

It is interesting to compare this design with that by Hiroshige for his series *The Sixty-nine Stations of the Kisokaidō*, published from *c.* 1837 to 1842 (see *Ukiyoe taikei*, XV, 39). Hiroshige's design is in a horizontal format, but it is otherwise quite similar to Hokusai's plate. Much of the striking effect of Hokusai's design is the result of the *bokashi* printing on the rocks and, more especially, that of the sky and the dark, almost black, area just to the right of the falling water.

41 TWO MEN ADMIRING YŌRŌ WATERFALL

Yōrō Waterfall in Mino Province (Mino no kuni Yōrō no taki)

woodblock, ōban, 388 x 261 mm (margins at top and right)
The Art Institute of Chicago, Gift of Chester Wright (1961.166)

Two men are looking up at a wide cascade bursting forth from the cliffs above them. In the thatched hut next to them (or is it just an awning?) several men are taking a rest. Yōrō waterfall, which is in Gifu prefecture, has a height of some thirty metres, and is more than four metres in breadth.

The good gradation printing in black, fading to grey below, that stands out in some impressions adds much to the effect of this design.

42 THREE MEN PICNICKING BY AMIDA WATERFALL

Amida Waterfall on the Kisokaidō Road (Kisoji no oku Amidagataki)

woodblock, ōban, 375 x 248 mm
Hotei Japanese Prints, Leiden

On an overhanging cliff two men sitting on mats are having a picnic, while their servant heats water for tea over a fire. The river, seen in a hollow in the mountain, is represented almost entirely in decorative lines, reminiscent of the style of Ogata Kōrin (1658–1716). Amida derives its name from the supposed resemblance between the hollow in the mountain from which its water falls and the ideally imagined round eye of Amida, the Buddha of Boundless Light, who is worshipped principally in Japan.

What seems to be the earliest impression of this print features considerable differences from this one, which has become the accepted standard impression: there, the water in the mountain's hollow flows in an all-blue ground, the grass is truly green and the cloud of mist is clearly set off against the cliffs at the top. A further characteristic is the additional reddish-brown overprinting just below the grass on the right-hand slope and at the base of the slope at the left.

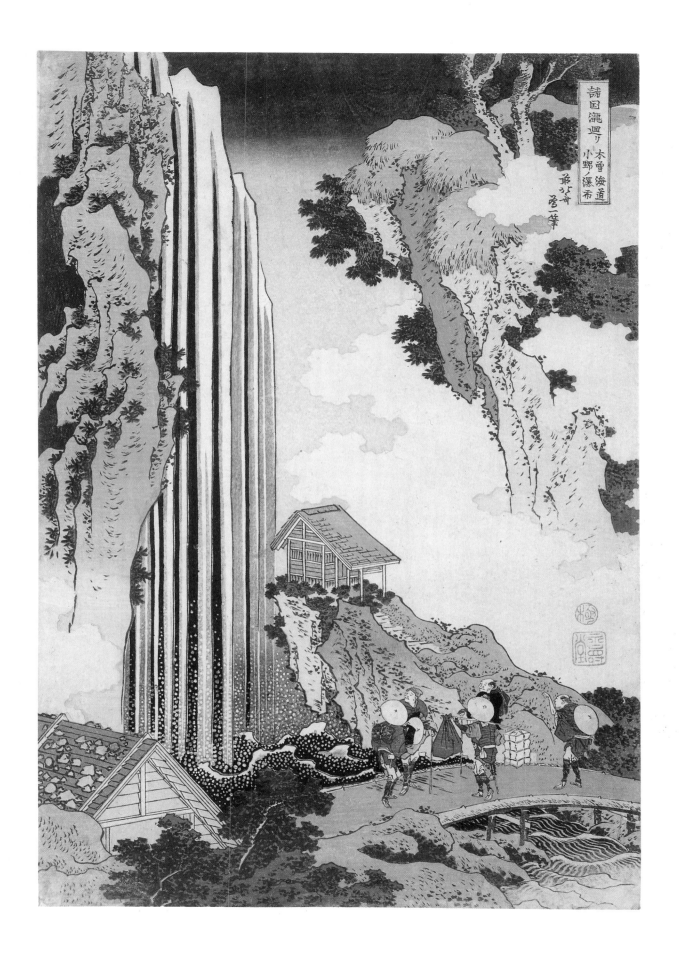

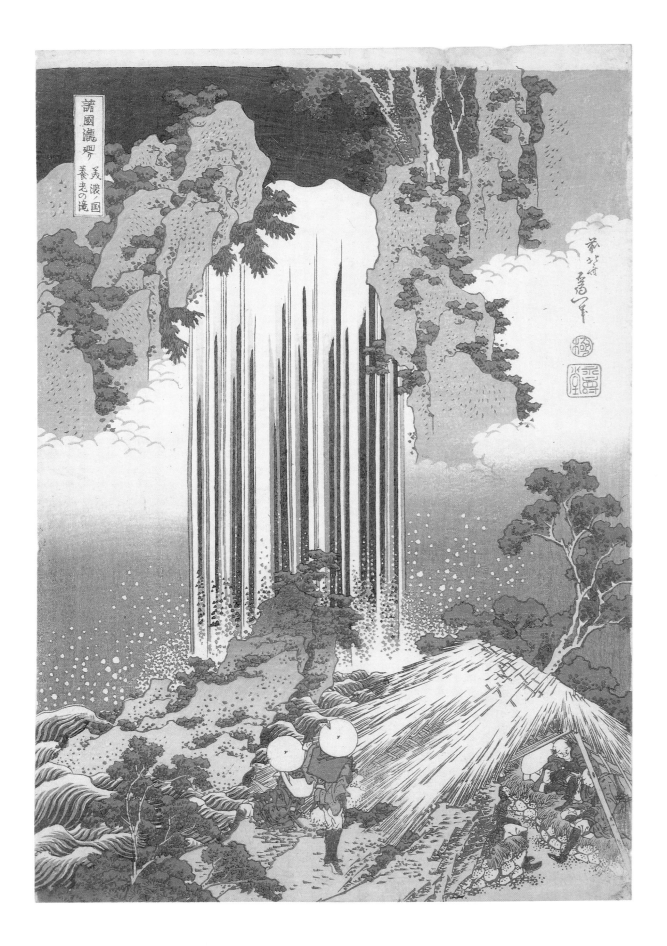

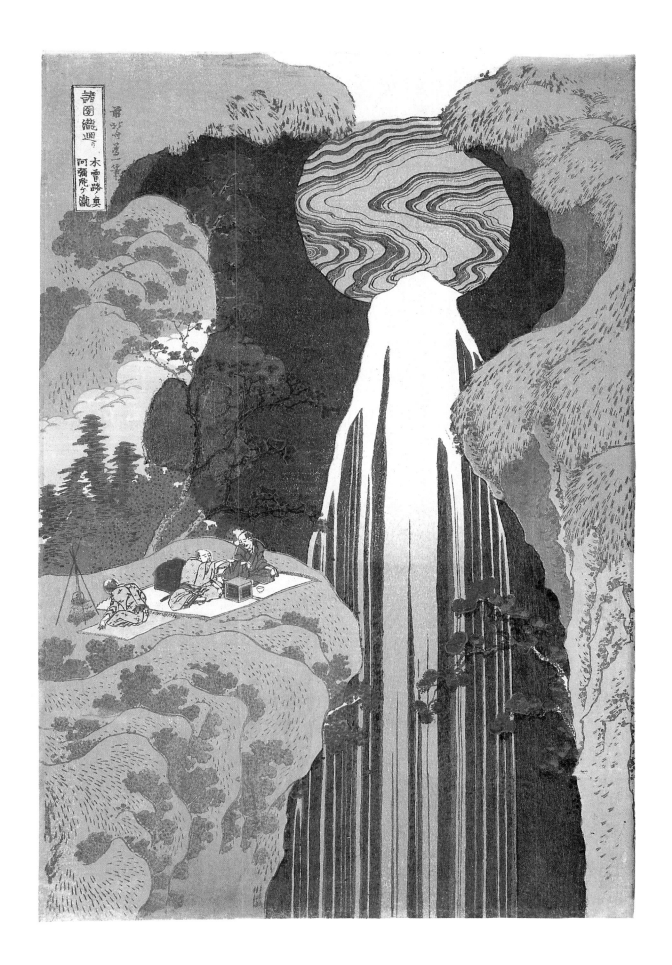

43 A VIEW OF AOIGAOKA WATERFALL IN EDO

Aoigaoka Waterfall in the Eastern Capital
(Tōto Aoigaoka no taki)

woodblock, *ōban*, 388 x 263 mm (margins at top, right and left)
Honolulu Academy of Arts, The James A. Michener Collection
(13.849)

A waterfall pours down from Akasaka pool, while two coolies with their baskets of shellfish on a yoke rest nearby. To the left are people on Aoichō, 'Hollyhock Street', a steep road on Edo's Akasaka Hill. Aoichō derived its name from the hollyhocks that flourished on the banks of the pool.

44 PILGRIMS CLIMBING THE STEPS TO A MOUNTAIN SHRINE

Kiyotaki Kannon Waterfall at Sakanoshita
on the Tōkaidō Road
(Tōkaidō Sakanoshita Kiyotaki Kannon)

woodblock, *ōban*, 382 x 256 mm (margins at top, right and bottom)
Mann Collection, Highland Park, Illinois

Pilgrims and travellers on the Tōkaidō Road are climbing steps cut in the rock that lead to a mountain shrine. A narrow stream falls down the wall of a large rock to the left, while in the foreground tea-houses or wayside restaurants are shown.

Because of its unusually clear water this fall was popularly named the Kiyotaki, the 'pure waterfall'. Kannon, originally a Hindu god, was transformed into a Buddhist god of compassion and mercy in China and Japan, largely as a result of the over-rounded body with which this deity was represented in Indian art.

45 PILGRIMS BATHING IN RŌBEN WATERFALL

Rōben Waterfall at Ōyama in Sagami Province
(Sōshū Ōyama Rōben no taki)

woodblock, *ōban*, 386 x 264 mm (margins at top, right and bottom)
The Chester Beatty Library and Gallery of Oriental Art, Dublin
(Ac. 844)

Pilgrims bearing long wooden poles are taking a ritual bath at Rōben waterfall before visiting the shrine at Ōyama, a mountain 1,253 metres above sea level in the province of Sagami (now Kanagawa prefecture).

In this design Hokusai incorporated several references to his publisher. The man admiring the waterfall has a kimono patterned with the character 'Jū', from Eijūdō, the name of the publisher's firm, while the hat hanging over the wooden fence in the centre has the character 'Ei'. The trademark of Nishimuraya Yohachi appears on the hat that lies at the top of a pile of headgear to the right.

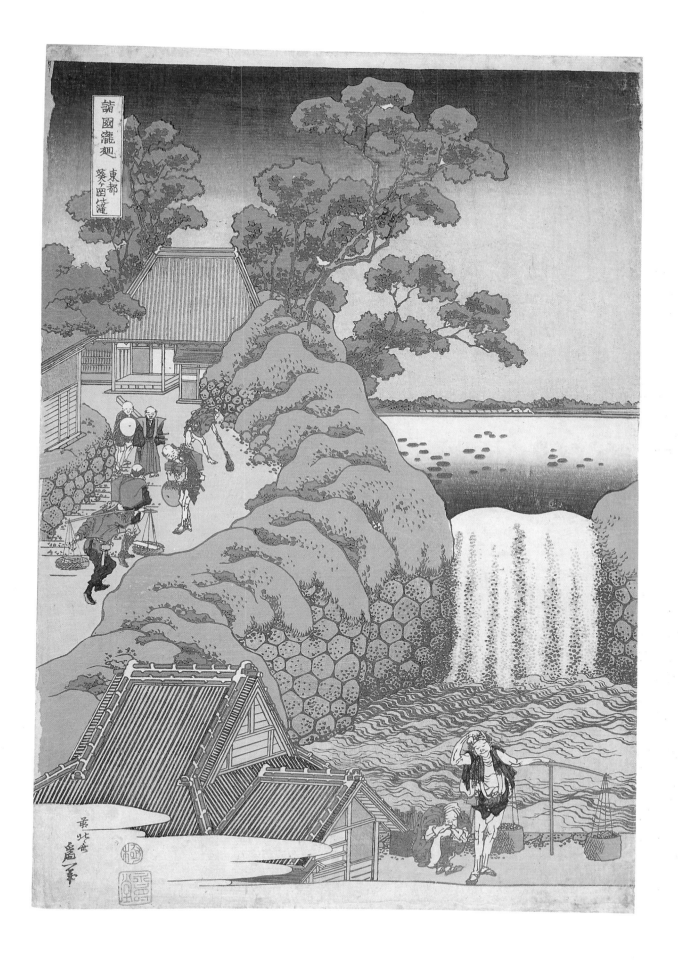

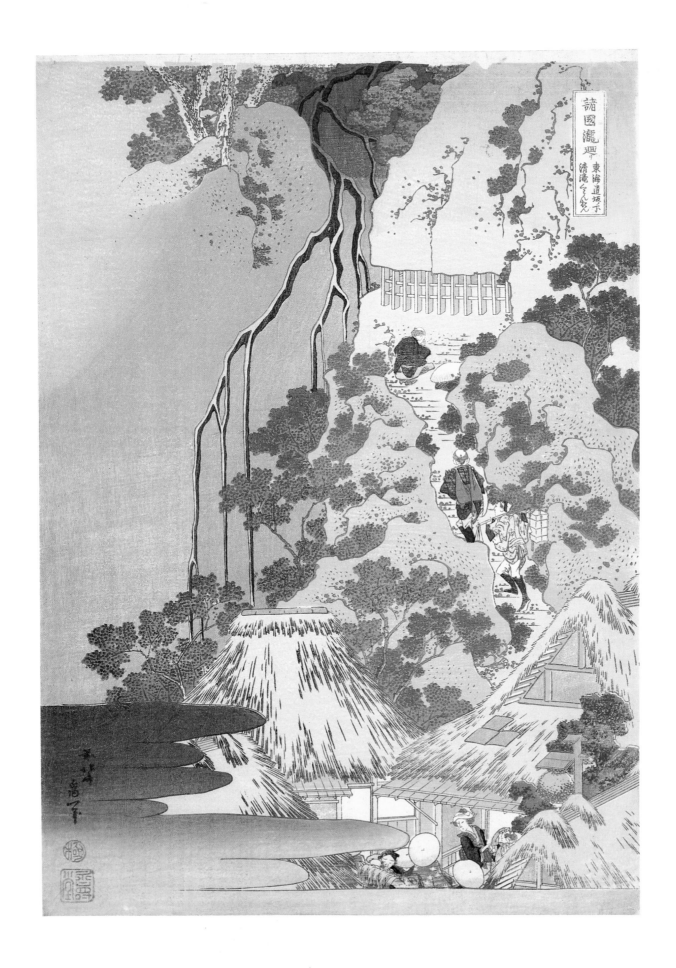

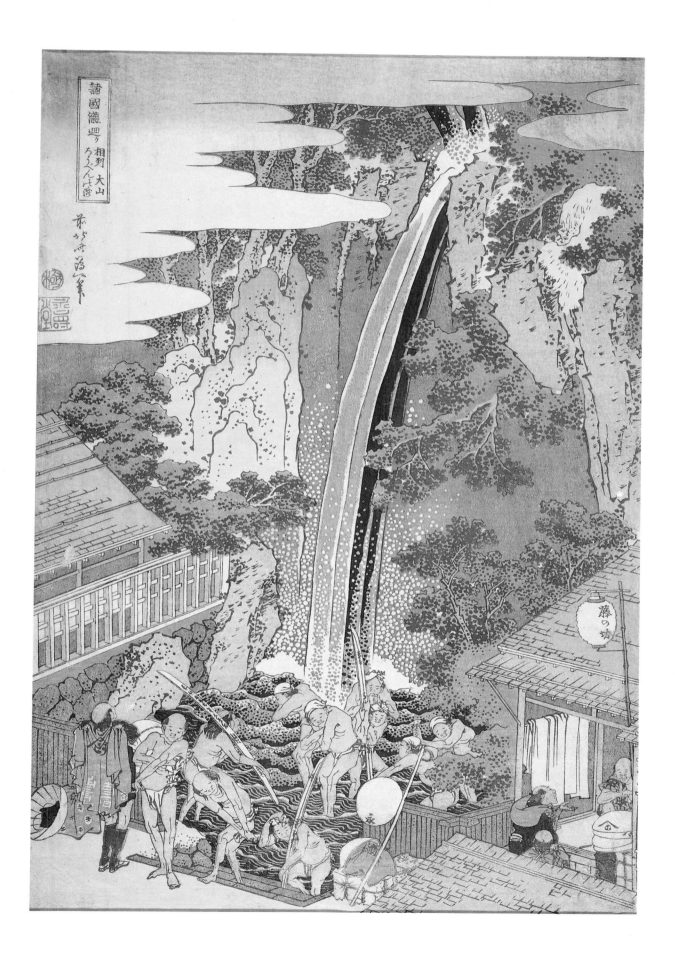

The Waterfall where Yoshitsune Washed his Horse
at Yoshino in Yamato Province
(*Washū Yoshino Yoshitsune uma arai no taki*)

woodblock, *ōban*, 379 x 259 mm (margin at top)
Honolulu Academy of Arts, The James A. Michener Collection
(15.492)

Two men are washing their horse in a waterfall at Yoshino in
Yamato province (now Nara prefecture). Legend has it that it
was here that the great general Minamoto no Yoshitsune
(1159–89) washed his horse while on one of his campaigns.
Although the name by which this waterfall became popu-
larly known obviously refers to that incident, Hokusai's
view does not depict this historical event: neither of the men
looks remotely like a famous general.

Early impressions are characterised by a small indenta-
tion in the grey block just above the waterfall, which left a
small, oval-shaped area unprinted.

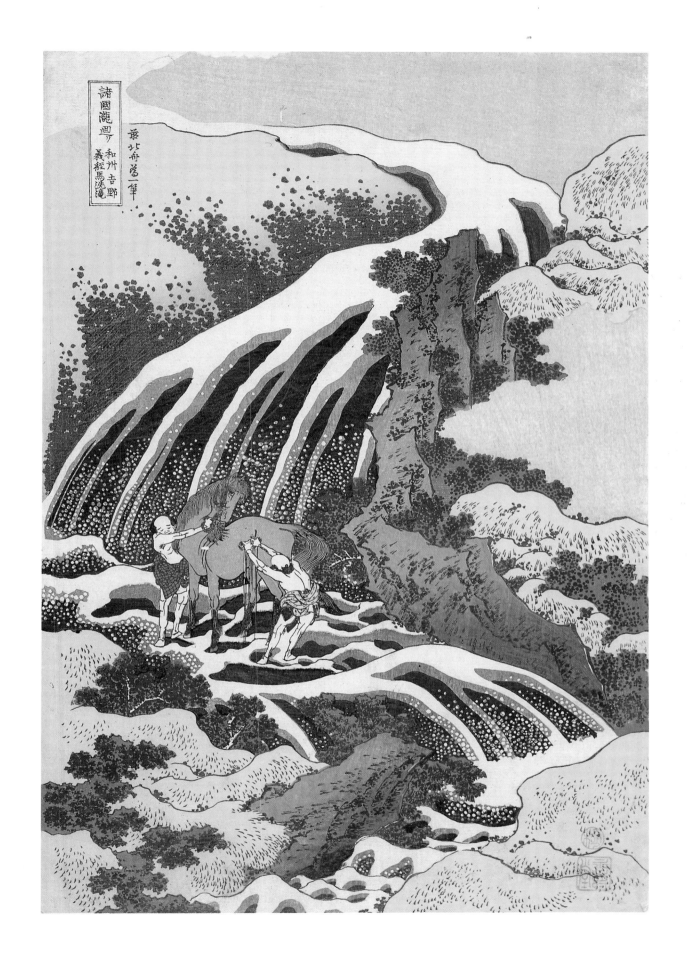

PICTURES OF THE OCEAN
CAT. 47–9

From the series *One Thousand Pictures of the Ocean* (*Chie no umi*)
published by Moriya Jihei, *c.* 1833 censorship seal: *kiwame*

47 WHALING OFF THE GOTŌ ISLANDS

Whaling off the Gotō Islands (*Gotō kujira tsuki*)

signed: *zen Hokusai Iitsu hitsu*
woodblock, *chūban*, 189 x 255 mm (margin at bottom)
The Chester Beatty Library and Gallery of Oriental Art, Dublin
(Ac. 853)

In a flotilla of boats, fishermen attack a whale off the coast of the Gotō Islands, which lie to the far west of Japan. In a hut to the right between pine trees some people are watching the hunt. Far below are the thatched roofs of houses. The enormous whale, printed in a very dark shade, stands out against the various shades of blue used for the water, all of which are accentuated by the white foam churned up by the thrashing beast. In comparison with the whale, the boats appear small and flimsy.

Although it seems unlikely that Hokusai ever travelled as far west as the Gotō Islands, he appears to have been fasci-nated by whaling. In his album *Hokusai gafu* of *c.* 1849 there is a whaling scene printed across three consecutive pages, while an earlier *surimono* from the series *A Matching Game with the Genroku Poem Shells* of 1821 is also of a whaling scene, though the creature itself is not included. Instead, a coastal view shows fishermen winding in a large rope, using a winch of the kind designed to haul in whales. If Hokusai never, in fact, witnessed a real hunt, he may well have based his depictions on those found in printed books or on scrolls, of which a considerable number survives.

The designs in this series were originally cut two to each block; once printed the illustrations were separated by cutting each sheet in two. Some, therefore, lack the artist's signature or the publisher's mark, which, of course, would only appear on one of the two designs that were printed on the same sheet. This whaling print comes from the same block as *Fishing by Torchlight* (cat. 49), and the tops of the trees in this print appear at the bottom of some impressions of that one.

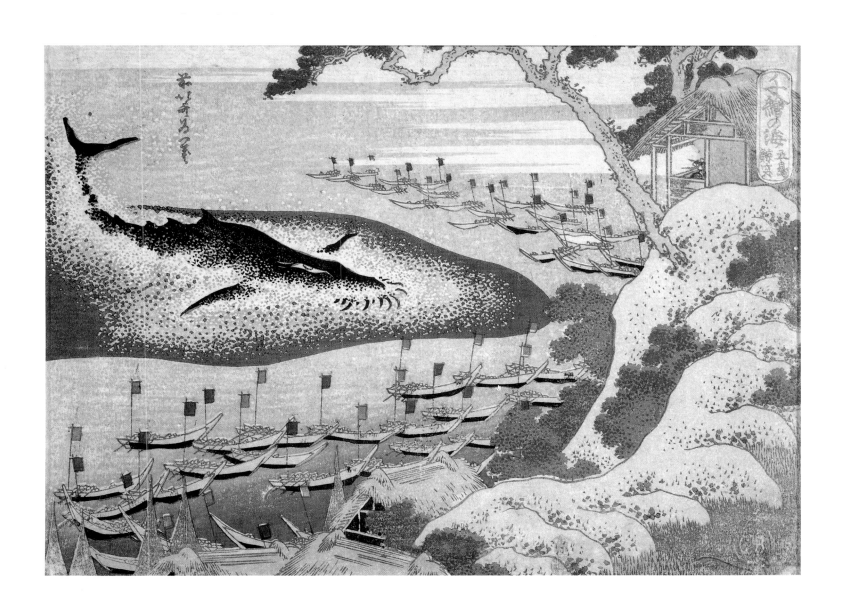

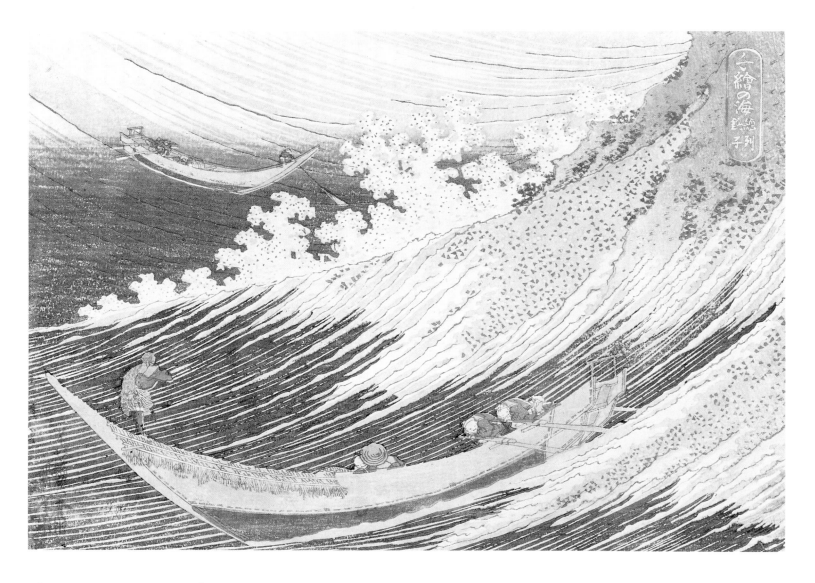

48 A WILD SEA AT CHŌSHI

Chōshi in Shimōsa Province (Sōshū Chōshi)

signed: *zen Hokusai Iitsu hitsu*
woodblock, *chūban*, 182 x 256mm
Musée National des Arts Asiatiques-Guimet, Paris (Eo 1852)

Two fishing boats are in a wild sea off the coast near the fishing village of Chōshi in Shimōsa province (now Chiba prefecture), east of Edo. Fishing in its various forms and in all weathers is the main subject of the *Chie no umi* series. Among the ten designs realised in print for this series, only three have fishing from a boat as their subject. In this print two boats struggle in a particularly violent sea. The two shades of blue used for the water produce a very distinct impression of movement, which is enhanced by the conspicuous alternation of dark and light blue in the foreground and the blue and white lines in the more distant areas of water. One can appreciate that the colour blocks had to be perfectly registered, or aligned, and the printing carefully carried out if the final effect was to be successful. If the different shades were blurred, the water is reduced to a murky mass.

With water extending right across this sheet, one gets a real sense of being caught up in the drama of the sea itself. In *The Great Wave* (cat. 11), for example, one remains a spectator at a safe distance.

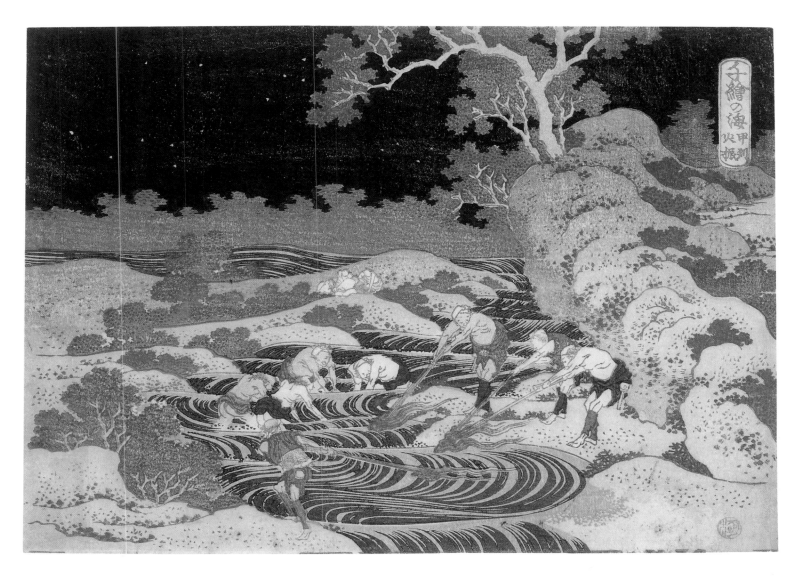

49 FISHING BY TORCHLIGHT

Fishing by Torchlight in Kai Province (*Kōshū hiburi*)

unsigned
woodblock, *chūban*, 187 x 260 mm
The Art Institute of Chicago, The Kate A. Buckingham Collection (1983.581)
(ex-J. T. Spaulding, F. W. Gookin, Colonna and Garland collections)

A group of men are fishing at night in a river in the province of Kai (now Yamanashi prefecture), west of Edo. Some of them crouch in the rapids of the stream, while others, standing on the bank, hold large torches to attract the fish.

Hokusai leaves us in no doubt that this scene is taking place in the dead of night: except for some stars, the sky is completely black. This is quite exceptional in a Japanese print. Most traditional night-scenes — such as those depic-

tions of the assault of Yoichibei by the highway-robber Sadakurō or the revenge attack by the Forty-seven Rōnin on the daimyō Kō no Moronao at his mansion (both of which were frequently illustrated in the series of prints that were devoted to the *Chūshingura*, the popular drama in which these incidents were retold) — usually show little more than a slightly shaded sky. The same is true of the views showing fireworks exploding over Ryōgoku bridge. It must be said, however, that as early as the 1780s, in a triptych depicting the night attack of the *rōnin*, Hokusai incorporated a very dark sky. In his first *Chūshingura* series (*c.* 1798), the prints of both Yoichibei's assault and the attack of the *rōnin* include a dark sky, with rain pouring down in the former plate and a sky lit with stars in the latter. In a second *Chūshingura* series, dating from 1806, dark skies are again used for these scenes. In a later impression, however, the earlier of these scenes has been conventionally adapted to show only a black line at the top, while the other scene features a grey sky.

From the series *Snow, Moon and Flowers* (*Setsugekka*)
published by Nishimuraya Yohachi (Eijūdō), *c.* 1833

censorship seal: *kiwame*

50 A VIEW OF SUMIDA RIVER IN SNOW

Sumida River (*Sumida*)

no seals
woodblock, *ōban*, 256 x 381 mm (margin at right)
Peter Morse Collection

A view of Sumida River in winter, with a man fishing from a boat in the foreground. On the far bank are two men in straw coats approaching a group of buildings that is surrounded by trees. Across from the dike are rice-fields covered in snow.

Although no precise location on the Sumida River is given in the title, a comparison of this scene with a similar one — also seen under snow — in Hokusai's picture album *Ehon Sumidagawa ryōgan ichiran* ('Both Banks of the Sumida River in One View') of *c.* 1803, suggests that the small building in the foreground is part of Massaki Shrine in present-day Arakawa-ku, Edo (but see Lane, 1989, p. 207, for its identification as Umewaka Shrine). The group of buildings on the far bank includes Mokubōji Temple, which was celebrated for its willow trees. Among Mokubōji's most frequent visitors were the fashionable courtesans from the nearby Yoshiwara entertainment district.

Variations in this design mainly involve the *bokashi* printing. In some impressions the blue of the horizon just below the title cartouche is stronger, or the water in the foreground up to where the gulls are paddling is so dark that the birds are barely visible.

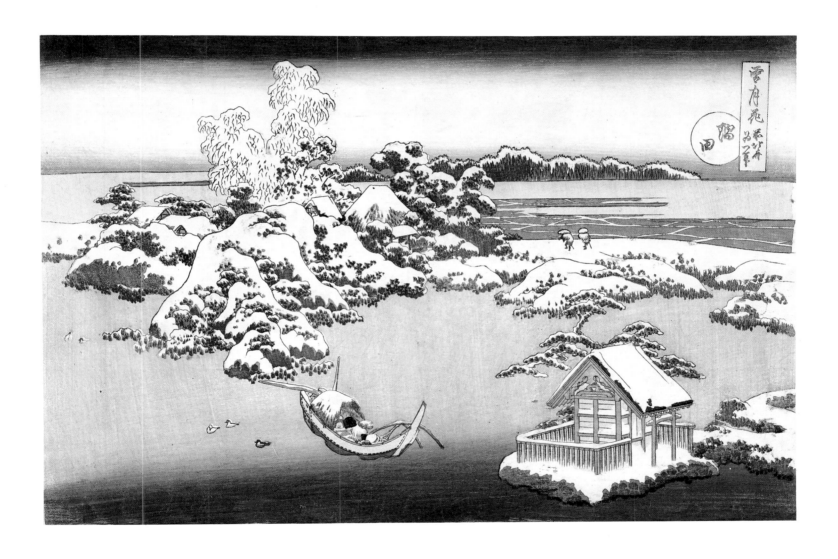

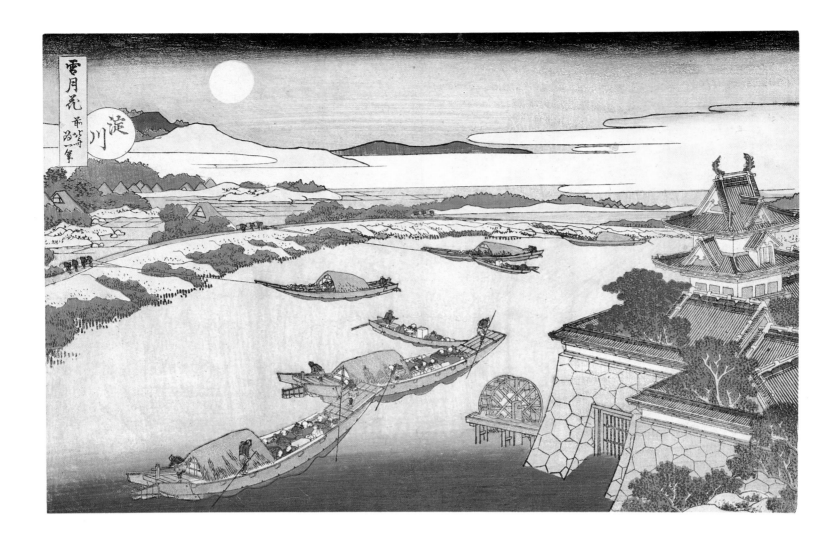

51 THE MOON ABOVE YODO RIVER AND ŌSAKA CASTLE

Yodo River (Yodogawa)

no seals
woodblock, *ōban*, 244 x 368 mm
Peter Morse Collection

An evening view of Yodo River, with some men on the bank pulling boats against the current. In the foreground looms Ōsaka Castle. Beyond the banks of mist that hang over the rice-fields are distant mountains, with the moon above.

In the 'moon' subject from the series *Shōkei setsugekka* ('Beautiful Views of Snow, Moon and Flowers'), produced around the same time, Hokusai presents a very similar scene of men pulling boats on Yodo River, but with Ōsaka Castle replaced by houses.

Some impressions feature a generally darker sky than is the case here, which gives an added emphasis to this twilight scene. The area of water printed in a strong blue in the foreground is usually shown in a diagonal alignment on Ōsaka Castle. In some impressions most of the waterwheel is included within this area of stronger blue. Impressions bearing a censorship seal and that of the publisher have been identified.

52 FLOWERING CHERRIES AT MOUNT YOSHINO

Mount Yoshino (Yoshino)

no seals
woodblock, *ōban*, 261 x 381 mm (margins at top and left)
Gerhard Pulverer Collection

The Yoshino Mountains, which lie near the ancient imperial capital of Kyōto, attracted many visitors during the third month of the lunar calendar, for that was when the cherry trees were in bloom. In this design, the approach to a Shinto shrine at Mount Yoshino includes a beautiful view of blossoming trees in the vale below the road, which almost hide the shrine from view. The cloudy mass of blossom that smothers the vale is strongly reminiscent of the billowing Western-style skies that figure in so many of Hokusai's landscapes.

Though neither a publisher's mark nor a censorship seal ever appears on impressions of this print, the design does contain several references to its publisher, Nishimuraya Yohachi. The bundle on a pole carried by one of the men to the right bears his trademark, and this same mark also appears on the bundle of the man who, hat in hand, climbs the road towards us from the left. The characters 'Ei' and 'Jū'—from Eijūdō, the name of the publisher's firm—can be seen on the shouldered bundle of the man approaching the pack-horse.

Whereas the two other designs in this series bear the traditional title of *Setsugekka*, the series title on this particular print wrongly reads *Setsukagetsu* ('Snow, Flowers and Moon')—a slip we can attribute to the block-cutter.

In the contemporary series *Shōkei setsugekka* ('Beautiful Views of Snow, Moon and Flowers'), which consists of small-format landscapes of scenery in Edo, Settsu and Yamashiro provinces, Hokusai depicted Arashiyama, near Kyōto, in the cherry-blossom season.

53 A VIEW OF A STONE CAUSEWAY

Clear Autumn Weather at Chōkō (Chōkō shūsei)

from the series *Eight Views of the Ryūkyū Islands (Ryūkyū hakkei)*
published by Moriya Jihei, *c.* 1832

signed: *zen Hokusai Iitsu hitsu*
woodblock, *ōban*, 258 x 378 mm
Honolulu Academy of Arts, The James A. Michener Collection
(L21.187)

A Chinese junk and a sampan are floating among the
Ryūkyū Islands (in present-day Okinawa prefecture), which
extend south of Japan towards Taiwan in a long chain that
separates the East China Sea from the Pacific Ocean. The
boats are shown nearing a stone causeway, probably the
sequence of linked bridges known as the 'Chōkō', or 'Long
Rainbow'. In the distance several more of the pine-clad
Islands can be seen.

At the time Hokusai designed this print, the Ryūkyū
Islands — then a remote, semi-autonomous kingdom — was
a topical issue, with both China and the province of Satsuma
in Japan insisting on collecting taxes from its inhabitants.
Various books connected one way or another with the
Islands had begun to appear in Japan, notably the *Ryūkyū
kokushiryaku*, an official history issued by the Government
that was, in fact, adapted from a book on the Islands pub-
lished in China by Shūkō in 1757. A visit by two hundred
Ryūkyūans to the shōgun in Japan in the eleventh month of
1832 excited much interest in Edo, not least among the vari-
ous artists and publishers who sought to capitalize on this
topical event. Among them was Hokusai who, in a series of
eight prints, adapted the plates he discovered in Shūkō's
book — adding a boat here and there, but on the whole
remaining quite faithful to the original line-block illus-
trations. The titles used for the individual prints in Hokusai's
series were all taken from the *Ryūkyū kokushiryaku*.

REFERENCE: Akimasa Kishi, 'Hokusai no "Ryūkyū hakkei" ni
tsuite', *Ukiyoe geijutsu*, 13 (1966), pp. 36–9

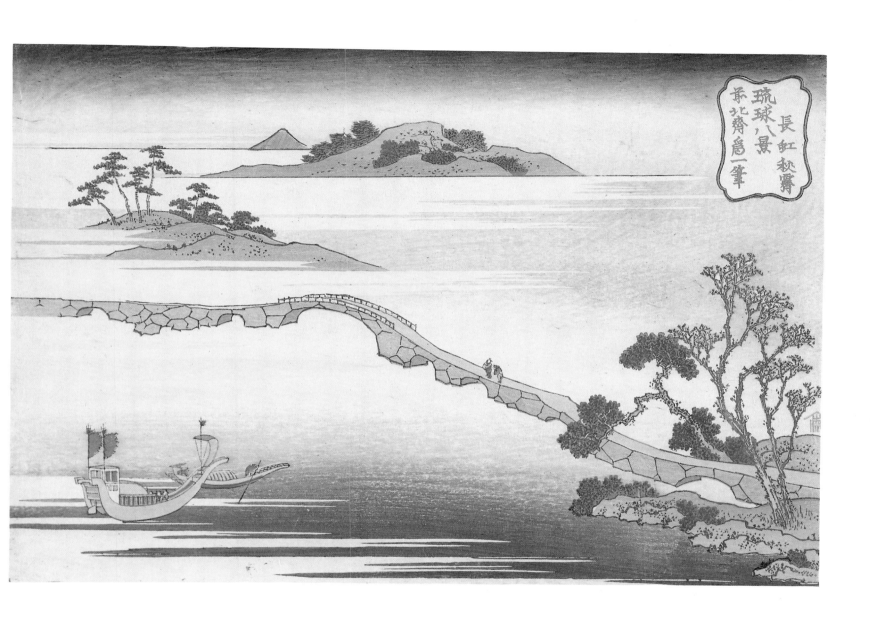

From an untitled series published by Nishimuraya Yohachi (Eijūdō), *c.* 1832

signed: *zen Hokusai Iitsu hitsu*
censorship seal: *kiwame*

54 BELL-FLOWER AND DRAGONFLY

woodblock, *ōban*, 260 x 375 mm
The Art Institute of Chicago, The Clarence Buckingham
Collection (1925.3377)

Against a yellow ground, a dragonfly flies down towards some Chinese bell-flowers. A slight breeze is blowing from the right.

Dragonflies quite often appear in prints of Nature, of which Utamaro's *Ehon mushi erami* ('Picture Book of Select Insects') of 1788 is the foremost example. One of Utamaro's plates features some Chinese bell-flowers with a dragonfly hovering nearby, which is, as in this print by Hokusai, of the red-bodied species, *aka tonbo*. In all other respects they differ, however, for unlike the blooms in Hokusai's plate, Utamaro's bell-flowers are gathered (with wild pinks) on the right of the sheet in order to provide a space on the left for poetry.

Dragonflies are among the more popular emblems of Japan, which, from the similarity that exists between the outline of the country as it appears in maps and the shape of these insects, is sometimes called the Island of the Dragonfly.

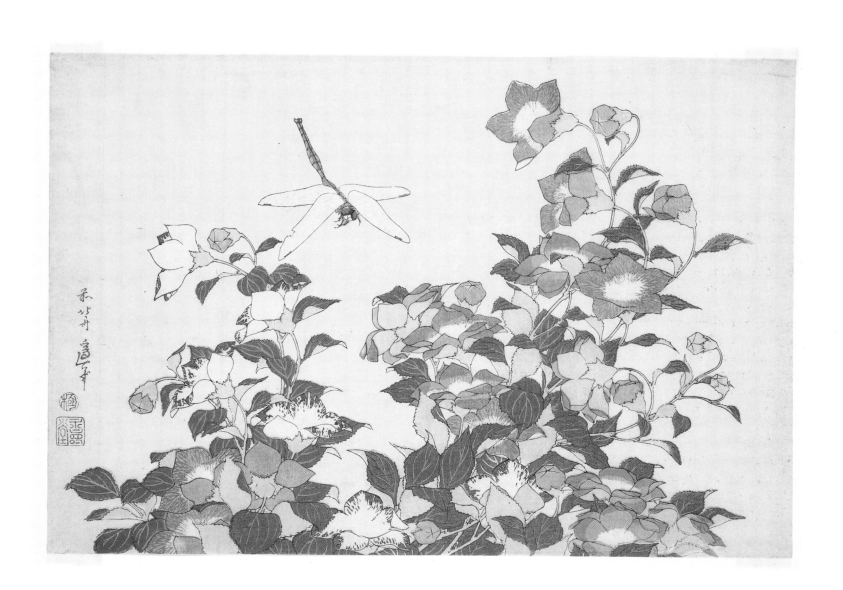

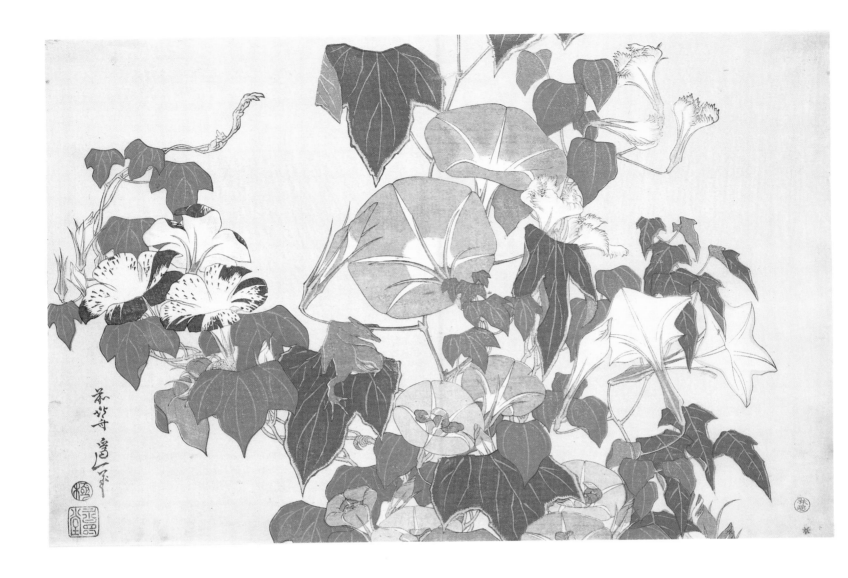

55 CONVOLVULUS AND TREE-FROG

woodblock, *ōban*, 250 x 375 mm
Mann Collection, Highland Park, Illinois (ex-Hayashi Tadamasa
and Henri Vever collections)

Against a yellow ground, a green tree-frog is seated on a leaf
of convolvulus, with some of the trumpet-shaped, blue and
purple flowers already in bloom.

The frog has always been regarded affectionately in Japan
as well as in China, and it figures prominently in numerous
stories and legends. The traditional Chinese belief in the
existence of a sacred three-legged toad may, in fact, have had
some bearing on the way Hokusai chose to depict his frog
here, for the actual differences that distinguish toads from
frogs rarely seem to have troubled artists or poets. Represen-
tations of frogs clinging to buckets were particularly popular
subjects in the art of *netsuke* for some reason, though in view

of the many literary allusions to be found in Hokusai's work
it may well be that the reference intended here was to a well-
known poem by Kaga no Chiyo (1703–75):

As I found my well-bucket caught by convolvuli
I had to go elsewhere for water.

Here the poet demonstrates her sensitivity towards the
convolvuli that, during the night, had entangled themselves
around the rope of her well-bucket: rather than disengage
the flowers, she goes to her neighbours for water.

It seems likely that in this series of *Large Flowers* Hokusai
was influenced to some extent by Utamaro's books on
insects and birds, the *Ehon mushi erami* of 1788 and
Momochidori kyōka awase of 1789. At that time, of course, a
different classificatory system governed the study of natural
history in Japan, in which frogs, along with all other am-
phibians, were included within the world of insects.

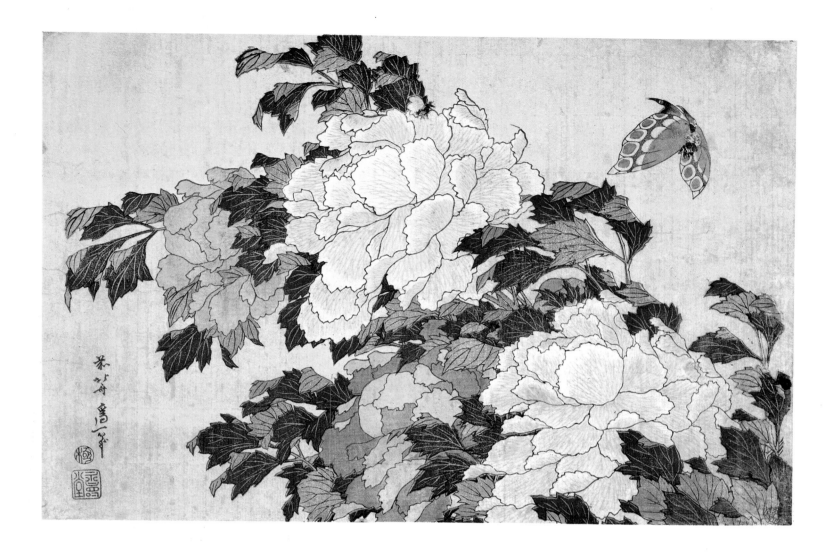

56 PEONIES AND BUTTERFLY

woodblock, *ōban*, 254 x 377 mm
Peter Morse Collection (ex-A. Rouart Collection)

Against a pale yellow ground, the petals and leaves of pink and red peonies are shown in disarray, blown by the breeze in which a butterfly also struggles.

In this unusually simple composition Hokusai effortlessly conveys a minor drama from the world of Nature. The elemental power he caught at a moment of strong flux in *A Sudden Gust of Wind at Ejiri* (cat. 21) is here too, but on a small scale: the butterfly struggles in the wind in much the same way as the travellers at Ejiri do, while the peonies serve as the scenery, the 'landscape' setting.

Earlier in his career Hokusai had used peonies as subject-matter for his prints. They generally appear as horizontal compositions in his long *surimono* dating from the early 1800s, one of which (Forrer, 1988, 113) is even in the exceptional format of a double long *surimono*, with the design spread across the whole sheet. (It actually includes a reference to the actor Ichikawa Danjūrō who, like others in his theatrical family, sometimes wore peony patterns on his clothing.) Most of Hokusai's earlier designs were, however, stiffly composed; in more ways than one, then, this print shows just what a little breeze can do.

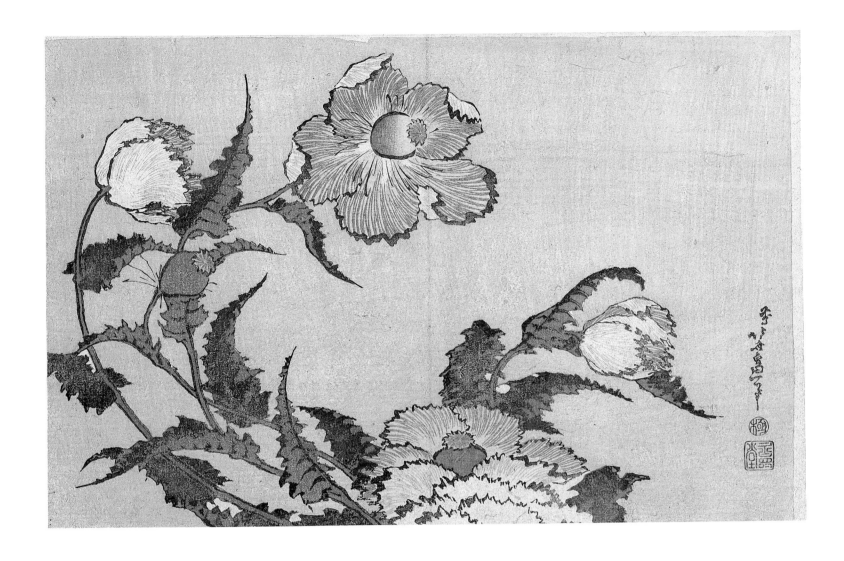

57 POPPIES

woodblock, *ōban*, 250 x 372 mm (margins at top and right)
Musée National des Arts Asiatiques-Guimet, Paris (Eo 1637)

Whereas the peonies in this series (cat. 56) easily withstand a light breeze, these poppies seem entirely at the mercy of a strong wind. Their curving composition does, in fact, closely mimic the design of *The Great Wave* (cat. 11), and the suggestion put forward in the entry for that print to explain the wave's effect on those trained to 'read' from right to left may well be relevant here as well.

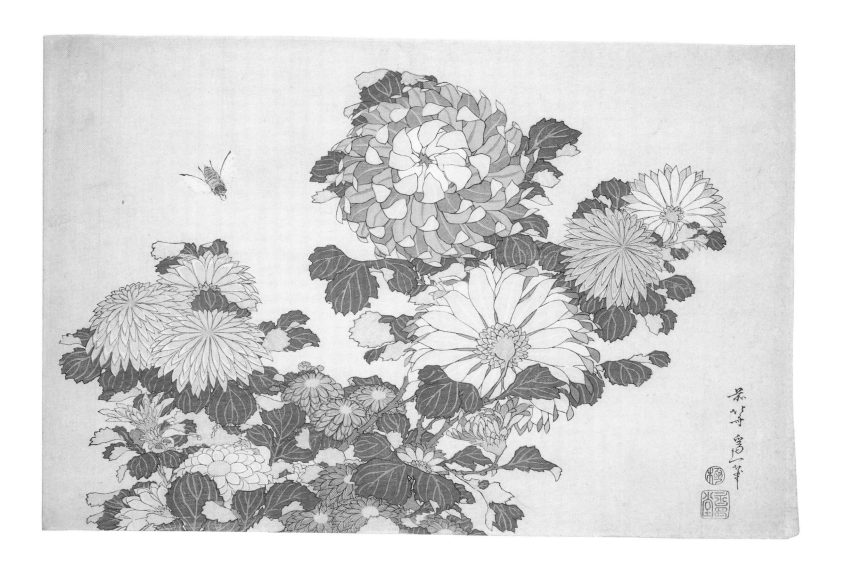

58 CHRYSANTHEMUM AND BEE

woodblock, *ōban*, 263 x 389 mm (margins at right and left)
The Art Institute of Chicago, The Clarence Buckingham
Collection (1925.3373)

Against a light-blue ground, a bee flies down to some
chrysanthemums in bloom. Chrysanthemums, which fea-
ture in the imperial crest and symbolise the ninth month, are
among Japan's most popular flowers. Since classical times
they have been a favourite subject in painting as well as in
various arts and crafts.

Hokusai depicted chrysanthemums on numerous occa-
sions, mostly in his *surimono* made soon after 1800, one of
which has an exhibition of them as its subject.

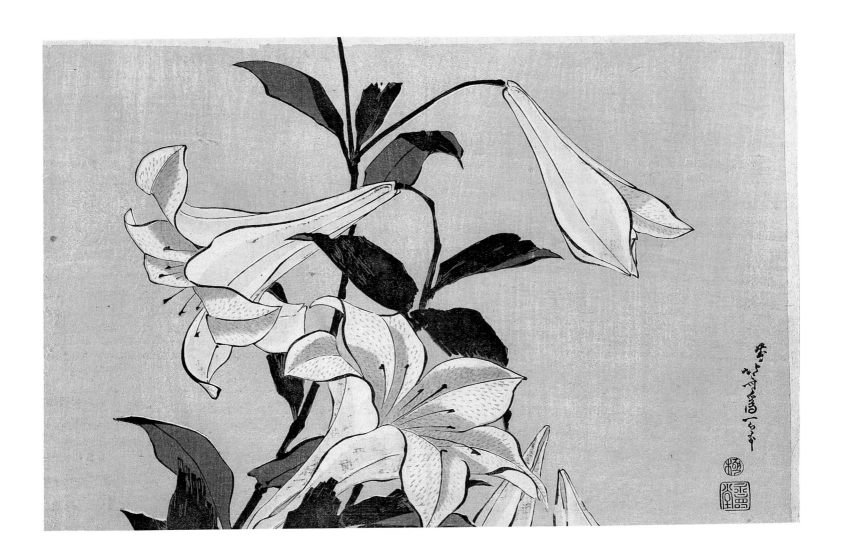

59 LILIES

woodblock, *ōban*, 250 x 370 mm (margins at top and right)
Musée National des Arts Asiatiques-Guimet, Paris (Eo 1641)

In this example of the striking close-ups that characterise the series *Large Flowers*, several lilies are shown against a pale blue ground.

Some fifteen years earlier, in the *Santei gafu* of 1816 — his 'Album of Drawings in Three Styles' — Hokusai had presented what he claimed as the equivalent in the visual arts of the three major forms, or styles, of writing — 'straight' (*shin*), 'cursive' (*gyō*) and 'running' (*shō*), demonstrating in this book how these styles might be applied to drawing (fig. 9). In a few prints from the series *Large Flowers*, notably *Hibiscus and Sparrow* (cat. 61), *Hydrangea and Swallow* (cat. 62) and the *Lilies* shown here, Hokusai attempted to combine two of the three styles within the same design: the carefully detailed 'straight' depiction of these petals offers a considerable contrast to the far more sketchily executed 'running' leaves.

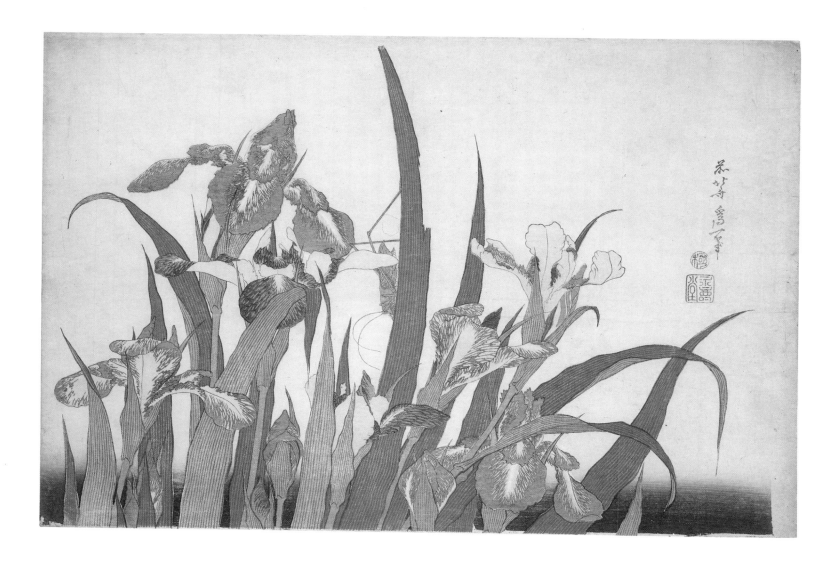

60 IRISES

woodblock, *ōban*, 266 x 393 mm (margins on all sides)
The Art Institute of Chicago, Gift of Mr and Mrs Gaylord
Donnelley (1969.696)

A grasshopper is walking down the tallest leaf of a clump of
blue and purple irises. Instead of the usual overall coloured
ground, here the *bokashi* is restricted to the bottom of the
print, from where it drifts up into a paler shade of blue.

In Japan irises were generally associated with the fifth
month and regarded as a symbol of success. Hokusai
depicted them in various albums, including the *Santei gafu* of
1816 and the *Hokusai shashin gafu* of three years later. The
three different styles of drawing that he had promoted and
illustrated in the *Santei gafu* (fig. 9) all seem to be present
here, with the iris petals represented in the 'straight', or
realistic, mode. The irises that appear in the *Hokusai shashin
gafu* (fig. 10) closely resemble those shown here, but only
some half-dozen are included, each of them depicted at a dif-
ferent stage of flowering.

Hokusai discusses irises and how they should be coloured
in the first volume of his *Ehon saishikitsū* ('Picture Book of
Colouring') of 1848.

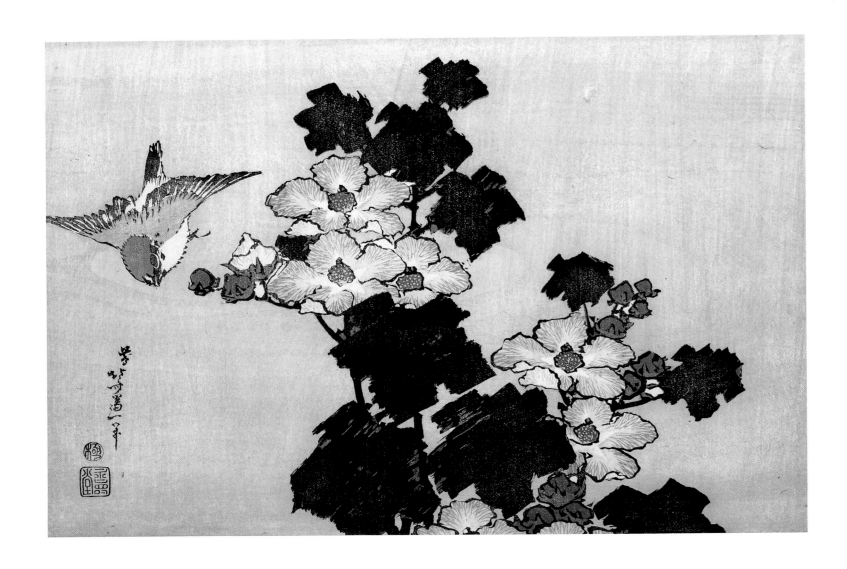

61 HIBISCUS AND SPARROW

woodblock, ōban, 252 x 370 mm
Musée National des Arts Asiatiques-Guimet, Paris (Eo 1638)

Several large hibiscus flowers are shown against a pale blue ground, with a sparrow flying down at the left. For this design Hokusai broke away from the conventional manner of representing hibiscus in bloom, in which the leaves were more or less ignored in favour of the blooms: here the leaves even blot out some of the petals from view.

By printing the leaves in two shades of green—the lighter green first, followed by the overprinted darker shade—and by avoiding giving them sharply defined outlines, Hokusai conveys the impression that a light breeze is blowing. The effect is, in fact, close to the 'running' style he used for the leaves in his *Lilies* (cat. 59).

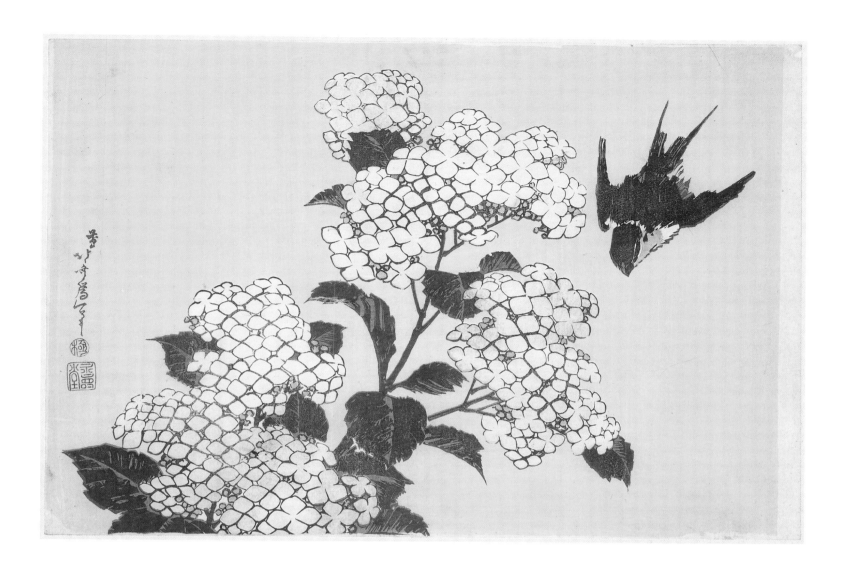

62 HYDRANGEA AND SWALLOW

woodblock, *ōban*, 261 x 385 mm (margins on all sides)
The Art Institute of Chicago, The Clarence Buckingham
Collection (1925.3376)

Set here against a yellow ground are some blooming hydrangea tinged with pink and blue. To the right, a swallow is flying down.

Hydrangea are common in Japan, where they bloom in June and July: they are often to be found growing at the margins of pools and in marshy ground.

63 ORANGE ORCHIDS

woodblock, *ōban*, 249 x 366 mm
Musée National des Arts Asiatique-Guimet, Paris (Eo 1635)

A spray of orange orchids, some of which are in flower, is shown against a pale blue ground; the jagged tips Hokusai has given to some of the leaves contribute to the overall realism of this plate.

The orange petals appear to have been printed in an oxidising pigment. In this impression the oxidation seems to have been controlled well, but in some others the petals appear in a much darker shade. In one particular example (see Vignier & Inada, 1913, pl. 90, no. 307) an overprinted pattern on the petals can clearly be seen. The break in the line-block that shows here on the left-hand side of the leaf far left is evident there too.

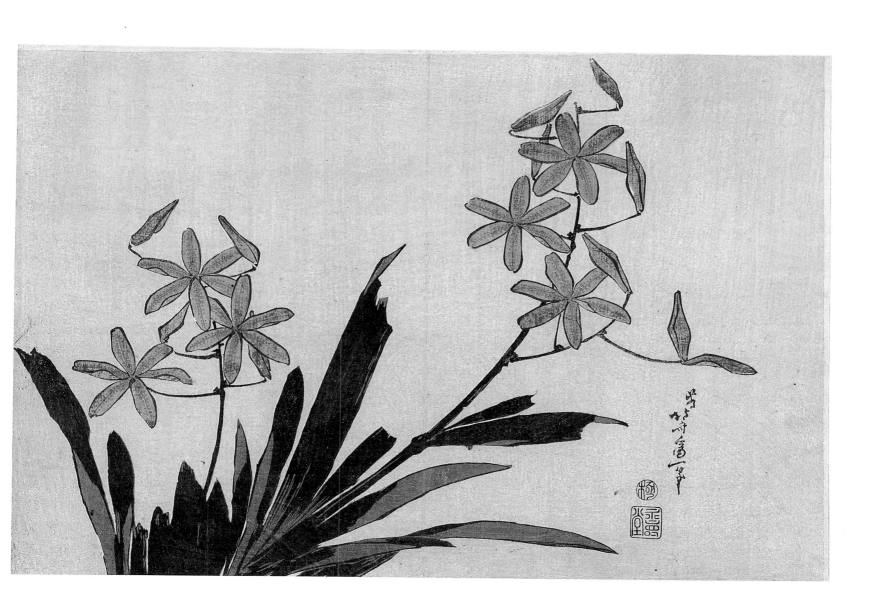

64 WEEPING CHERRY AND BULLFINCH

from the series *Small Flowers*
published by Nishimuraya Yohachi, *c.* 1834

signed: *zen Hokusai Iitsu hitsu*
woodblock, *chūban*, 251 x 181 mm
Honolulu Academy of Arts, The James A. Michener Collection
(L21.291)

Against a deep blue ground, a bullfinch hangs upside-down from a branch of weeping cherry. A poem by the little-known writer Raiban reads:

Tori hitotsu nurete
dekeri asazakura

One single bird, wet with dew,
Has come out:
The morning cherry.

Hokusai's series *Small Flowers*, so-called in order to distinguish it from the horizontal *ōban* series, *Large Flowers*, comprises ten designs. Unlike the earlier series, however, *Small Flowers* is restricted to plates of birds and flowers, two of which are set against a coloured ground. The only known external source for dating *Small Flowers* is the advertisement for the series discovered in a novel that was published in 1834.

A later impression of the complete set omits the censorship and publisher's seals, and bears, instead, a rectangular seal incorporating the *kiwame* seal and the character 'Manji', a name Hokusai used from 1834. In addition, in that impression the coloured grounds were omitted.

A preparatory design for this print is known (Hillier, 1980 (b), 61), in which the twig to the right is further extended; this effect had to be modified in order to accommodate the poem seen here.

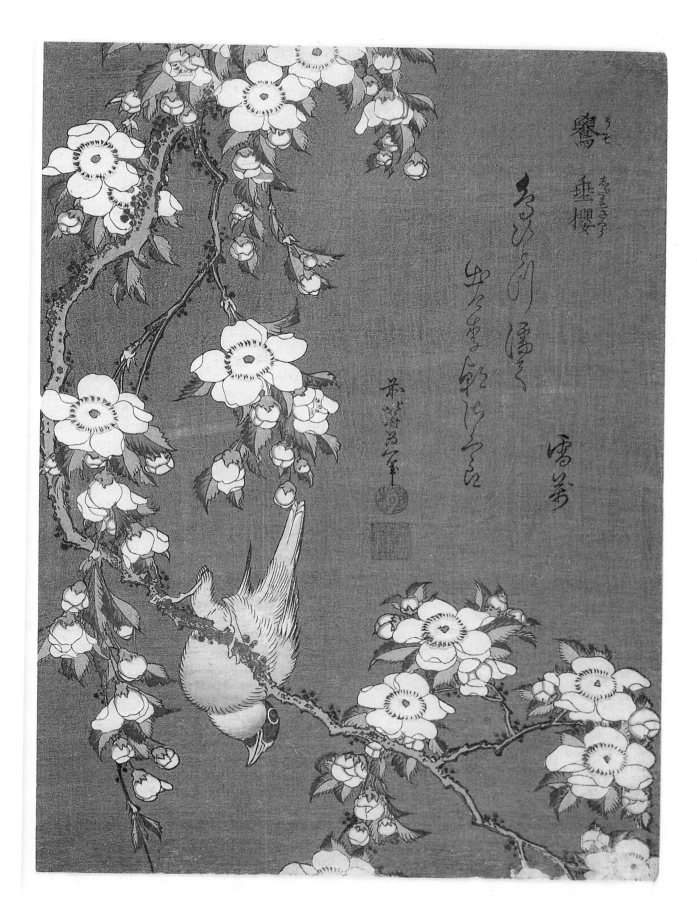

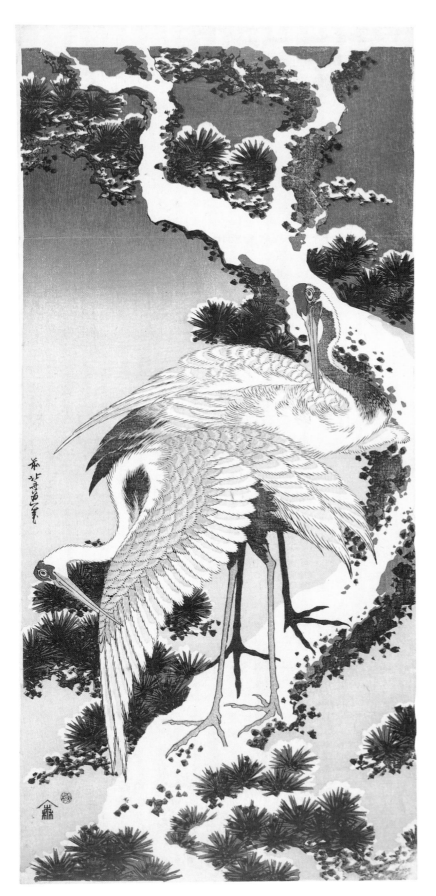

65 CRANES ON A SNOWY PINE

from an untitled group of prints published by Moriya Jihei, *c.* 1833

signed: *zen Hokusai Iitsu hitsu*
censorship seal: *kiwame*
woodblock, *nagaban*, 527 x 236 mm (margins on all sides)
Honolulu Academy of Arts, The James A. Michener Collection
(15.970)

Two cranes on a snowy pine are set off against a grey *bokashi* sky. The bird with a white crown and nape attends to the feathers at the tip of one outstretched wing; its companion — which, from the black nape and tail-feathers and the crimson patch on its forehead, can be identified as the more common Manchurian crane — also occupies itself in a preening display.

In Japan, both the crane — a notable emblem of longevity — and the pine tree were associated with the New Year, hence the inclusion here of some seasonal snow. No doubt Hokusai is also alluding to 'the happy land of the immortals' — the mythical Mount Hōrai, among whose pine-clad slopes cranes were believed to dwell.

66 CARP IN A WATERFALL

from an untitled group of prints published by Moriya Jihei, *c.* 1833

signed: *zen Hokusai Iitsu hitsu*
no seals
woodblock, *nagaban*, 520 x 230 mm (margin at top)
The British Museum, London (1927.4.13.014)

A close-up view of two carp in a waterfall, with one ascending, the other swimming downstream.

In Japan this fish is associated with strength and perseverance, deriving from an ancient Chinese belief that carp alone were able to penetrate the highest reaches of the Yellow River and pass through the symbolic Five Cataracts. Having achieved this, some even managed the leap through the Dragon's Gate, transforming themselves into dragons in the process. That carp streamers are still hung outside houses in Japan during the Boys' Festival held each May, proves just how enduring are these symbols of a rite of passage.

Although perhaps in this print Hokusai did mean to allude to a strand of popular belief, none of the other four prints in this group — which include *Horses in a Pasture* and *Turtles among Seaweed* — suggests he intended anything of that kind for them. Only *Carp in a Waterfall* and one other actually bear Moriya Jihei's seal, but the overall similarity of the printing allows us to assume that all were issued by this publisher.

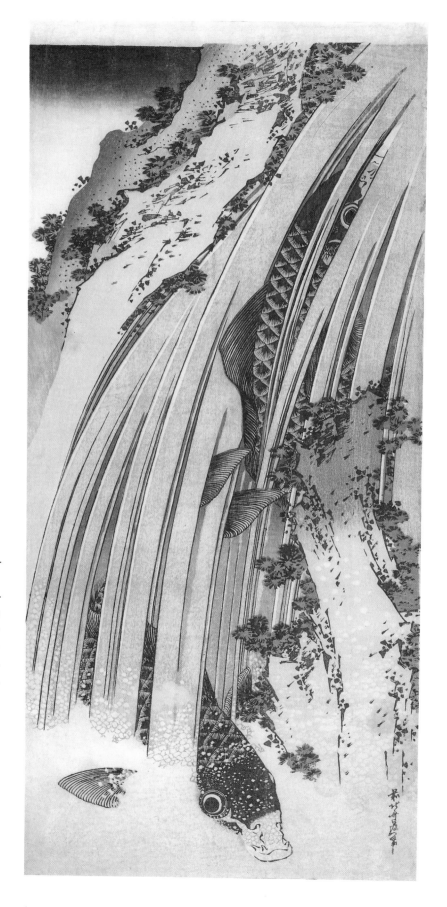

67 TWO CARP

fan print, publisher unidentified

signed: *Hokusai aratame Iitsu hitsu*, with seal: *Tengu*
date seal: Year of the Hare, i. e. 1831
censorship seal: *kiwame*
woodblock, *uchiwa*, 185 x 235 mm
Musée National des Arts Asiatiques-Guimet, Paris (Eo 1901)

In this, one of the small number of Hokusai's designs for fan prints so far identified (most of which date from the 1830s), two carp are shown swimming among water-weeds. The subject-matter for this kind of print seems in the main to have been drawn from the animal world — birds, for example, or fish of one kind or another. The two extant exceptions to animal subjects are known only in the form of proof impressions, both of which date from the 1810s: one shows a tea-house waitress (cat. 2), the other a branch of flowering plum (Hokusai Museum, Tsuwano).

Fan prints were usually issued by those publishers who had organised themselves into a specialised guild for that purpose, many of whom have so far not been identified — as is the case here. The censorship and date seals that appear on these prints are different from the ones to be found on other kinds of print formats.

As can be seen from the impression left by the bamboo ribbing, this print has actually been used to make a fan. Very few fan prints by Hokusai are known today: it is hard to be sure whether this is simply because he rarely made any or because most fans were thrown away at the end of summer. Since fans designed by Utagawa Hiroshige — one of Hokusai's contemporaries — have survived in quite large numbers, it seems very likely that Hokusai worked only occasionally in this format.

A later impression (Rijksmuseum, Amsterdam) of this design has the water-weed printed in green rather than in blue, and omits the censorship and date seals.

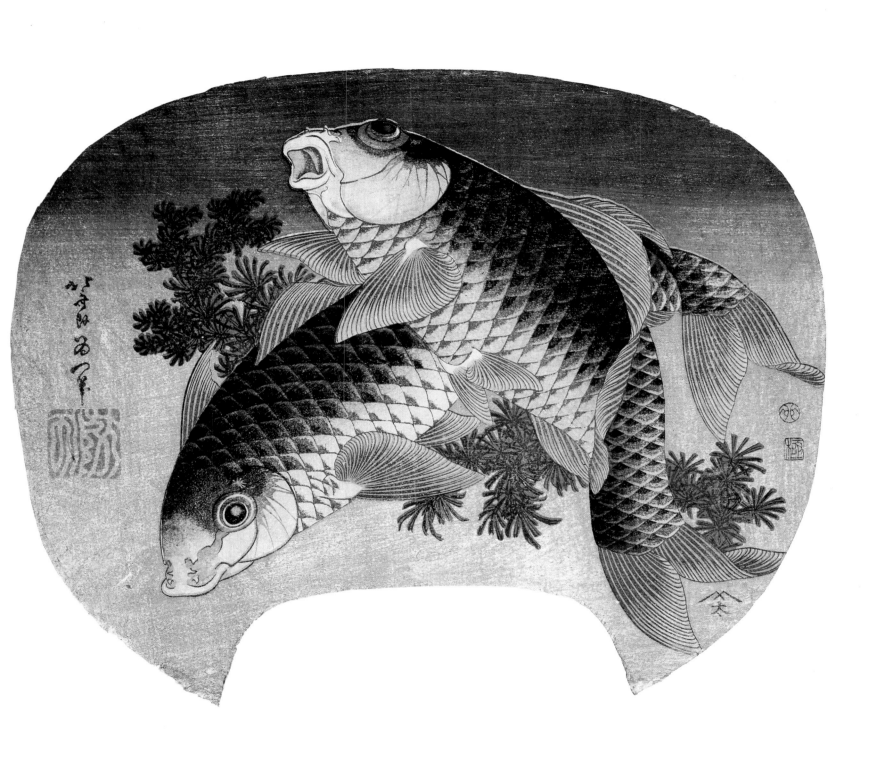

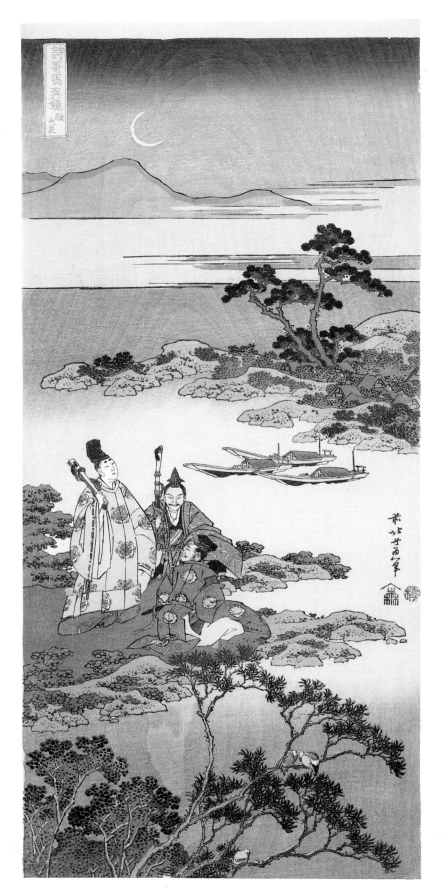

From the series *A True Mirror of Chinese and Japanese Poems* (*Shiika shashinkyō*) published by Moriya Jihei, *c.* 1833

censorship seal: *kiwame*
signed: *zen Hokusai Iitsu hitsu*

68 THREE NOBLEMEN BY A LAKE

The Minister Tōru (Tōru daijin)

woodblock, *nagaban*, 506 x 227 mm (margins at top and left)
The Art Institute of Chicago, The Clarence Buckingham Collection (1925.3332)

Minamoto no Tōru (822–95) is enjoying the company of two other men in his extensive landscape garden. Some boats can be seen near the far shore, and a sickle moon shines above.

Tōru daijin, a high-ranking minister, was the son of the Emperor Saga. The grounds he landscaped next to his palace at Rokujō Kawara near Kyōto included a large lake. Made in imitation of Shiogama Bay in Michinoku province, this lake was filled with water transported all the way from the coast. One poem by Tōru mentions 'boats floating on the water in bright moonlight, shaded by the pines'; quite possibly, this was the poem Hokusai had in mind when he made his design.

REFERENCE: Binyon & Sexton, 1960, pp. 142-3

69 ABE NO NAKAMARO GAZING AT THE MOON FROM A TERRACE

Abe no Nakamaro

woodblock, *nagaban*, 520 x 229 mm (margins on all sides)
Honolulu Academy of Arts, The James A. Michener Collection
(15.494)

The Japanese nobleman Abe no Nakamaro (698–770) is seated on the terrace of a Chinese palace. While he continues to gaze at the moon, several attendants arrive with some food. This occasion is undoubtedly connected with Nakamaro's best-known poem, in which he expresses a longing to see his home in Japan once more:

> *Ama no hara furisake mireba*
> *Kasuga naru*
> *Mikasa no yama ideshi tsuki kamo*

> When I look over Heaven's plain I wonder:
> Is that the same moon that rose
> Over Mount Mikasa in Kasuga?

When only sixteen years of age Nakamaro had accompanied a Japanese envoy to China, who had been sent to obtain the secrets of the system invented in China for calculating time. The visitors were received in a friendly manner by the Chinese emperor, but Nakamaro was subsequently refused permission to return home. Although nominally held as a captive in China for the rest of his life, he became an able administrator, and eventually a regional governor. He is said to have composed the above poem at some melancholy moment during this career.

Impressions differ mainly in the degree of *bokashi* printing: sometimes the sky and most of the water are almost uniform in colour.

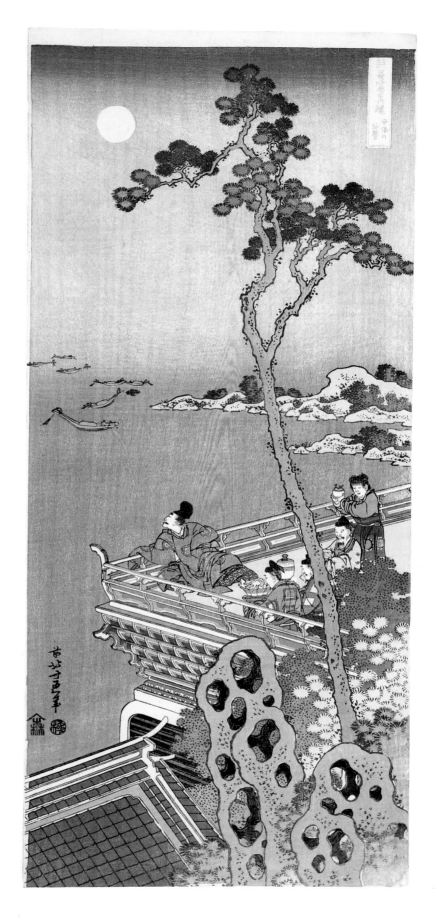

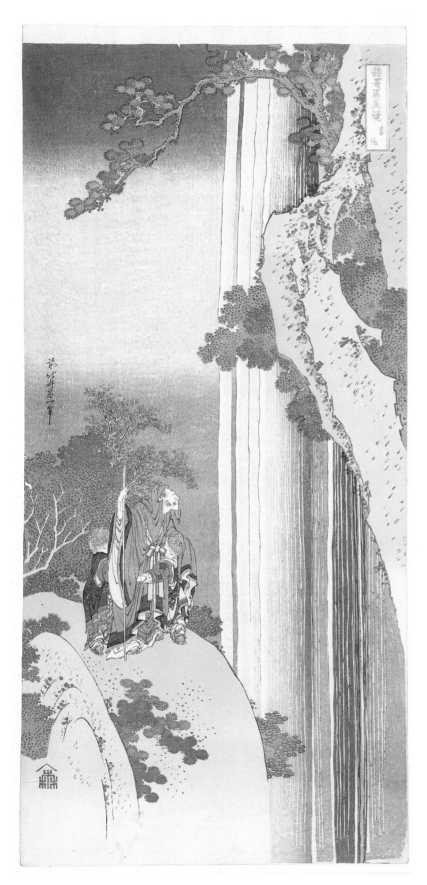

70 LI PO ADMIRING THE WATERFALL OF LO-SHAN

Li Po (Ri Haku)

woodblock, *nagaban*, 519 x 231 mm (margins at top, right and bottom)
Honolulu Academy of Arts, The James A. Michener Collection (L21.162)

Protectively supported by two youthful followers, the famous Chinese poet Li Po (701–62) leans on his staff and admires the waterfall of Lo-Shan in the Chinese province of Kiang-Si.

Li Po is particularly renowned for having composed his best work under the influence of wine. When quite young he had once been invited to the court of the Emperor Ming Huang, but having displeased the Emperor's favourite concubine, Yang Kuei-fei, he left to take up the life of a wanderer.

Hokusai's design seems to be inspired by Li Po's poem on the waterfall of Lo-Shan:

> As wind-driven snow speed the waters,
> Like a white rainbow spanning the dark.
> I wonder if Heaven's River has fallen from above
> To course through the mid-sky of clouds.
> Long I lift my gaze. Oh, prodigious force!
> How majestic the creation of Gods!

Impressions of this print vary in the degree of *bokashi* applied at the top. In addition, in some impressions the partial overprinting of the protruding rock at the right, and of the top of the rock on which the poet stands, is more clearly visible, although this may, in fact, be explained by the colours having faded.

REFERENCE: Binyon & Sexton, 1960, p. 143

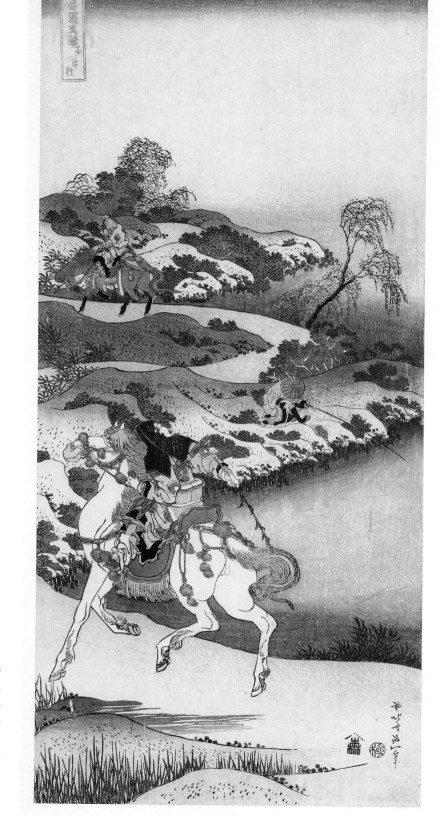

71 A YOUNG MAN ON A WHITE HORSE

Youth Setting out from Home (Shōnenkō)

woodblock, *nagaban*, 500 x 226 mm
The British Museum, London (1906.12.20.571)

A Chinese youth, who carries a branch of willow for his whip, is riding a white horse along a winding lake-side road. A fisherman is dozing on the bank, while farther up the road a second horseman seems to be waiting for the young man to catch him up.

 Although the subject of the young man setting out from home was a popular theme in Chinese poetry, no one poem in particular has been firmly linked with this design.

REFERENCE: Binyon & Sexton, 1960, p. 144

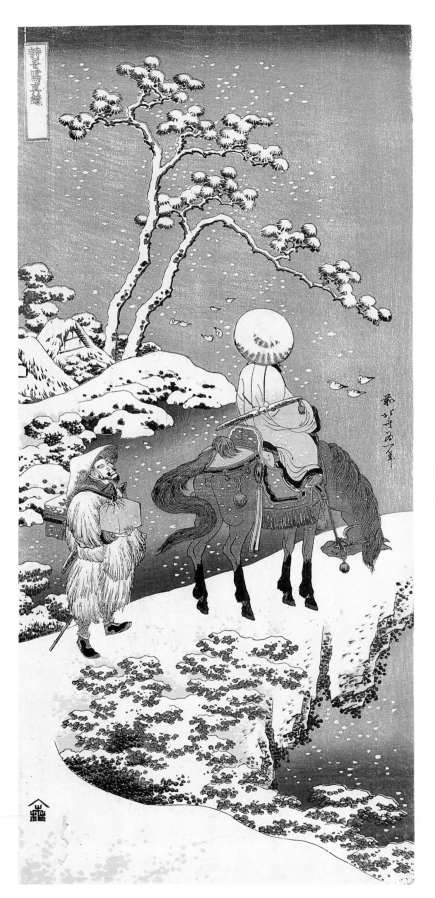

woodblock, *nagaban*, 507 x 227 mm (margins at right and left)
Musée National des Arts Asiatiques-Guimet, Paris (Eo 1704)

A Chinese horseman is gazing at a snowy scene that comprises several thatched houses, a pine tree and some paddling waterbirds. Behind him, a servant in a straw raincoat carries some luggage over one shoulder.

The title is not indicated in the cartouche, which has led to disagreement about the horseman's identity, and thus the subject illustrated. Some believe him to be the Chinese poet Su Tung-p'o (1037–1101) pictured during his exile, although the similarity of this print to an illustration by Hokusai in a collection of Chinese T'ang dynasty poems published in 1833 makes the Chinese poet Tu Fu (712–70) a more likely candidate. In an autobiographical poem by Tu Fu included in that anthology, he expresses his appreciation for the friendship of someone left behind when, quitting his homeland at a time of war, Tu Fu rode out into a desolate winter landscape.

There appear to be two, variant, impressions of this print, the differences mainly relating to the areas printed in *bokashi*. In what are likely to be the earlier impressions, the water in the right foreground is entirely printed in a deep blue *bokashi*, applied to the near edge of the water beyond the path on which the travellers pause and only reaching up to the horse's forelegs. The variant impression has *bokashi* printing in the foreground and at both the near and far shore of the water beyond the path, reaching up to the horse's neck.

73 A PEASANT CROSSING A BRIDGE

Gathering Rushes (Tokusa kari)

woodblock, *nagaban*, 519 x 235 mm (margins on all sides)
Honolulu Academy of Arts, The James A. Michener Collection
(15.498)

The moon has already risen as an old peasant, returning
home at dusk, crosses a bridge over a wild stream. From a
pole on his shoulder hang two bundles of rushes—the
'horse-tails' he has been out gathering.

 The subject of this design has been identified with the
Tokusa kari—a Nō play that was also adapted for the kabuki
theatre—in which an old farmer recognises his lost child
through song. But various poems on the theme of gathering
rushes have also been put forward, most recently (by Jūzō
Suzuki and Kondō Eiko) one from the *Fuboku wakashō* of
c. 1309, an anthology compiled by Fujiwara no Nagakiyo
that contains the following lines:

 Tokusa karu Sonoharayama no
 ki no ma yori
 migakare dazuru aki no yo no tsuki

 When I was cutting horse-tails
 The autumn moon appeared,
 Shining through the trees on Mount Sonahara.

 In a later impression, the *bokashi* printing was left out
entirely.

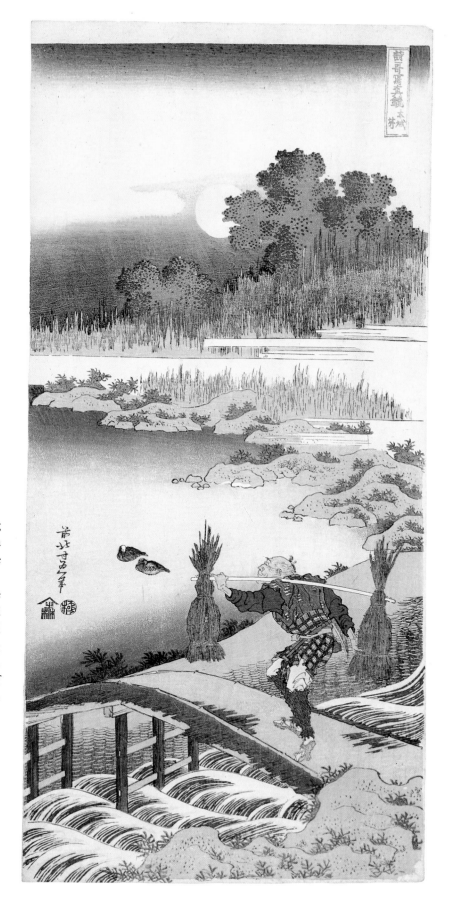

ONE HUNDRED POEMS

CAT. 74–83

From the series *One Hundred Poems Explained by the Nurse* (*Hyakunin isshu uba ga etoki*) published by Nishimuraya Yohachi and Iseya Sanjirō, *c.* 1835–6

signed: *zen Hokusai Manji*

censorship seal: *kiwame*

74 TRAVELLERS CLIMBING A MOUNTAIN PATH

Yamabe no Akahito

woodblock, *ōban*, 262 x 379 mm (margins at right and bottom)
Honolulu Academy of Arts, The James A. Michener Collection
(L 21.198)

A line of travellers is climbing a winding mountain path overlooking the sea. Mount Fuji, capped with snow, can be seen in the distance. The setting is Tago's Coast on the Izu peninsula, east of Suruga Bay.

The poem by the early eighth-century writer Yamabe no Akahito that is illustrated here reads:

> *Tago no ura ni uchi idete mireba*
> *shirotae no*
> *Fuji no takane ni yuki wa furitsutsu*
>
> When to Tago's Coast
> I the way have gone, and see
> Perfect whiteness laid
> On Mount Fuji's lofty peak
> By the drift of falling snow.

REFERENCE: Morse, 1989, 4

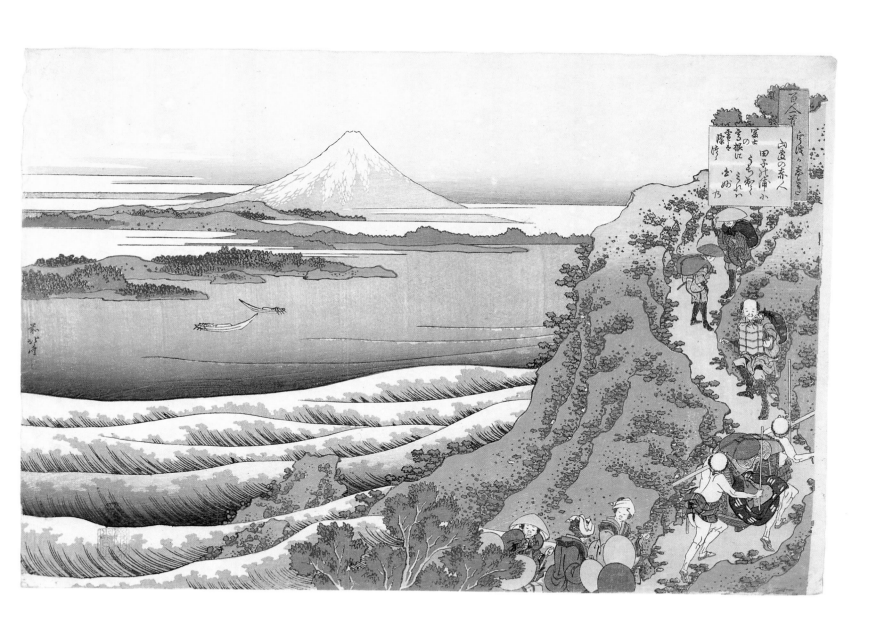

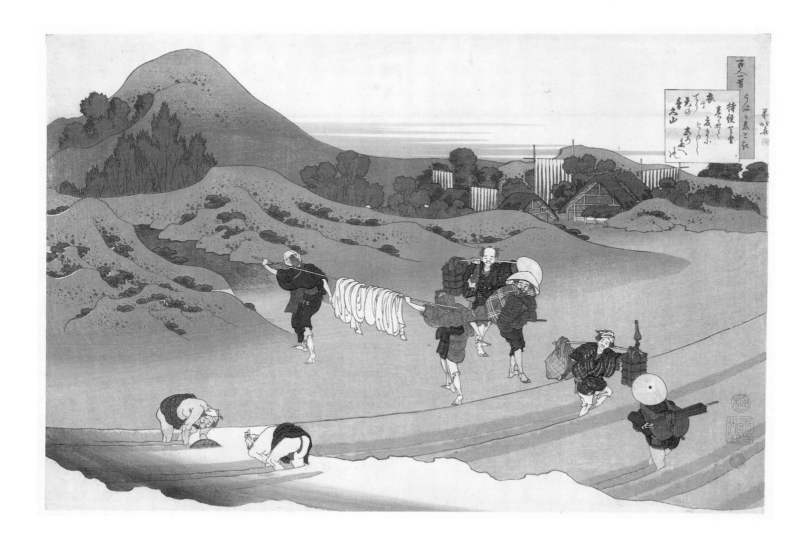

75 WASHING IN A RIVER

The Empress Jitō (*Jitō tennō*)

woodblock, *ōban*, 257 x 374 mm
The Metropolitan Museum of Art, New York,
Rogers Fund, 1914 (3)

Travellers are fording a shallow river in which two local women have been washing linen. To the left, two men are fishing. Below a high mountain is a village crowded with frames from which lengths of flax are hanging. The poem by the Empress Jitō (645–702) that is illustrated here reads:

> *Haru sugite natsu kinikerashi*
> *shirotae no*
> *koromo hosu chō ama no kagu yama*

> Spring, it seems, has passed,
> And the summer come again;
> For the silk-white robes,

So 'tis said, are spread to dry
On the 'Mount of Heaven's Perfume'.

The mountain corresponds to the one mentioned in the poem. However, *ama no kagu*, 'Heaven's Perfume', can also be taken to mean 'the stench of flax'—the unpleasant odour that is given off when flax is being prepared to be made into linen. Hokusai also seems to have taken the 'sugi' of *sugite* to refer to cryptomeria trees, shown below the mountain.

In early impressions the mountain was rendered in a brown *bokashi* that is lightest at the summit. The shore of the river and the gap in the dunes ahead of the women are sometimes in one uniform colour, and occasionally the gap and the entrance to the village are in a grey to black *bokashi*. In later impressions the area between the hills and the village has a grey *bokashi*, the mountain is green at the bottom and brown at the summit, while a grey *bokashi* has been applied to the area between the hills and the village.

REFERENCE: Morse, 1989, 2

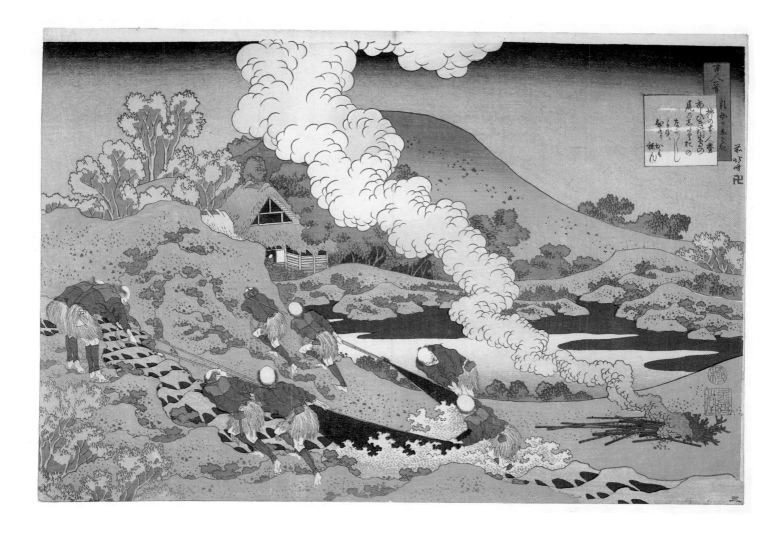

76 FISHERMEN HAULING A NET

Kakinomoto no Hitomaro

woodblock, ōban, 261 x 375 mm
The British Museum, London (1919.7.15.02)

Fishermen are hauling a net upstream at night; the smoke rising from their fire partially obscures the hill in the distance. The poem by Kakinomoto no Hitomaro (*c.* 660–739) illustrated here reads:

> *Ashibiki no yamadori no o no*
> *shidari o no*
> *naga nagashi yo wo hitori ka mo nen*

> Ah! the foot-drawn trail
> Of the mountain pheasant's tail
> Drooped like down-curved branch!
> Through this long, long-dragging night
> Must I keep my couch alone?

There are several puns or allusions discernible in this design. The *hiki*, or 'dragging', of *ashibiki*, for example, is probably what inspired Hokusai to invent a scene in which fishermen are shown dragging a net. Both the bow-shaped net and the column of rising smoke suggest the curving shape of the pheasant's tail mentioned in the poem. The man leaning from the window of the house represents the sleepless poet forced to spend the night alone.

In early impressions of this print the thatched roof of the house is printed in a light shade, whereas in later impressions it is as dark a brown as that of the fishermen's coats. These impressions also show a break in the line that traces the balding head of the fisherman facing us.

REFERENCE: Morse, 1989, 3

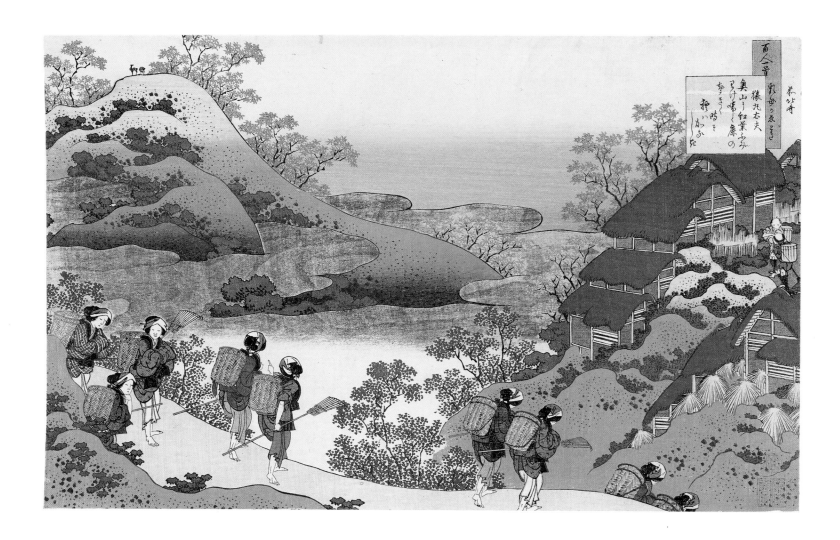

77 WOMEN RETURNING HOME AT SUNSET

Sarumaru Dayū

woodblock, *ōban*, 254 x 381 mm
Peter Morse Collection

Women are returning to their village in the hills after a day spent gathering herbs, or possibly mushrooms. Two of the women pause and turn on hearing the cry of a stag from a distant hilltop. The sun is setting and mist rises from the valley; the autumnal colours of the leaves indicate the time of year.

The poem by the early eighth-century writer Sarumaru Dayū that is illustrated here reads:

> *Oku yama ni momiji fumiwake*
> *naku shika no*
> *koe kiku toki zo aki wa kanashiki*

In the mountain depths,
Treading through the crimson leaves,
Cries the wandering stag.
When I hear the lonely cry,
Sad, — how sad — the autumn is!

This design contains more than just the descriptive details of the poem, for Hokusai balances the poem's valedictory mood against a scene of imminent arrival: two men are shown waiting in the village for their women to return home.

In early impressions of this print the banks of mist often appear much darker, the result of heavy oxidation, although this must have been done deliberately, as the lighter patch that serves to highlight the women glancing back clearly indicates. Later impressions show these two women wearing skirts of the same colour, while some of the clothing of the woman at the rear is left uncoloured.

REFERENCE: Morse, 1989, 5

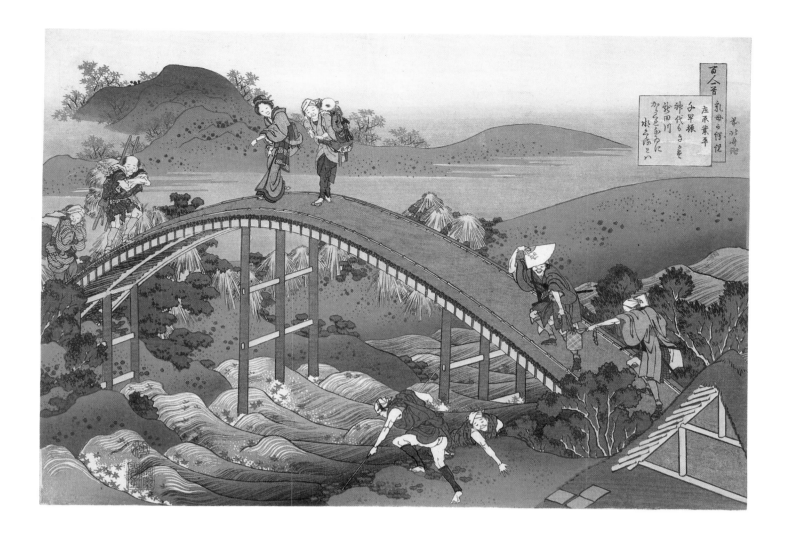

78 PEOPLE CROSSING AN ARCHED BRIDGE

Ariwara no Narihira

woodblock, *ōban*, 262 x 376mm (margins at bottom and left)
The Art Institute of Chicago, The Clarence Buckingham
Collection (1928.1094)

Two couples, one a pair of peasants returning from the
fields, the other two drunken samurai, have stepped on to a
steeply arched bridge spanning the Tatsuta River near the
city of Nara. The Tatsuta was renowned for its delicate
freight of fallen maple leaves, and the woman at the summit
of the bridge appears to be pointing to the leaves that float
downstream. Beyond a bank of mist, maple trees can in fact
be seen among the distant hills. The poem by Ariwara no
Narihira (823–80) that is illustrated here reads:

Chihayaburu kami yo mo kikazu
Tatsutagawa
kara kurenai ni mizu kukuru to wa

I have never heard
That, e'en when the gods held sway
In the ancient days,
E'er was water bound with red
Such as here in Tatta's stream.

In early impressions of this print the mist is printed in a
pinkish shade, while the summit of the hill to the left and the
far bank are in a brown *bokashi*. In later impressions the mist
is yellowish and the summit of the same hill — but not the far
bank — is brown. The orange used for the maple leaves has
tended to oxidise. In Hokusai's original design for this print
(cat. 108) the hills have a quite different form.

REFERENCE: Morse, 1989, 17

Abe no Nakamaro

woodblock, *ōban*, 260 x 378 mm (margins on all sides)
Honolulu Academy of Arts, The James A. Michener Collection
(20.083)

The Japanese nobleman and poet Abe no Nakamaro stands
on a hill overlooking the sea, in which the moon is reflected.
Two Chinese attendants kneel before him, while more have
assembled below. The story of this poet — and his best-
known poem — are also the subject of a design in the series *A
True Mirror of Chinese and Japanese Poems* (see cat. 69). The
scene depicted here that accompanies Nakamaro's poem
appears to illustrate another version of the story of his captiv-
ity, in which, having been granted permission by the
Chinese emperor to return to Japan, Nakamaro gives a
farewell party. Clay MacCauley's translation of the poem
reads:

> When I look abroad
> O'er the wide-stretched 'Plain of Heaven',
> Is the moon the same
> That on Mount Mikasa rose,
> In the land of Kasuga?

Since the preparatory design for this print (fig. 12) shows
the moon in the sky above, its inclusion here only in the form
of its reflection in the water was clearly an afterthought on
Hokusai's part.

A small deficiency in the block used to print the pine tree
to the right of the hill affects all impressions, though in some
cases it has been retouched.

REFERENCE: Morse, 1989, 7

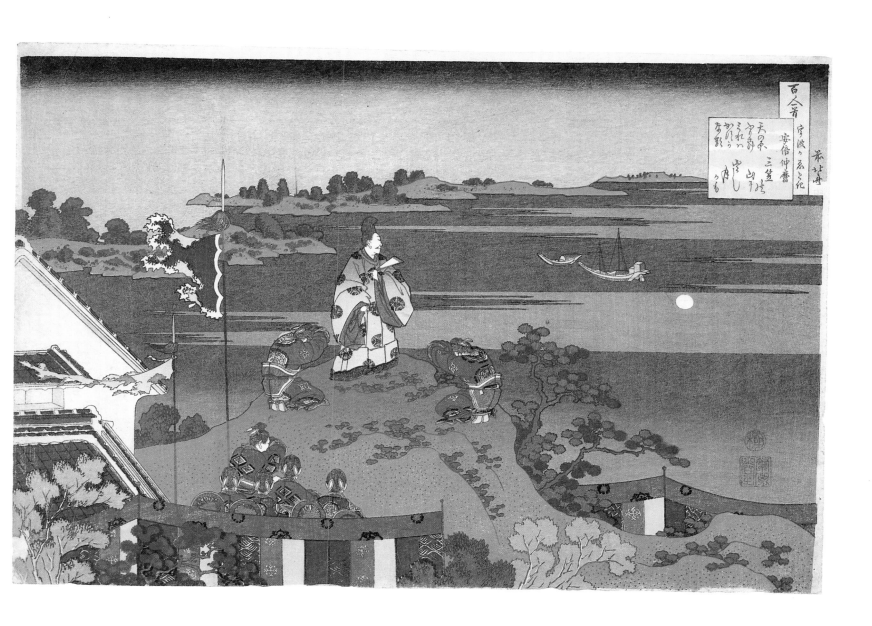

Minamoto no Muneyuki ason

woodblock, *ōban*, 259 x 374 mm (margins at top, right and left)
Mann Collection, Highland Park, Illinois (ex-Wakai Kenzaburō
and Le Véel collections)

A group of hunters are warming themselves by a fire outside
a hut in the mountains. It is winter and snow covers the
thatched roof of the ramshackle hut.

The poem by Minamoto no Muneyuki (*d.* 939) that is
illustrated here reads:

> *Yamazato wa fuyu zo sabishisa*
> *masari keru*
> *hito-me mo kusa mo karenu to omoeba*

> Winter loneliness
> In a mountain hamlet grows
> Only deeper, when
> Guests are gone, and leaves and grass
> Withered are; — so runs my thought.

REFERENCE: Morse, 1989, 28

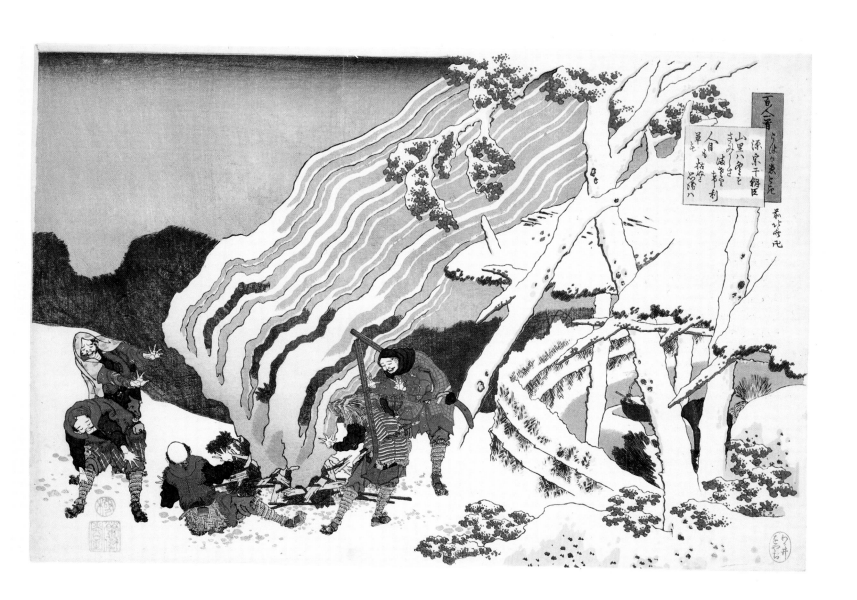

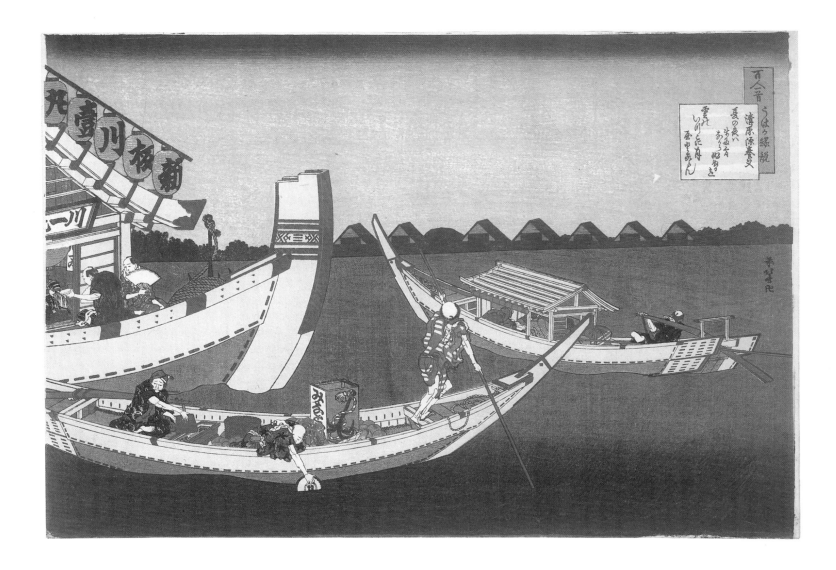

81 PLEASURE BOATS ON SUMIDA RIVER

Kiyowara no Fukayabu

woodblock, *ōban*, 260 x 373 mm (margins on all sides)
The British Museum, London (1919.7.15.05)

It is evening in Edo, and pleasure boats are out on the Sumida River near the Ryōgoku bridge. In the largest boat a gathering is being entertained, while alongside, in a boat belonging to the Minatoya restaurant — which, presumably, is providing the catering — a cook attends to his fire and an assistant rinses out a bowl in the river. In the other pleasure boat a smaller group of people can be seen enjoying a meal.

The boat-houses lining the far bank served to shelter the shōgun's warships. Both the reduced size of the three boat-houses to the right and the downward tilt given to the horizon are perspective effects that Hokusai has employed here as a way of emphasising the Sumida's breadth.

The poem by the early tenth-century writer Kiyowara no Fukayabu that is illustrated here reads:

Natsu no yo wa mada yoi nagara
akenuru wo
kumo wo izuko ni tsuki yadoruran

In the summer night,
While the evening still seems here,
Lo! the dawn has come.
In what region of the clouds
Has the wandering moon found place?

In early impressions of this print the sides of the boats are printed in a greyish shade at the bottom, as is the coil of rope on the larger boat. For later impressions, the same block was employed to print brown.

REFERENCE: Morse, 1989, 36

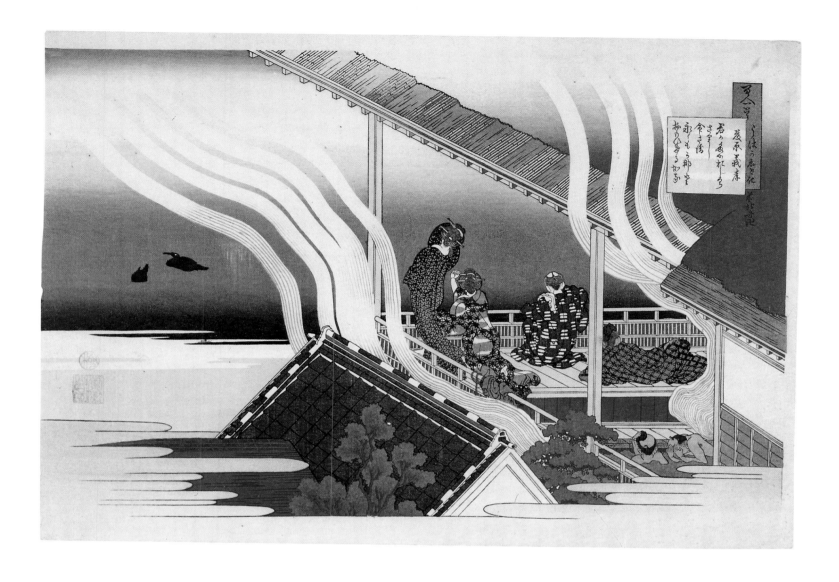

82 A BATH-HOUSE BY A LAKE

Fujiwara no Yoshitaka

woodblock, *ōban*, 262 x 375 mm (margins on all sides)
Honolulu Academy of Arts, The James A. Michener Collection
(L21.217)

After taking their baths, several people are out on the balcony enjoying a cool breeze and the view over the water. In the pool below them two men are bathing.

The poem by Fujiwara no Yoshitaka (945–74) that is illustrated here reads:

Kimi ga tame oshikarazarishi
inochi sae
nagaku mo gana to omoikeru kana

For thy precious sake,
Once my eager life itself
Was not dear to me.
But 'tis now my heart's desire
It may long, long years endure.

It remains obscure which words, or possibly puns, in this poem led Hokusai to depict a bath-house.

REFERENCE: Morse, 1989, 50

Fujiwara no Michinobu ason

woodblock, *ōban*, 264 x 379 mm (margins at right, bottom and left)
The Art Institute of Chicago, The Clarence Buckingham
Collection (1938.540)

Teams of palanquin bearers are running down Emonzaka, the route from Nihon dike to the licensed quarters of the Yoshiwara, one of Edo's pleasure districts. On the road through the marshes ahead of them are other palanquins carrying visitors to the same district.

Emonzaka, literally 'Hill of Clothes', owes its name to the numerous garments that used to be found there, apparently lost or abandoned by people hurrying home late at night. The lantern swinging from the palanquin in the foreground is inscribed 'Isesan', probably a reference to the publisher, Iseya Sanjirō.

The poem by Fujiwara no Michinobu (972–94) that is illustrated here reads:

Akenureba kururu mono to wa
shirinagara
nao urameshiki asaborake kana

Though I know full well
That the night will come again
E'en when day has dawned;
Yet, in truth, I hate the sight
Of the morning's coming light.

Although the poet clearly refers to dawn, Hokusai chose to depict evening, and a scene of revellers heading for a night out. That the occupants of the palanquins have sought to conceal their identities by drawing the blinds, may be explained as Hokusai's witty response to the lines *kururu mono to wa / shirinagara*, which can also be understood to mean 'I know those people that come'. His choice of the Yoshiwara as their destiny may have been inspired by the word *nureba*, which can be interpreted to mean 'love scene'.

In early impressions of this print the distant marsh is generally printed in a dark tone, as here, whereas in later examples the printing is much lighter. In those early impressions the grey steps and the rooftiles have tended to oxidise. All later impressions feature a clear break in the line-block, which appears at the top of the left-hand side of the title cartouche.

REFERENCE: Morse, 1989, 52

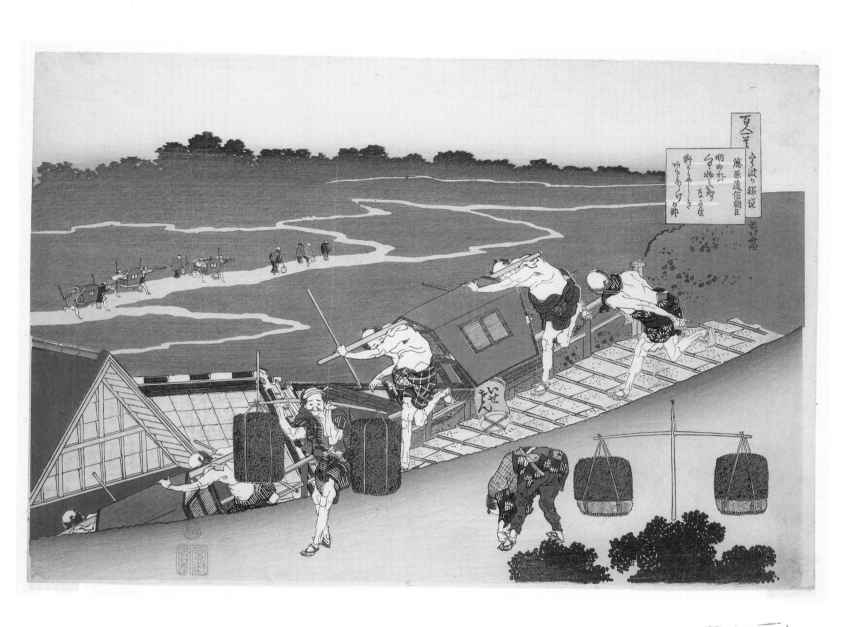

Surveying a Region (Chihō sokuryō no zu)

no publisher indicated, 1848

signed: ōju rei hachijūkyūsai Manji rōjin hitsu ('On request by the
89-year-old Manji')
woodblock, double ōban, 393 x 530 mm (margins on all sides)
Honolulu Academy of Arts, The James A. Michener Collection
(19.479)

A team of men are surveying an area near the coast that
includes several villages overlooked by a hilltop castle. A tree
stands conspicuously in the centre of the print.

The rectangular cartouches in this design contain techni-
cal specifications, while the little circular ones are inscribed
with some of the animals of the zodiac, giving the cyclical
dates for the years 1848 and 1849. The first date corresponds
with the one given at the top, to the left of the inscription
Kaei gannen sangatsu ('Kaei first year, 1848, third month').

Most impressions of this double ōban print, which was
originally sold folded in a paper envelope bearing the title
Ryōchi no zu ('Print of surveying land'), lack the glittering
'mica beams of vision' that this example bears. (It should be
noted that it is almost impossible to reproduce this unusual
feature in photographs.) The 'mica' is, in fact, crushed
mother-of-pearl that has been mixed with a glue made from
rice starch and then applied with a brush to the print's sur-
face. The purpose of these long and narrow cone-shaped
beams was to indicate the trajectory of sight that is enjoyed
by the surveyors shown peering through their instruments.

85 AN OIRAN AND MAIDS BY A FENCE

privately issued by the Biwa poetry club (?), *c.* 1796–7

signed: *Hokusai Sōri ga*
woodblock, double long *surimono*, 416 x 554 mm
Musée National des Arts Asiatiques-Guimet, Paris (Eo 1718)
(ex-Hayashi Tadamasa Collection)

Next to a latticework fence an *oiran* (a courtesan of the highest rank) wearing a gorgeous and elegant kimono is standing with her two maidservants beneath some flowering cherry trees. Although several of the poems inscribed above refer to the Yoshiwara, the district in Edo that contained the city's licensed pleasure quarters, it seems more likely that these three women are on a day's outing to view the cherry trees in bloom.

Both the subject-matter and the composition are unusual in Hokusai's *œuvre*. Courtesans from the Yoshiwara are encountered more often in his paintings than they are in his prints — indeed, during the 1790s Kitagawa Utamaro, Hosoda Eishi and the latter's followers more or less monopolised the market for prints of courtesans. As for the composition, very few of Hokusai's long *surimono* designs involve the overleaf, as is the case here and in *Asters and Susuki Grass* (cat. 93), for this was normally reserved for poetry or for details of a theatrical programme. The expansiveness of the design and its strong colouring does, at least, help compensate for the somewhat dumpy appearance of the figures.

privately issued, *c.* 1796

signed: *Sōri ga*, with seal: *Kanchi*. The cuckoo design by Santō
Kyōden is signed *Kyōden sha* (seal unread)
woodblock, double long *surimono*, 391 x 558 mm
The Chester Beatty Library and Gallery of Oriental Art, Dublin
(Ac. 2236)

A party of courtesans with their maidservants and two
kamuro (girls in training) are gazing out from behind a
screened balcony on the first floor of a brothel in the Yoshi-
wara, one of Edo's pleasure districts. They are watching a
cuckoo flying through the rain (both bird and rain are por-
tents of autumn). The cuckoo they observe is, in fact, the one
that appears upside down at the bottom right of the print.
This apparent oddity is explained by the fact that large sheets
such as this one were seen by recipients only after they had
been folded — first horizontally, and then into three. (The
folds that divide this sheet into six are clearly discernible.)
Having been folded in this way, these *surimono* were then dis-
tributed among friends, rather than sold in shops.

The covering panel of this *surimono* — the panel the reci-
pient would see first — consists of the still-life that appears
top right: the umbrella, cloth, flower-pot and lacquered
table. By turning this panel in the way one would turn the
page of a book, two new panels presented themselves: on the

right, the top left-hand panel of courtesans, and on the left,
the cuckoo (flying the right way up), at which the *kamuro*
would, of course, be pointing. Upon lifting the panel of
courtesans, the three panels of poetry would be revealed, and
if one then turned the sheet over, the full width of the bal-
cony scene came into view. Only after one further, and final,
unfolding, revealing the entire sheet (as seen here), would
the cuckoo in the rain make a fresh appearance — upside
down, and with the courtesans shown looking in the oppo-
site direction.

Long *surimono* were often carefully designed in order to
gradually build up a complete scene in this way. However,
examples such as this one, in which even the overleaf is integ-
rated into the design, are very rare: no other complete im-
pression is known. As three of its poems are by courtesans of
the Daimojiya, it may be that the scene depicted is actually
set on the balcony of that famous brothel.

The design of the cuckoo is signed by Santō Kyōden
(1761–1816). This writer, poet and owner of a tobacco acces-
sories shop at Kyōbashi was also a skilled painter and
designer of prints, which he often signed with his artist's
name Kitao Masanobu. He regularly collaborated with
Hokusai, especially during the late 1790s and early 1800s,
mostly contributing poems to the latter's paintings. They
also worked together on plates for *kyōka* anthologies.

REFERENCE: Keyes, 1985, 170

87 GIRLS PICKING PLUM BLOSSOMS

privately issued, *c.* 1796

unsigned
woodblock, *surimono* or album plate, 190 x 361 mm
The Chester Beatty Library and Gallery of Oriental Art, Dublin
(Ac. 813b)

Three girls, one holding a lantern, have gathered in a garden at night to pick some branches of flowering plum. The whole scene is delicately printed in rather soft hues, so that even the dark sky is suggested only by a blueish-grey shade.

The date of this *surimono* — or, since there is no poetry, what is more likely to be a detached plate from a lost poetry album — is not indicated. Yet, the soft pigments and the women's hairstyles, round faces and small figures suggest 1796 at the latest. The compressed composition, and its concentration on the right half of the sheet, support this dating.

At the top is a conventional representation of sky, or possibly mist, of the kind one finds in works by Suzuki Harunobu (1724–70) of thirty years earlier. Yet within five years of making relatively traditional prints such as this, Hokusai was to begin experimenting with Western-style clouds and skies.

REFERENCE: Keyes, 1985, 185

88 THREE LADIES BY A WELL

privately issued, c. 1795–6

signed: *Kanchi Sōri ga*, with seal: *Hyakurin*
woodblock, *surimono*, 190 x 357 mm
The Chester Beatty Library and Gallery of Oriental Art, Dublin
(Ac. 813a)

Two ladies are drawing water from a well, while a third, who carries a lacquered bucket entwined with straw and hung with paper charms, stands to the right. Behind them are the angle of a house and some young pine trees.

The scene is obviously that of drawing the first water on New Year's morning. The straw wound around the ceremonial bucket is there to keep evil spirits away. Such straw ropes were often used around the time of New Year, as well as in Shinto rituals.

The signature on this print poses some problems. There are examples of Hokusai using a seal that reads 'Kanchi', and there are works in which this signature and the seal on this print are found in combination with the signature 'Sōri' and the seal 'Hyakurin'. Whether all these signatures and seals refer to Hokusai, or some to another artist, remains open to debate. On the basis of style alone, no clear distinction can be made.

89 GATHERING HERBS

privately issued, *c.* 1796–7

signed: *Hokusai Sōri ga*, with seal: *Kanchi*. The two Ōharame and
horse by Santō Kyōden are signed: *Santō Kyōden ga* (seal unread)
woodblock, long *surimono*, 196 x 530 mm
The Art Institute of Chicago, The Gift of Helen C. Gunsaulus
(1954.643) (ex-Wakai Kenzaburō Collection)

Two ladies and a young girl are out in the snow gathering
herbs in their baskets. To the left, a couple of 'Ōharame'
(women from the village of Ōhara) are collecting branches
of kindling wood which they load on to their horse.

The inclusion of snow in this design indicates that the
occasion here is the gathering of the 'Seven Herbs of Spring'.
These were used in a traditional dish eaten at New Year in
order to prevent illness.

Hokusai and Kyōden, or Masanobu, worked even more
closely together on this print than they had on *Courtesans and
a Cuckoo* (cat. 86).

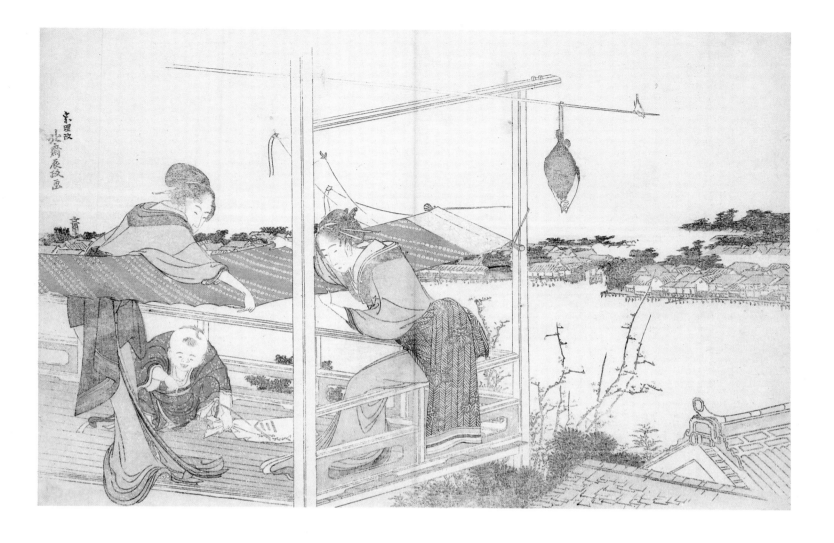

90 STRETCHING CLOTH

privately issued, *c.* 1799

signed: *Sōri aratame Hokusai Tatsumasa ga*
woodblock, *surimono* or album plate, 232 x 352 mm
The Art Institute of Chicago, The Clarence Buckingham
Collection (1925.3292)

Two women on the balcony of a house are applying stretchers at regular intervals to a length of cloth. Crouched at their feet is a boy absorbed in playing with the bag that contains the stretchers. A brace of flounders is hanging above the rooftops from a pole, at the end of which a small bird is perched. A number of houses can be seen across Sumida River; kites are being flown there.

The facial features of these two women are typical of Hokusai's work of the late 1790s. In this design he has brought together a landscape and an example of his interest in handicrafts, a combination that is frequently to be found in much of his later work.

Although the format of this print is different from those customarily used for books and albums, in view of the absence of poetry it is more likely to be a detached plate from an unidentified poetry album rather than a single *surimono*.

91 A MOUNTAINOUS LANDSCAPE WITH A BRIDGE

privately issued, and dated *Hitsuji no hatsuharu* ('New Year of the Goat'), i.e. 1799

signed: *Sōri aratame Hokusai ga*
woodblock, *surimono*, 126 x 171 mm
Matthi Forrer Collection

A coastal view in which an arched bridge in the middle foreground connects the village at the left with a spit of land extending to the right. Beyond banks of mist a lofty range of mountains can be seen, whence a flight of geese is descending to the spit of land.

Of the more than two thousand *surimono* that Hokusai designed between the 1790s and *c.* 1810, this print is one of a very small number that can be considered true landscapes, that is to say, landscapes that were not designed simply to provide backdrops for figures. Despite its modest format, this print and others like it prefigure Hokusai's great landscapes of the 1830s.

The soft colours that were used for this print give it an almost pastel-like appearance, one that is enhanced by the omission of outlines for the mountains. That this effect was deliberately sought after can be inferred from the imitation silk pattern that was applied to the paper by means of blindprinting, just as it was on the print of Enoshima (cat. 9). This was done in order to suggest that what one sees is really a painting on silk.

Only two other landscapes dating from 1799 have been identified, both of which appear in the same soft hues as here. In addition to their distinct place in Hokusai's *œuvre*, these landscapes have a special place among Japanese prints in general. Apart from a few Western-influenced copperplate landscapes that had appeared in the 1780s, these prints Hokusai made at the end of the 1790s predate the craze for landscape views that was ushered in by Jippensha Ikku's comic travelogue, *Tōkaidōchū hizakurige* ('A Shanks's Mare'), which appeared in instalments from 1802.

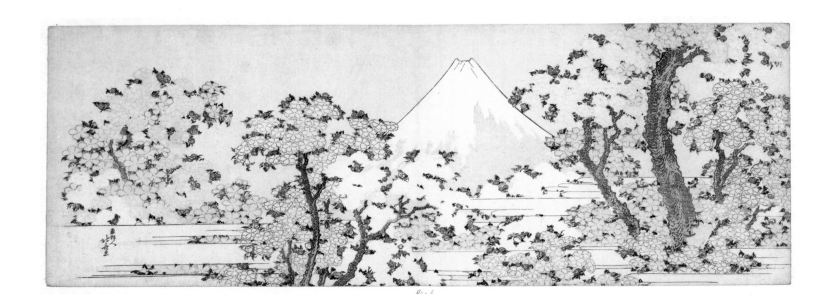

92 MOUNT FUJI WITH CHERRY TREES IN BLOOM

privately issued, *c.* 1800–5

signed: *Gakyōjin Hokusai ga*
woodblock, long *surimono*, 201 x 554 mm
Rijksprentenkabinet, Rijksmuseum, Amsterdam (1980:6) (ex-Louis Gonse Collection)

Although Mount Fuji figures in quite a number of the designs for prints and book-plates that Hokusai made long before his great landscape series of the early 1830s, the *Thirty-six Views of Mount Fuji*, probably no design qualifies so well as a direct precursor of the *Thirty-six Views* as this long *surimono*. Here, Fuji is given a prominent position in the centre of the design, while a mass of cherry trees bloom in the foreground. The season is late spring, for cherries flowered in the third month of the traditional lunar calendar.

Both Fuji and the cherry trees are reduced to essentials: the mountain's slopes and summit are rendered in one continuous line, while the blossoms conceal most of the smaller branches and stems of the trees they adorn.

As is often the case with horizontal long *surimono*, the intended effect can only be properly appreciated when the process of folding — or, rather, unfolding — them is retraced. On opening the first fold of this *surimono*, one would discover the blooming cherries (at right) plus the text that was printed upside-down on the overleaf. Once the second fold had been opened, the cherry trees would be seen to continue across the full width of the sheet, with Fuji in the centre.

Inexplicably, in a later impression of this print (British Museum, London) Mount Fuji was omitted. Though printed on a larger sheet than the one shown here, the block used for that impression was trimmed at the top, thus lopping off the crowns of the cherry trees on the right-hand side. In addition, the signature (which here is to the left) is on the far right; although partly trimmed off, originally it must have read 'Katsushika Hokusai ga', thus implying a date of *c.* 1810.

93 ASTERS AND SUSUKI GRASS

privately issued by the Asakusa poetry club, *c.* 1805

signed: *Gakyōrōjin Hokusai ga* (seal unread)
woodblock, double long *surimono*, 411 x 558 mm
The Chester Beatty Library and Gallery of Oriental Art, Dublin (Ac. 987)

Several spears of blooming susuki grass towering over some yellow asters form a vertical composition on the right-hand side of a large sheet, the remainder of which is filled with *kyōka* poems by members of the Asakusa poetry club. Farthest left are two poems by the group's leader, Asakusaan (or Sensōan) Ichindo (1755–1820).

All the poems in this *surimono* refer to the moon. *Tsukimi*, or 'moon viewing', was especially popular in autumn, which was also the time of year when the wild susuki grass bloomed. The moon over Musashino — the plain of Musashi near Edo — as seen through susuki grass was a popular subject in Japanese art. There is an account in *The Tales of Ise* (*Ise monogatari*) by Ariwara no Narihira (823-80) in which a pair of lovers elope and hide in Musashino, and the associations the area had with this romantic adventure no doubt added to its attractiveness.

Long *surimono* with a design over both folds are exceptional, at least in Edo during this period. In the Kamigata region, however, which included the cities of Ōsaka and Kyōto, they were made more frequently, especially in the 1850s and after.

The signature 'Gakyōrōjin' appears on several *surimono* that can be dated to 1805, hence the estimated year for this undated design.

REFERENCE: Keyes, 1985, 185

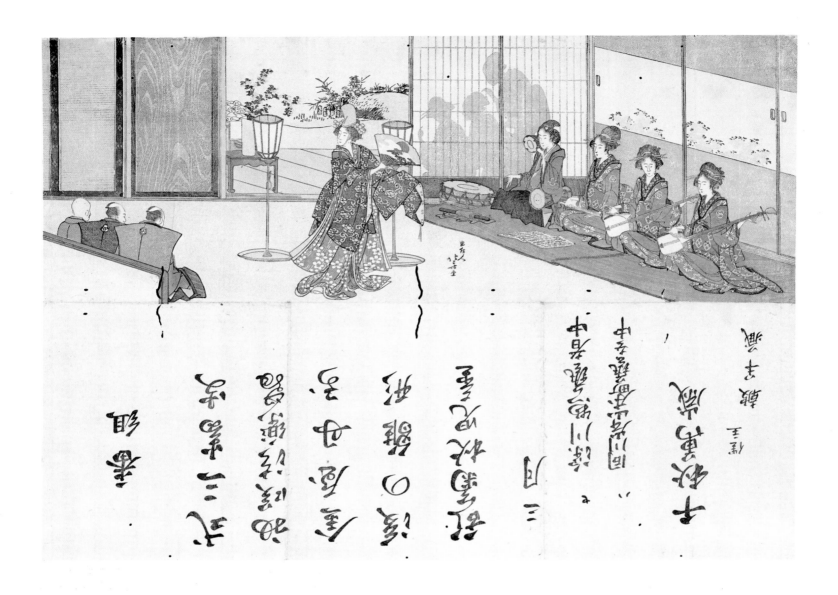

94 A DANCE PERFORMANCE

privately issued, *c.* 1802–4

signed: *Gakyōjin Hokusai ga*
woodblock, double long *surimono*, 382 x 528 mm
Peter Morse Collection

A scene in a mansion with a geisha dancing. The small orchestra accompanying her is seated on mats to the right, while the audience on the left leans back and relaxes. Behind the papered sliding doors the silhouettes of three more women are visible. At the back of the orchestra are some sliding cupboard doors decorated with painted sheets of cherry trees in bloom, a reference to the third month of the traditional Japanese calendar, in which, appropriately, this double long *surimono* was issued.

The orchestra depicted here is similar to that which was employed to accompany kabuki performances: two women each play a three-stringed *shamisen*, a kind of banjo, while a third sings. The male percussionist, in addition to various drums, has a flute, which lies before him on his mat.

The overleaf of this *surimono* carries a programme for a dance and theatrical performance organised by Tsuzumi Hanzō and presented by geishas from the Fukagawa district of Edo.

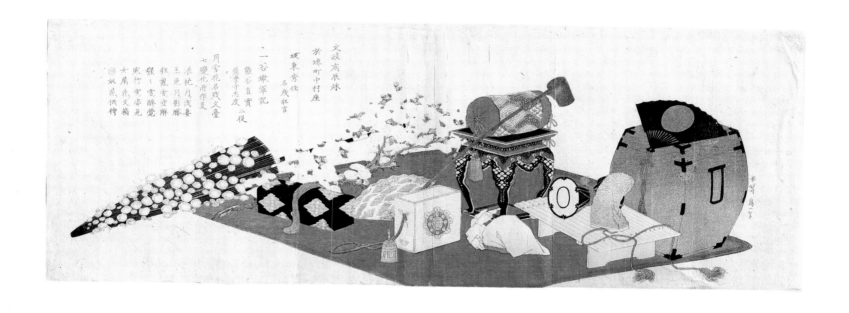

95　STAGE PROPERTIES FOR A FAREWELL PERFORMANCE

privately issued by the Yomogawa poetry club, 1820

signed: *zen Hokusai Iitsu hitsu*
woodblock, long *surimono*, 198 x 552 mm
The Brooklyn Museum Collection, New York (X632.3)

The properties and costume accessories depicted in this *surimono* were used for a farewell performance by the kabuki actor Bandō Mitsugorō III, which he gave at the Nakamura theatre in Edo before leaving on a tour of Ōsaka. The inscription at top left announces the programme: a short play, *Ichinotani futaba gunki* ('The Tale of the Battle of Ichinotani'), is to be followed by the *shichihenge*, a popular sequence of seven dances in which the performer changes into each of his costumes on stage.

The objects shown lying on some red matting comprise the properties needed for each of the seven dances that make up the *shichihenge*: *Tama usagi* (the box and fan), *Asazuma* (the hat and hand-drum), *Kyōran* (the pillow), *Shōjō* (the ladle), *Kangyō* (the collection-box), *Ōgi onna* (the fan) and *Rendō* (the umbrella).

The overleaf of this print bears poetry written by members of the Yomo club of poets, the first of which is by their leader, Yomo Utagaki Magao (1753–1829).

REFERENCE: Bowie, 1979, 108

The White Shell (*Shiragai*)

from the series *A Matching Game with the Genroku Poem Shells* (*Genroku kasen kai awase*), privately issued by the Yomogawa poetry club, 1821

signed: *Getchirōjin Iitsu hitsu*
woodblock, *surimono*, 199 x 176 mm
Peter Morse Collection

This still-life, which consists of rolls of paper, a few painting tablets leant against a box, a pair of fans, an inkstone and some brushes in a vase, suggests the studio of one of the literati, or possibly that of a painter.

The painting visible on the uppermost tablet represents a branch of flowering plum and a crescent moon. One of the fans has some pine trees at the foot of Mount Fuji painted on it, while the other has bamboo leaves. Pine, bamboo and plum — *Shōchikubai* in Japanese — constitute the 'three friends', each of which has a specific symbolic connotation.

The 'white' shell of the title (the shell is a *Circe stutzeri Donovan*) is alluded to in the large number of white objects the design contains. In the poems above, by Kinkokuen Mahiro and Manmansai Managa, the plum is also associated with whiteness — that of snow. The first of these poems includes a reference to *kakizome*, which constitutes the first piece of writing or painting executed at each New Year.

At the time of its appearance, the *Matching Game with the Genroku Poem Shells* series was probably the largest number of *surimono* in this more or less square format that had ever been privately published. A similar series, also on the theme of shells but in a smaller format, had been commissioned from Hokusai's pupil Shinsai for the year 1809. Both 1809 and 1821, the latter the year in which Hokusai's *Shells* was published, are Years of the Snake in the Japanese calendar.

The connection that is being made here between shells and snakes can be appreciated only if the extent to which associative imagery prevailed in Japanese art is taken into account; many *surimono* prints can be understood only in the light of this fact. The snake was believed to be the messenger of the goddess Benten, who was one of the Seven Gods of Good Fortune. Benten was often conceived of as half-human and half-dragon, and since dragons were supposed to live in water as well as in the clouds, shrines to her were often built near water. A visit to one, such as the shrine on the island of Enoshima (see cat. 8), provided the opportunity to collect shells on the nearby shore, and this activity was probably sufficient reason for associating shells with the Year of the Snake.

The selection of shells illustrated by Hokusai is from the *Gokasenkai sanjūrokushū* ('The Latter Group of Thirty-six Poem Shells') published in 1689 — which, not suprisingly, was a Year of the Snake.

REFERENCE: Forrer & Keyes, 1979, pp. 35–57; 14

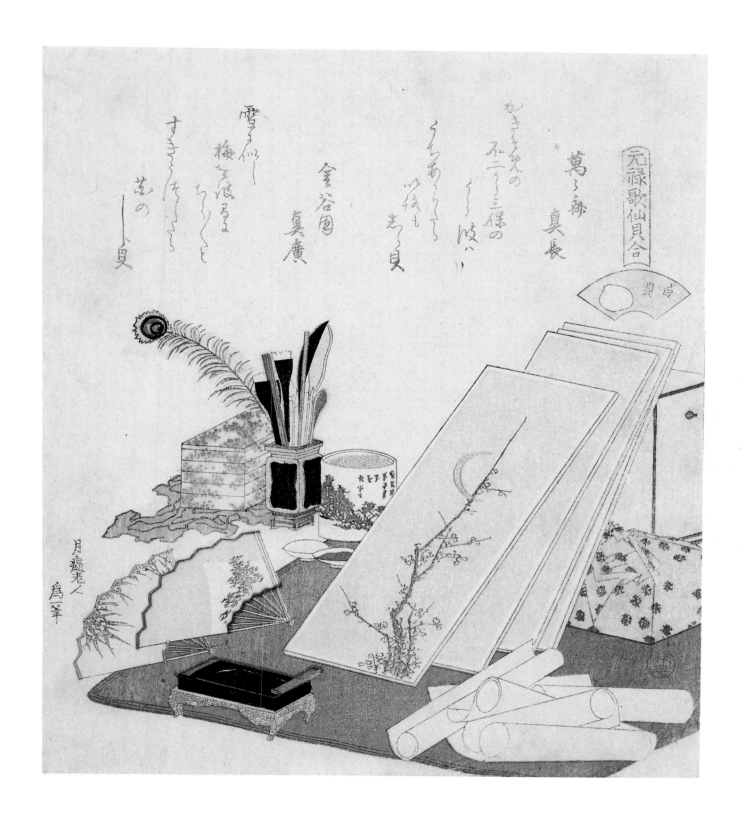

97 A PILLOW AND A PAINTING OF THE TREASURE SHIP

The Pillow Shell (*Makuragai*)

from the series *A Matching Game with the Genroku Poem Shells* (*Genroku kasen kai awase*), privately issued by the Yomogawa poetry club, 1821

signed: *Getchirōjin Iitsu hitsu*
woodblock, *surimono*, 204 x 183 mm
The Arthur M. Sackler Museum, Harvard University, Cambridge, Massachusetts, Gift of the Friends of Arthur B. Duel (1933.4.1767)

According to traditional Japanese belief, placing a picture or model of the Treasure Ship under one's pillow on New Year's Eve ensured that lucky dreams followed during the night. The Treasure Ship was the boat in which the Seven Gods of Good Fortune — who were said to bring wealth and long life — sailed into harbour on New Year's Day.

A lucky dream involved Mount Fuji, a hawk and the egg-plant, or aubergine. Although this design includes all three, their joint presence is implied rather than explicitly presented, as the poets who commissioned these *surimono* designs would, of course, have appreciated. Fuji is suggested in the triangular shape of the lacquered pillow, while the white paper wrapped around the cushion stands for the mountain's snowy cone. The hawk, *taka* in Japanese, is represented by the Treasure Ship depicted on the print, for Takarabune was the name by which this vessel was known. A further reference to the hawk seems to be included in the inscription on the print, which reads 'The good sound of ships — the village to the south' (*Minami no sato fune no oto no yoki kana*), presumably referring to the harbour village of Takanawa, south of Edo. The egg-plants are pickled ones that have been boxed; the label on the box is a reminder that the Fujiya, a shop in Edo's Suruga Street, specialised in selling them. Not only is the shop's own name formed from the word 'Fuji', the label includes its trademark — a hawk and two egg-plants beneath an outline of the mountain. Even the shell in the fan-shaped cartouche above the cushion has been adapted to form a *nasubigai*, or 'egg-plant shell', rather than a *makuragai* (a shell known in the West as *Oliva mustelina Lamarck*).

REFERENCE: Forrer & Keyes, 1979, 18

98 A POTTED DWARF PINE WITH A BASIN AND A TOWEL ON A RACK

Horse Talisman (Mayoke)

from the series *A Set of Horses* (*Umazukushi*), privately issued by the Yomogawa poetry club, 1822

signed: *Fusenkyo Iitsu hitsu*
woodblock, *surimono*, 206 x 183 mm
Rijksprentenkabinet, Rijksmuseum, Amsterdam (58:292)

A still-life that consists of a dwarf pine tree, a *fukujusō* (adonis) and a *yabukōji* ('spear-plant') in a porcelain pot, along with a lacquered basin, a jug and a towel hung on a rack. The pine tree and the two plants were traditionally associated with the New Year. The designs shown on the containers and the towel make up a well-known classical subject, the 'Eight Views of Lake Biwa', which was inspired by a scenic area in Ōmi province (present-day Shiga prefecture) not far from Kyōto. Traditionally, these views were associated with different times of day, seasons and kinds of weather. Here, Mount Hira and the temples of Mii and Ishiyama appear on the pot, Seta bridge is on the basin and the temple at Katada on the jug. The well-known pine tree at Karasaki is suggested by the dwarf pine, while the towel conveys the theme of 'returning sails at Yabase'. The adjacent poem is by Sanseitei Maumi, one of Hokusai's contemporaries.

This design is one of a series of thirty *surimono*, which includes one 'triptych' — that is to say, three related sheets — commissioned for the Year of the Horse, 1822. In one way or another they all relate to horses. The gourd-shaped title cartouche that appears in this impression (there are others, in the Chester Beatty Library, without it) was inspired by the story of Chōkarō, one of the Chinese *sennin*, or immortals, all of whom had temporarily freed themselves from the cycle of transmigration endured by ordinary mortals. Chōkarō was thought to keep a horse in a gourd which he released and rode whenever he needed to travel.

REFERENCE: Keyes, 1985, 200

A View of the Town of Koshigoe from Shichirigahama
(*Shichirigahama yori Koshigoe o enbō*)

privately issued, 1829

signed: *rō Iitsu shai* ('Drawn after nature by the old man Iitsu')
woodblock, *surimono*, 205 x 179 mm
Staatliche Museen Preussischer Kulturbesitz, Museum für
Ostasiatische Kunst, Berlin (6265-19.317)

On the 'Seven League Beach' at Shichirigahama (see also cat. 18), a boy leads an ox on which a woman rides with a pipe in her hand. A second woman walks alongside while cleaning her pipe. In the distance is the rocky island of Enoshima.

Although most *surimono* prints that featured Enoshima were issued for the Year of the Snake, which occurred every twelve years, this print seems to have been issued for 1829, a Year of the Ox. This dating is corroborated by the stocky appearance of the figures (which accords with the ideal of feminine beauty current in the late 1820s), the style of printing and the form the name of the poet takes at left (this was Shūchōdō Monoyana, born in 1761, who in the late 1820s began using a different initial character to write his name).

This design has a number of interesting features that set it apart from much of Hokusai's work, including his *surimono*. The short curves and sharp angles used here for the rocky promontory behind the women imitate Chinese painting, while the overall painterly effect, especially noticeable in the nearby mounds and in the foliage of the trees, which involved delicate overprinting using various pigments, suggests Hokusai was consciously imitating Western painting techniques. The subject-matter is, however, typically Japanese, as is the use of specks of gold, seen here in the foreground. This glistening effect is reminiscent of both decorated poetry paper and lacquerwork.

REFERENCE: Schmidt & Kuwabara, 1990, 46

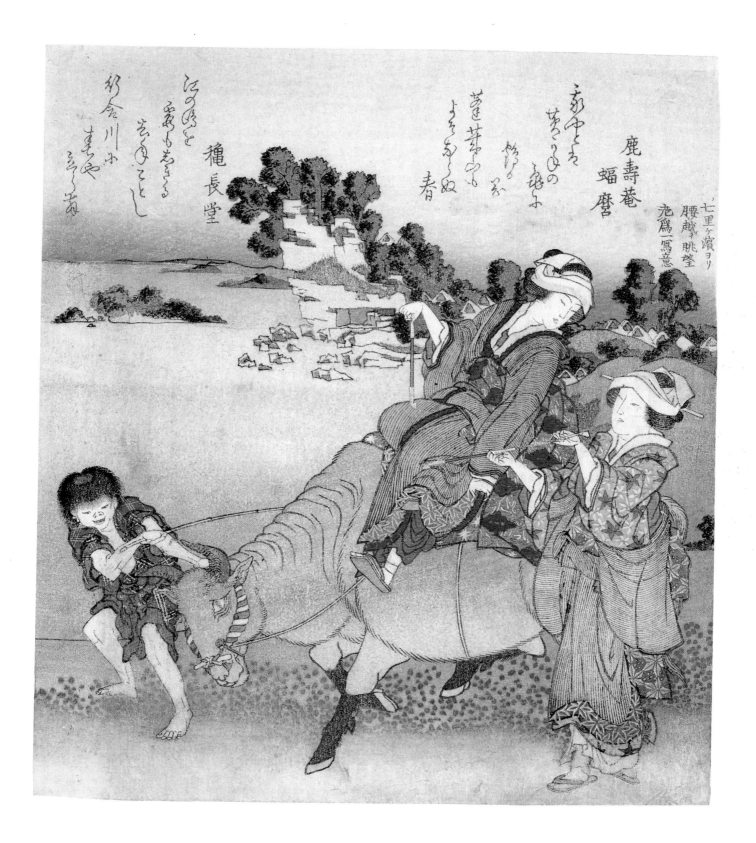

100 A SEATED NOBLEMAN

1820s

unsigned
ink and blue wash on paper, 109 x 109 mm
Janette Ostier Collection (?ex-Kobayashi Shinbei Collection)

The style of drawing here, which is restricted to a few lines, is reminiscent of some of the illustrations in Hokusai's *Ippitsu gafu* ('Album of Drawings with One Stroke of the Brush') of 1824, an album which also contains a similar drawing, representing the poet Kakinomoto no Hitomaro (*c.* 660–739).

The seal that can be seen on the edge of this sheet has puzzled scholars. One recent suggestion is that it reads 'Sū', very likely an abbreviation of Sūsanbō, the name of the firm of the publisher Kobayashi Shinbei, with whom Hokusai frequently worked from the 1830s onwards.

101 MEN ROLLING CASKS

from the so-called *Day and Night Albums*, *c.* 1817

unsigned
ink and pink and grey wash on paper, 95 x 260 mm
Museum of Fine Arts, Boston, John T. Spaulding Collection (48.619-20) (ex-Hokuyō Shigeyoshi, K. Honma, E. F. Fenollosa, Hamilton Easter Field and J. T. Spaulding collections)

Two men are rolling sake casks bound in straw, while a third man carries a cask on his shoulder. Nearby are two women and a man dancing, a boy throwing a book in the air and a man carrying bundles of wood.

This rough sketch comes from a collection of forty-eight loose drawings formerly bound in two volumes called the *Day and Night Albums*. The drawings cover a variety of subject-matter, providing a good idea of what daily life was like in pre-modern Japan. It seems unlikely that they were made with any form of publication in mind: the colour washes would certainly not have been added had that been the case. Hokusai appears to have presented them in 1832 to his pupil Hokuyō Shigeyoshi, an Ōsaka artist who had been involved in correcting the plates for the album *Hokusai gashiki* ('Hokusai's Method of Drawing'), published in 1819. This suggests that the *Day and Night Albums* drawings may have been made during Hokusai's stay in Ōsaka in 1817. Both the seals and the names that appear on some of the sheets accord with 1817 as the likely date, while Ōsaka as the drawings' possible place of execution would explain the large number of jugglers and other entertainers included in them, for street performers seem to have been far more common in western Japan.

REFERENCES: Fenollosa, 1901, 107; Tomita, 1957; Hillier, 1966, 14–16, Forrer, 1988, 220–2

102 BANNER RAISING

from the so-called *Day and Night Albums, c.* 1817

signed: *Hokusai*, with seal (on the banner): *Katsushika Hokusai*
ink and pink and grey wash on paper, 95 x 260 mm
Museum of Fine Arts, Boston, John T. Spaulding Collection
(48.665-66)
(ex-Hokuyō Shigeyoshi, K. Honma, E. F. Fenollosa,
Hamilton Easter Field and J. T. Spaulding collections)

Several men are raising a large banner, probably as part of the preparations for a festival. The two men carrying lanterns appear to be giving directions.

This is one of the night scenes in the *Day and Night Albums*. It is the only signed sheet and, apart from one other, the only one bearing Hokusai's seal.

REFERENCES: Fenollosa, 1901, 107; Tomita, 1957; Hillier, 1966, 14–16; Forrer, 1988, 220–2

103 BEGGING FOR ALMS

c. 1817

unsigned
ink on paper, 153 x 109 mm
Huguette Berès Collection (?ex-Kobayashi Shinbei Collection)

A woman with an infant on her back and her son beside her pauses to beg for alms outside a restaurant, or perhaps sake shop: sake casks can be seen in the foreground. The shopkeeper responds by holding out a string of coins.

This is one of a group of drawings that are related stylistically to those in the *Day and Night Albums*. All the drawings are approximately the same size and format and, like those in the *Day and Night Albums*, feature scenes from daily life. They include a man standing next to a craftsman's shop (Tikotin Museum of Japanese Art, Haifa), a woman passing a resting porter (Forrer, 1988, 243), two men carrying a chest past a resting porter (ibid., 257) and a scene in a kitchen (ibid., 258), the last two designed as diptychs, or a pair. Like those in the *Day and Night Albums*, the group of drawings to which this sheet belongs consists of free sketches, none of which is likely to have been made with the intention of being worked up into a publishable design. The seal that appears on the sketches is also to be found on the *Seated Nobleman* (cat. 100).

REFERENCE: Forrer, 1988, pp. 222–3, 358–9

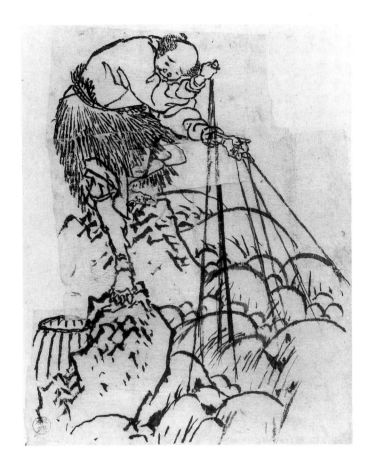

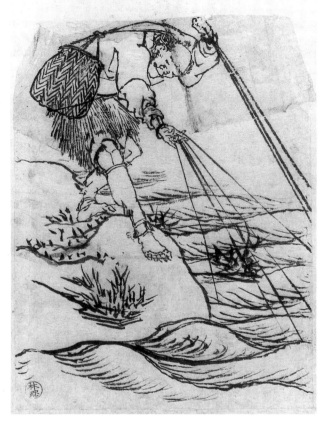

104 a/b TWO STUDIES OF A CORMORANT
FISHERMAN

1830s

unsigned
ink on paper, 176 x 135 mm (104a); 175 x 127 mm (104b)
National Museum of Ethnology, Leiden (3481-18) (ex-Hayashi
Tadamasa Collection)

Two sketches of a fisherman holding the lines attached to his
cormorants. In the version on the left (104a) he is fishing by
a cascade; on the right (104b), with a fire burning in a shallow
oblong dish to attract the fish, he is depicted by a river.
Hokusai's pasted corrections are clearly visible.

Cormorant fishermen appear in several of Hokusai's
designs, of which the plate of *A Fisherman at Kajikazawa*
(cat. 16) from the *Thirty-six Views of Mount Fuji* is probably
the best known. These two studies differ considerably from
that plate, however, and are not likely to be connected with
it. Both these figures are too large for any of Hokusai's land-
scape series; moreover, his method of working, which can
be inferred from surviving designs made for *One Hundred
Poems Explained by the Nurse* and *One Hundred Views of Mount
Fuji*, seems to have involved drawing the landscape first and
then pasting in the figures, which had been drawn on sepa-
rate sheets. The format of these sketches suggests that they
are probably designs for a book-plate.

105 A WOMEN AND A BOY CROSSING A BRIDGE

1830s

unsigned
ink on paper, 925 x 345 mm
Huguette Berès Collection
(ex-Henri Vever and L. L. Weill collections)

A fisherwoman and her son are crossing a high wooden bridge over water in which reeds are growing. In the foreground are some thatched storage bins, with a fishing village and Mount Fuji in the distance. Various corrections to the original drawing have been pasted on.

The composition of this drawing suggests it was done in the 1830s. Its upright format indicates a link with the contemporary series *A True Mirror of Chinese and Japanese Poems* (cat. 68–73), but does not correspond to any of the standard sizes of paper used for prints. It is probable, therefore, that it represents a preparatory design for a painting, or possibly for a multi-panel folding screen.

REFERENCE: Hillier, 1980 (b), 64

106 TWO TREES

1830s

unsigned
ink and grey wash on paper, 554 x 290 mm
National Museum of Ethnology, Leiden (3513–557)
(ex-F. Lieftinck Collection)

A study of two trees, or rather their trunks, starkly rendered on the edge of a hillside.

Three sheets of paper have been used to make this drawing. Whether it represents a preparatory design for a painting is uncertain: although the format does not correspond to any of the standard sizes of paper used for prints, the unfinished branches at the top suggest that it was not intended as part of a larger design. It is a good example of Hokusai's brushwork, the use of jagged outlines being a constant feature of his draughtsmanship.

107 FISHING AT SHIMADAGAHANA

c. 1833–4

unsigned
ink on paper, with corrections in red ink, 181 x 252 mm
Huguette Berès Collection (ex-Henri Vever and L. L. Weill
collections)

Several people are angling at Shimadagahana. Fishing boats
and cargo vessels are out on the river, and Mount Fuji is vis-
ible in the distance.

This is a preparatory sketch for a double-page illustration
(sheets 15b–16a) in the second volume of the *One Hundred
Views of Mount Fuji*; the line that divides the design to make
two pages has already been drawn in. The actual plate in the
One Hundred Views is entitled 'Fuji from Shimadagahana at
Sunset' (*Shimadagahana sekiyō no Fuji*; fig. 11), and it has been
suggested that the setting is the Fuka River, somewhere near
the village of Shimada.

REFERENCE: Suzuki, 1986, p. 231

108 PEOPLE CROSSING AN ARCHED BRIDGE

c. 1835–6

unsigned

ink on paper, with corrections in red ink, 266 x 384 mm
Huguette Berès Collection

A couple with a child and two peasants are crossing an arched bridge. To the right is a pair of samurai, apparently drunk, while below them are two men fishing.

This is a preparatory design for the plate illustrating a poem by Ariwara no Narihira (823–80) in *One Hundred Poems Explained by the Nurse* (cat. 79). A comparison of this drawing with the published plate shows just how much detail was left to be added by the copyist who worked from Hokusai's original draught. The only parts here that

Hokusai has worked on in some detail are the figures, all of which seem to have been prepared separately, copied onto small pieces of paper and then pasted into position on the sheet. From the unfinished designs for other plates in the *One Hundred Poems* we know that Hokusai on occasion made corrections to the finished drawings that had been prepared from his draughts by the copyist.

The floating maple leaves that appear in the finished plate are not to be seen here, the reason being that this design was made with only the line-block in mind, from which the black outlines would be printed on the sheet. The leaves are not indicated because they were to be printed in red from a different block.

REFERENCES: Hillier, 1966, pp. 20-2; Forrer, 1988, pp. 341-3; Morse, 1989, pp. 13 f

c. 1840

unsigned
ink and grey wash on paper, 265 x 384 mm
The Museum of Fine Arts, Springfield, Massachusetts,
Raymond A. Bidwell Collection (60.DO5.1565)

This rather free sketch of a seaside village backed by trees and
distant mountains is a rare example of Hokusai's work in a
manner that is half-way between a preparatory line drawing
and a painting. On stylistic grounds it appears to date from
c. 1840, a period when Hokusai made hardly any designs for
printed works of any sort. By 1840 his great series of land-
scape prints had all been published, while most of his paint-
ings were yet to come.

The height of this drawing suggests that originally it may
have formed part of a scroll; a scroll of the same height, dated
1839, with various designs on it in a style that is similar to
this drawing is in the Freer Gallery of Art, Washington,
D.C. (Forrer, 1988, 391, 393). Hokusai's brushwork here
closely resembles that to be seen in a group of drawings
known as the *Nisshin joma* ('Daily Exorcisms'), the depic-
tions of mythic *shishi*, or Chinese lion-dogs (Forrer, 1988,
445–6, 477), he made in 1842–3.

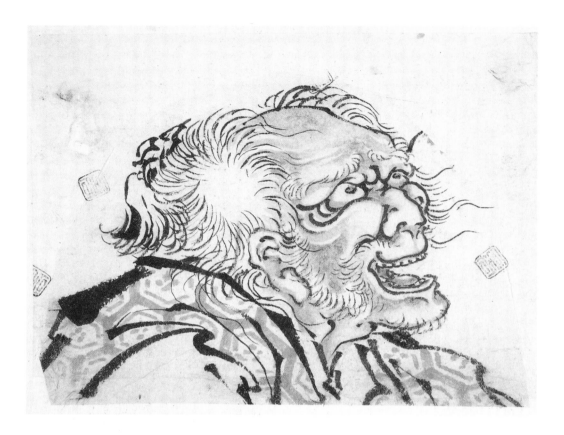

110 HEAD OF AN OLD MAN

early 1840s

unsigned
ink and grey and pink wash on paper, 110 x 140 mm
National Museum of Ethnology, Leiden (2736–11/2)
(?ex-Kobayashi Shinbei Collection)

The features of this old man with his mouth half-open resemble those of Hokusai's self-portrait at the age of eighty-three (cat. 111) and of the thunder-god Raijin (Freer Gallery of Art, Washington, D. C.), though whether this drawing was actually intended as a self-representation is unknown.

111 A SELF-PORTRAIT AT THE AGE OF EIGHTY-THREE

1842

drawn on a letter signed *hachijūsansai Hachiemon*, with seal: *Manji*

ink on paper, 269 x 169 mm
National Museum of Ethnology, Leiden (3513–1496)
(ex-Kaneko Fusui, F. Tikotin and F. Lieftinck collections)

Hokusai appended this self-portrait to a letter to his publisher. Dressed in a simple kimono, he presents himself as an old man with a wry smile.

There are various extant self-portraits of Hokusai, but this is undoubtedly the most important one. The earliest that is known today (Forrer, 1988, 87) was included at the end of *The Tactics of General Oven*, a popular novella published in 1800. There are obvious similarities between this *Self-portrait at the Age of Eighty-three* and two others: the old man with his mouth half-open (cat. 110) and the thunder god Raijin in the Freer Gallery of Art, the latter painted only five years after this drawing was made.

The text of Hokusai's letter reads:

> Well then, the sketches in this volume were made when I was about forty-one or forty-two; moreover, a number of them duplicate one another. After all these years some of them might be better worked out. The remainder, which you may smile about, should be regarded as immature work from the past. Sincerely yours, the 83-year-old Hachiemon [seal] Manji.

REFERENCES: Hillier, 1980(b), 73; Forrer, 1988, p. 359

112 A BRANCH OF PLUM

from the privately published *kyōka* album *The Nightingale of Miyama (Miyama uguisu)*, *c.* 1798

signed: *Hokusai Sōri utsusu* ('copied'), with written seal (*kakihan*)
woodblock, album plate, 194 x 263 mm
The British Museum, London (H.410)

For this plate depicting a branch of plum Hokusai sought to imitate a classical *sumi*, or ink painting on silk: certain parts are lighter in tone and some of the lines are partly un-inked, both of which features represent deliberate attempts to suggest the 'wet and dry brushwork' of a painting. The blindprinting, too, imparts to the paper the look and texture of silk.

Hokusai's signature confirms that the design was copied 'after a painting by *hokkyō* Kōrin'. This was Ogata Kōrin (1658–1716), a legendary decorative artist of the Rimpa School who was also active as a potter, lacquerer and textile designer. Kōrin was given the title of *hokkyō* (which was granted to those painters who worked for the daimyō courts) in 1701.

The other plate in *The Nightingale of Miyama* was designed by Kitao Shigemasa. The date of the album appears only in the preface.

REFERENCE: Hillier, 1980 (a), p. 31

113 PEASANTS BY A STREAM

from the *kyōka* album *The Mist of Sandara* (*Sandara kasumi*)
privately published by the Kasumi poetry club, 1797

signed: *Hokusai Sōri ga*
woodblock, album plate, 214 x 318 mm
The British Museum, London (JH 407) (ex-Hayashi Tadamasa, Siegfried Bing, Théodore Duret and Jack Hillier collections)

Having asked directions, two fashionably dressed towns-women, accompanied by a servant carrying their luggage, have aroused the curiosity of some villagers. A woman with a child on her back listens to the travellers, while a peasant in the foreground has ceased sharpening his scythe to watch and a woman with a hoe and two small children pauses out-side her home. In the distance a small flock of cranes can be seen near a thatched Shinto shrine.

The straw rope that hangs from the pine tree at the left (the rope's dangling strands are there to ward off evil spirits) and the flowering plum to the right beyond the roofs of the village identify the season as New Year.

The other two plates in this album were designed by Kitao Shigemasa (1739–1820) and Ittei.

REFERENCE: Forrer, 1982(b), p. 54

114 A NETSUKE WORKSHOP

from the album *The Mist of Sandara* (*Sandara kasumi*)
privately published by the Kasumi poetry club, 1798

signed: *Hokusai Sōri ga*
woodblock, detached album plate, 220 x 315 mm
The Art Institute of Chicago (1925.3205)

A woman offers tea to a traveller who has halted at the work-shop of a man busy turning the ivory rings for making *kagamibuta netsuke*, a type of *netsuke* fitted with a metal cap. Behind the two women assisting the craftsman stands a screen decorated with prints, one of which appears to be a *surimono* depicting the sun rising above pine trees on New Year's morning. Beyond the workshop is Mount Fuji.

Whereas Hokusai's contributions of 1797 to the large-format poetry album *The Threads of the Willow* and the first *Mist of Sandara* cannot be considered to have been altogether successful, his compositional skills rapidly improved, as can be seen by the plate shown here from the second *Mist of Sandara* and one from *The Stamping Song of Men* (cat. 116). Common to both is a compositional scheme that became one of his favourites: a pyramidal arrangement of the figures, which here is echoed by Fuji's silhouette.

The other two plates in this album are by Kitao Shigemasa (1739–1820) and Hasegawa Settan (1778–1843).

REFERENCES: Forrer, 1982(b), pp. 54f; Lane, 1989, p. 36

115 THREE LADIES IN A BOAT

from the privately published *kyōka* album *The Elegance of Spring*
(*Haru no miyabi*), *c.* 1797

signed: *Hokusai Sōri ga*
woodblock, album plate, 167 x 392 mm
Peter Morse Collection

Three ladies are on an outing in a small boat. Hokusai's limited and very generalised scenery – trees either side of the stream and a shallow footbridge – suggests that no specific location was intended. While one of the women concentrates on steadying the boat, another attempts to cut a branch of flowering plum. The scissors and knife lying in the boat confirm that the express purpose behind this modest voyage was to gather some branches of plum – which was, of course, always associated with New Year and with springtime flower-arranging.

Though undated, *The Elegance of Spring* was probably issued for the New Year of 1797. Its preface and postscript are signed *Sentei Shakuyaku* and *Sentei Uranari* respectively, two early names of Shakuyakutei Nagane (1767–1845), the founder of a small club of poets.

There are two plates in this album of thirteen folds, both of which were designed by Hokusai. This particular one of women in a boat was reprinted in a drastically altered form *c.* 1815–20 (Vignier & Inada, 1913, pl. 57, no. 184): it was enlarged to an *ōban* size in order to accommodate some sky, the river's left bank was simplified and the trees omitted. In addition, the patterns on the kimonos were revised, the trees were turned from plum to cherry and *Sōri* was dropped from the signature.

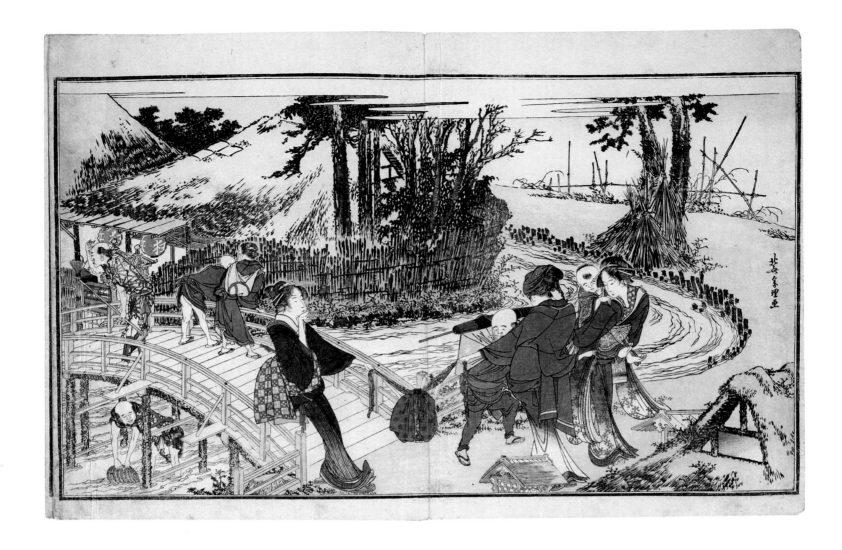

116 A VILLAGE BY A BRIDGE

from the *kyōka* album *The Stamping Song of Men* (*Otokodōka*)
published by Tsutaya Jūsaburō, 1798

signed: *Hokusai Sōri ga*
woodblock, album plate, 235 x 374 mm
L. B. Schlosser Collection

Three townswomen from Edo, apparently out on a New Year's visit, have halted on a winding road at a drum bridge. One of the women, who wears a long-sleeved kimono with a maple-leaf pattern, carries a child on her back. There appears to be some confusion over the direction the travellers should take: the young male servant carrying the furled umbrella and a package is suggesting a different direction to that pointed out by the woman resting against a rail. On the bridge itself are three men, one of whom is angling; below them in the water is a fisherman with his basket.

Hokusai contributed this one plate to *The Stamping Song of Men*, a de-luxe poetry album published for the New Year of 1798. Three more were designed by well-known artists and two by relatively minor ones from other schools, Hakuhō Ekigi (*fl.* 1790s–1810) and Tsutsumi Tōrin III (*c.* 1743–1820). Albums such as this one, each including six colour prints and numerous pages of poetry, were issued annually from 1794 to 1798 by the Yomogawa poetry club, with whom Hokusai collaborated on two of them, the *Threads of the Willow* (cat. 8) and this one.

REFERENCES: Forrer, 1982(b), p. 54; Lane, 1989, pp. 36–7; Forrer, van Gulik & Kaempfer, 1982, 76

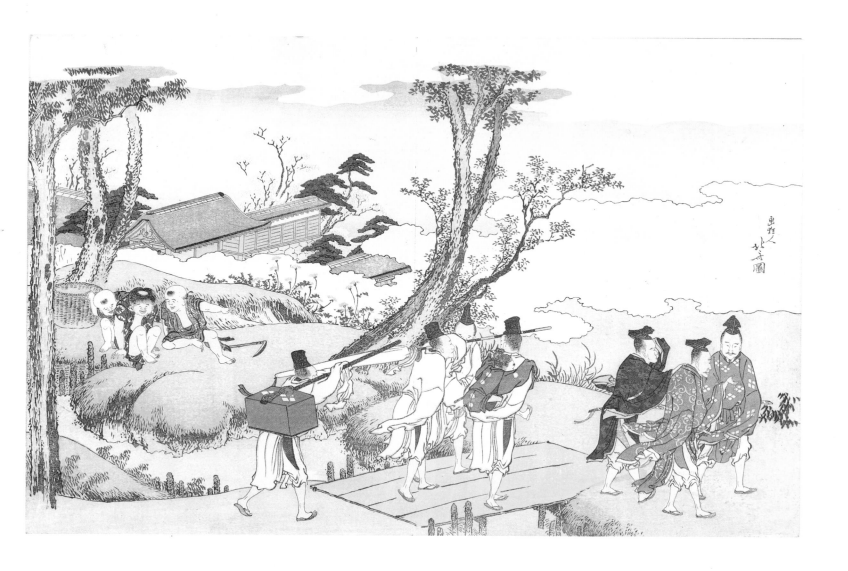

117 COURTIERS CROSSING A BRIDGE

from the poetry album *The Thirty-six Women Poets in Brocade Prints* (*Nishikizuri onna sanjūrokkasen*) published by Nishimuraya Yohachi, 1801

signed: *Gakyōjin Hokusai zu*
woodblock, album plate, 250 x 376 mm
Gerhard Pulverer Collection (ex-Tamura and Hayashi Tadamasa collections)

Several courtiers, deep in conversation, are striding along with their attendants hurrying behind. One of the attendants carries a child on his back, another has a furled umbrella, while a third struggles with the heavy trunk on his carrying pole. Sitting on the bank nearby are three small boys who have paused to chuckle at the passing procession.

Although the bank of mist that partially obscures the distant group of buildings is conventionally stylised, the sky and clouds above are clearly not: this print is among the first examples of Hokusai's interest in Western-style skies.

This plate forms the frontispiece to an album devoted to *The Thirty-six Poetesses*, an anthology of poetry dating from the Heian period (eighth to twelfth centuries). The album was designed by an *ukiyoe* artist of noble birth, Hosoda Eishi (1756–1829), and features thirty-six somewhat unadventurous likenesses of the poetesses in addition to the poems in bold calligraphy.

Hokusai's choice of subject for the frontispiece suggests that some mockery of the album's contents was intended.

REFERENCES: Keyes, 1985, 177, 389; Forrer, van Gulik & Kaempfer, 1982, 77

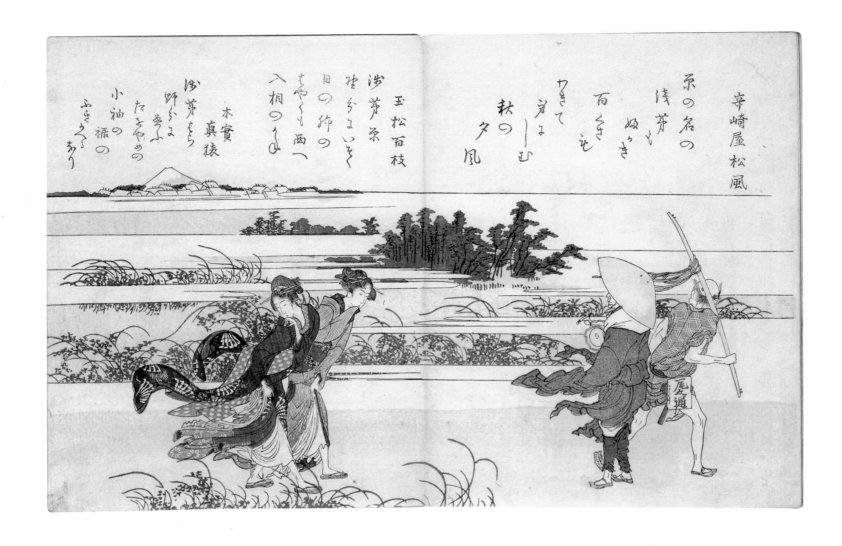

118 WOMEN STRUGGLING IN THE WIND

from the *kyōka* album *Birds of the Capital (Miyakodori)*, privately published by the Nogawa poetry club, *c.* 1802

signed (in the colophon): *Gakyōjin Hokusai hitsu*
woodblock, album plate, 228 x 348 mm
The Art Institute of Chicago, Martin A. Ryerson Collection
(IV. 1–49 F 761.952 H7 mi 2)

It is a breezy day and people are on the Ōshū road that runs across Asajigahara, an open plain lying between Asakusa and Sōsenji temple in the north of Edo. One of the poems above the landscape contains a reference to 'autumn's evening breezes'. On the left are two women struggling against the wind, while just ahead of them are an itinerant monk and a porter with his carrying pole. Among the trees beyond the roadside autumn flowers and grasses, a Shinto shrine can be seen, while farther away are the roofs of Edo with Mount Fuji beyond.

Although a number of museums have one or more detached plates from *Birds of the Capital*, complete editions, one of which is in the Art Institute of Chicago, are extremely rare. There is an incomplete one in a private collection in Paris (see cat. 119) that was formerly owned by Edmond de Goncourt. Its condition seems to have persuaded him that *Birds of the Capital* was no more than a series of loose sheets. Unlike most early-nineteenth-century albums of this type, this particular one was folded together rather than stitched.

REFERENCE: Goncourt, 1896, pp. 49ff

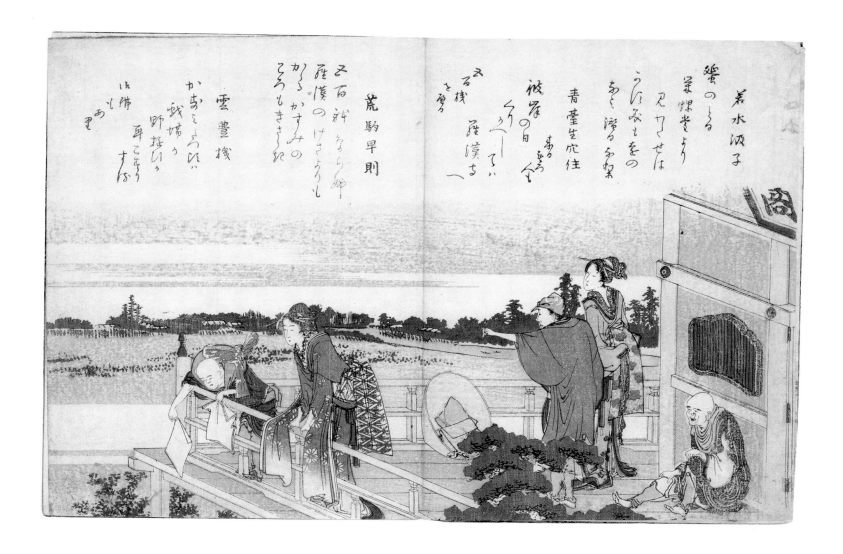

119 PEOPLE ON THE BALCONY
OF THE SAZAIDŌ

from the *kyōka* album *Birds of the Capital* (*Miyakodori*), privately
published by the Nogawa poetry club, *c.* 1802

signed (in the colophon): *Gakyōjin Hokusai hitsu*
woodblock, album plate, 227 × 347 mm
Huguette Berès Collection (ex-Edmond de Goncourt Collection)

Several people on the balcony of the Sazaidō are enjoying the
view over the marshes. The climb up this three-storey tower
has evidently exhausted the old man on the right, who sits
on its deck regaining his breath. Nearby is a man pointing
out something (Mount Fuji?) to his female companion;
she wears a headscarf displaying the device of the poetry club
that commissioned *Birds of the Capital* and the *obi*, or sash,
tied at the front, that identifies her as a courtesan. To the left
is a woman whose son idly drops sheets of paper.

The Sazaidō also appears in the *Kyōka ehon – Yama mata
yama* ('Range upon Range of Mountains') of 1804 and in
People on a Temple Balcony, one of the plates in the *Thirty-six
Views of Mount Fuji* (cat. 22), where, once again, several
people are shown enjoying the view it offered. By com-
paring the scene shown here with the later one of *People on a
Temple Balcony* one can see the influence Western-style one-
point perspective was to have on Hokusai's work.

REFERENCE: Lane, 1989, p. 41

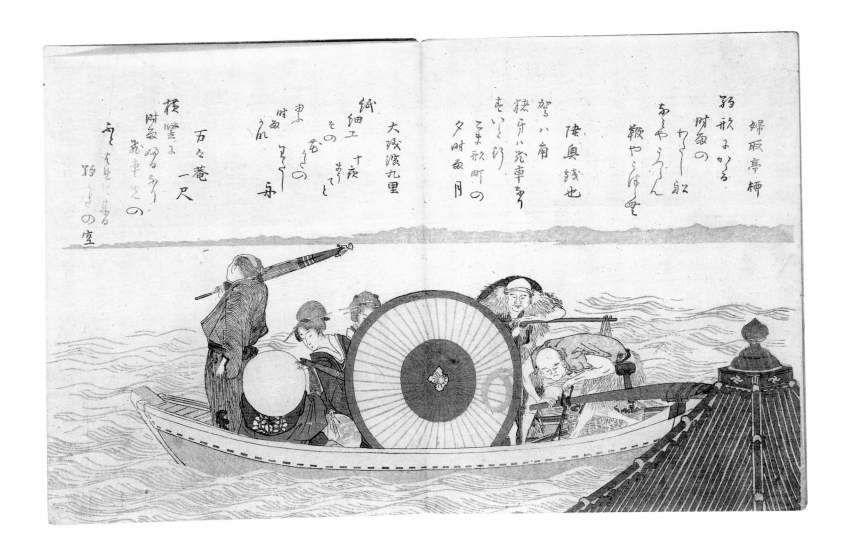

A FERRY ON SUMIDA RIVER

from the *kyōka* album *Birds of the Capital (Miyakodori)*, privately published by the Nogawa poetry club, *c.* 1802

signed (in the colophon): *Gakyōjin Hokusai hitsu*
woodblock, album plate, 228 x 348 mm
The Art Institute of Chicago, Martin A. Ryerson Collection
(IV. 1–49 F 761.952 H7 mi 2)

One of Edo's small ferry boats that used to ply the Sumida River is carrying several passengers past Komagata Hall, the roof of which can be seen bottom right. The large sunshade half-obscuring a party of women in the boat displays the emblem of the Nogawa club of poets, which commissioned this de-luxe album.

This stretch of the Sumida's bank was known as the Onmayagashi; it features in one of the plates in the *Thirty-six Views of Mount Fuji* (cat. 26). In Hokusai's day the temple, popularly known as the Komagatadō, or 'Colt-shaped Hall', that stood on this bank was dedicated to Horse-headed Kannon, a deity whose responsibilities included the spiritual welfare of the animal world. When seen from the river, the Komagatadō's silhouette looked like that of a young horse, hence its nickname.

This temple to Kannon also features in the *kyōka* album *Ehon Sumidagawa Ryōgan ichiran* ('Both Banks of the Sumida in One View') of *c.* 1803 and in the 'triptych' that forms part of the series *Umazukushi* ('A Set of Horses'), published in 1822.

After World War II the temple was rebuilt in ferro-concrete on its present site in Tokyo's Komagata Park.

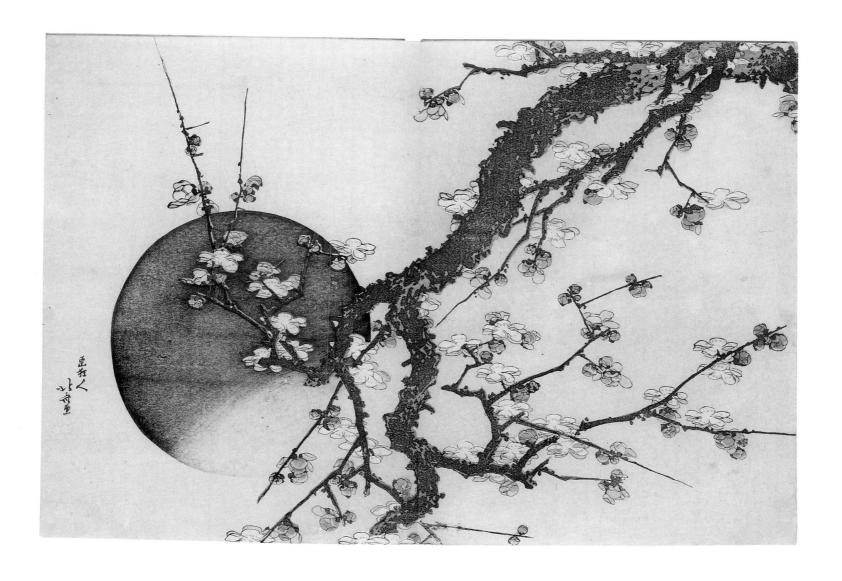

121 PLUM BLOSSOM AND THE MOON

from the *kyōka* album *Mount Fuji in Spring (Haru no Fuji)*, *c.* 1803

signed: *Gakyōjin Hokusai ga*
woodblock, album plate, 220 x 320 mm
The Art Institute of Chicago, Martin A. Ryerson Collection
(IV. 1–49F 761.952 H7 fj)

This depiction of a gnarled branch of flowering plum and a golden moon is one of only three plates in *Mount Fuji in Spring*. Since all three are by Hokusai, presumably his reputation was such that by this date he was not obliged to share the budget for the illustrations with other artists. Of the additional plates, one is a view of Mount Fuji from the coast and the other a landscape with women gathering herbs.

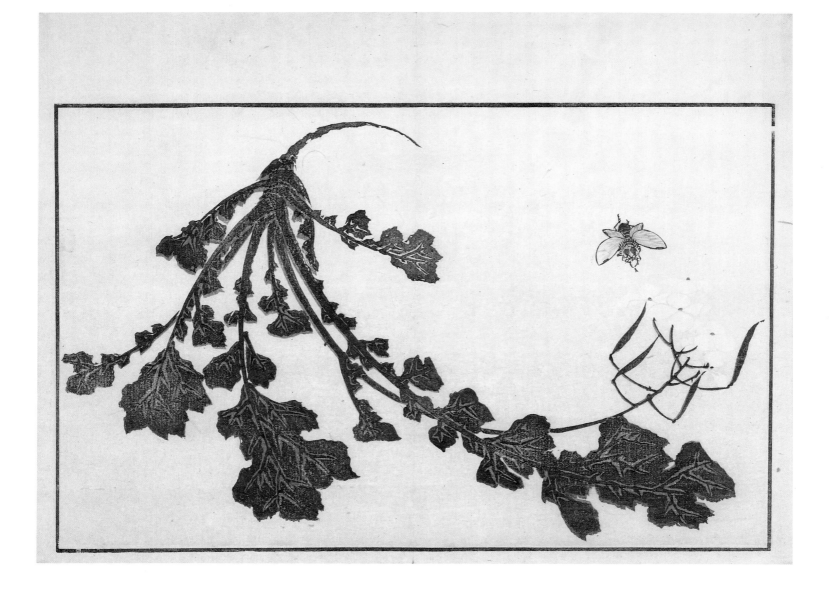

122 RADISH AND BEE

from the album *Pictures after Nature by Hokusai* (*Hokusai shashin gafu*) published by Tsuruya Kiemon, 1814 or 1819

unsigned
woodblock, album plate, 257 x 338 mm
National Museum of Ethnology, Leiden (1−4448)
(ex-Philipp Franz von Siebold Collection)

This print of a bee flying down to a leafy stalk of radish (*daikon*) is one of the fifteen colour plates that make up the large-format *Pictures after Nature*, a de-luxe folding album. All the plates were carefully printed on fine-quality heavy paper and some of the images are meant to look as if they had been painted. Originally the album must have been issued in an envelope with a design on it by Hokusai.

Two-thirds of the plates in this album are studies from Nature, as here; the remainder depict people, gods or landscapes. Although Hokusai usually appended titles to individual plates in his albums and books, as in the *Hokusai manga*, for example, or in his various drawing manuals, none of those in *Pictures after Nature* was given one. This album was, of course, aimed at an audience of well-to-do merchants, to whom the *Manga*, which went through numerous impressions, would have appeared far too vulgar to have been of interest to them.

Philipp Franz von Siebold, the Dutch physician and collector who spent the years 1823−9 in Japan at the settlement of Deshima, was so impressed with *Pictures after Nature* that he returned to Europe with no less than six copies of it. In his efforts to make Hokusai's name known in the West he

donated several copies to major libraries that included the Bibliothèque Nationale in Paris and, it appears, the Imperial Library in Vienna. Of the two copies he kept back, one fell into the hands of the collector Louis Gonse and is now in the Chester Beatty Library in Dublin.

REFERENCES: Hillier, 1980(a), p. 95; Forrer, van Gulik & Kaempfer, 1982, 98

123 A PHILOSOPHER WATCHING A PAIR OF BUTTERFLIES

from the album *Pictures after Nature by Hokusai* (*Hokusai shashin gafu*) published by Tsuruya Kiemon, 1814 or 1819

unsigned
woodblock, album plate, 258 x 344 mm

The Chester Beatty Library and Gallery of Oriental Art, Dublin (Ac. 170) (ex-Philipp Franz von Siebold and Louis Gonse collections)

In an attitude of rapt contemplation a man seated on a mat is watching two butterflies. A fan lies half-open on the floor. This is a depiction of the Chinese philosopher Chuang Tsze (*fl.* fourth century BC), who is known in Japan by the name of Sōshi. Chuang Tsze was famous for a dream he once had in which he found himself fluttering through the air like a butterfly; afterwards, however, he was unable to decide whether this meant he had briefly turned into a butterfly or a butterfly into him.

REFERENCES: Hillier, 1980(a), p. 95; Forrer, van Gulik & Kaempfer, 1982, 98

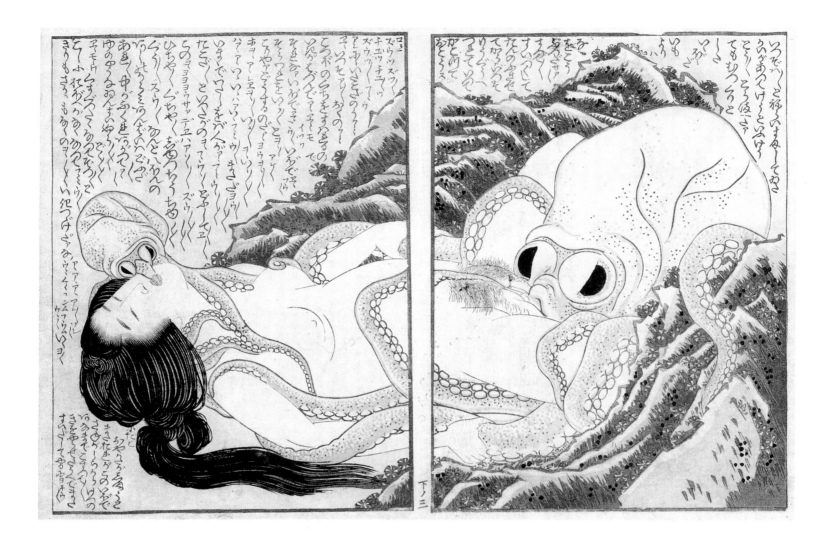

124 A PEARL DIVER AND TWO OCTOPUSES

from the anonymously published album *Young Pines*
(*Kinoe no komatsu*), 1814

signed: *Shiunan Gankō*
woodblock, album plate, 221 x 156 mm
Gerhard Pulverer Collection

A female pearl diver and two lascivious octopuses are caught
up in an erotic encounter on a rocky seashore. While one
octopus wraps his slithering tentacles about the girl's thighs
and waist in order to draw himself more tightly to her, his
smaller companion grips her neck and plies her with kisses.

The three-volume album *Young Pines* is an erotic tale both
written, it is thought, and illustrated by Hokusai. Volumes
one and two each contain six double-page illustrations
printed in colour; volume three has seven. In each volume
the double-page illustrations are preceded by a single-page
portrait of a woman.

Prints of female pearl divers being interfered with sexu-
ally by one or more men, gods or stranger creatures are not
uncommon in Japanese erotic art. One from the 1780s that
contains a scene similar to that shown here may or may not
have been known to Hokusai, for this kind of art was cir-
culated then as cautiously as it is today and was not always
readily available for examination or sale.

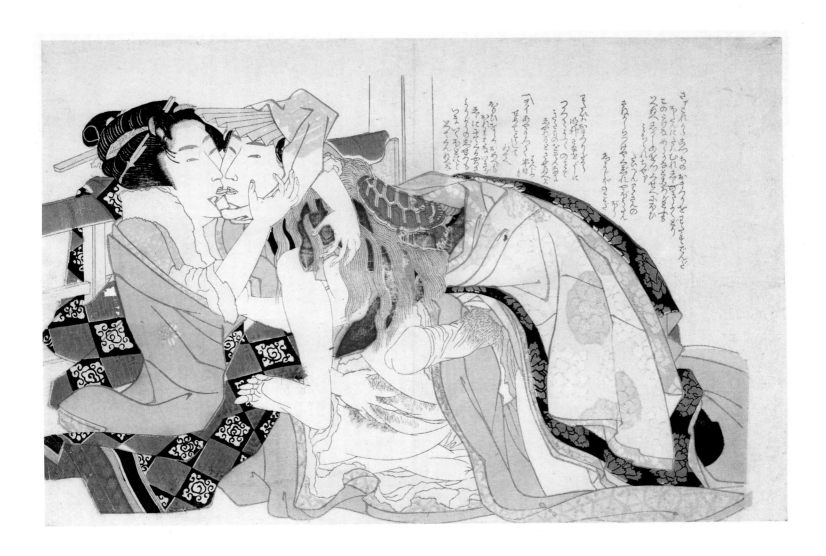

125 A COUPLE MAKING LOVE

from the anonymously published *Picture Album of Couples*
(*Ehon tsui no hinagata*), *c.* 1810–5

unsigned
woodblock, detached album plate, 265 x 391 mm
The British Museum, London (1972.7.24.016)

A festival at a shrine in Edo has provided two ardent lovers
with the opportunity for a hurried meeting. The woman is
still dressed in her best festive outfit, as her companion is in
his, although the fan on his head and the scarf draped over it
are in danger of becoming dislodged.

A device frequently used in Japanese erotic art appears in
the background: the conversation and subjective fantasies
one might suppose the couple is indulging in are very graphi-
cally spelled out on the wall.

Normally, erotic albums were made up of twelve plates,
and this *Picture Album of Couples* is no exception. Its attribu-
tion to Hokusai is based on the signature *Shishoku Gankō*
that appears on several of the plates, although it has been
argued that he only used this signature in his early work and
that this album is by Keisai Eisen or, possibly, by Hokusai's
daughter Oei, an artist whose authenticated *œuvre* is of a
refined nature.

REFERENCE: Hayashi, 1968, pp. 101 ff

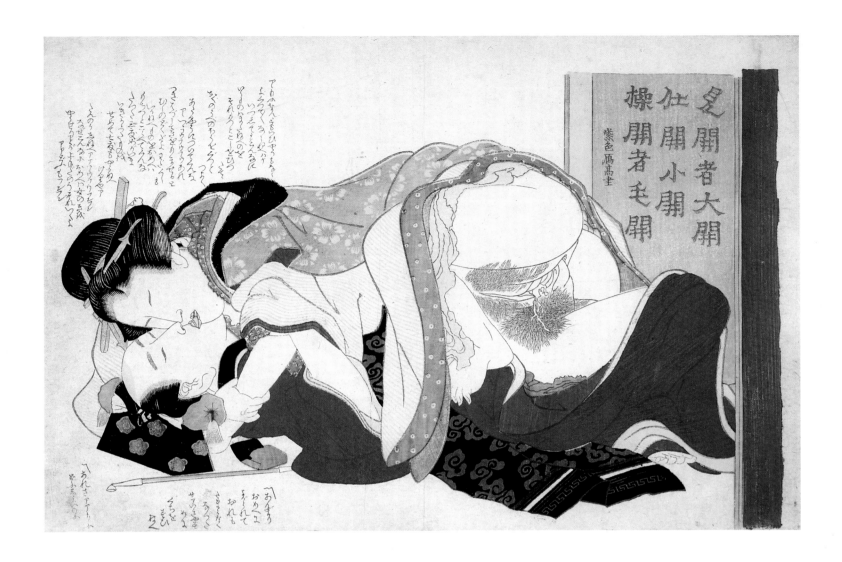

126 A COUPLE MAKING LOVE

from the anonymously published *Picture Album of Couples*
(*Ehon tsui no hinagata*), *c.* 1810–5

signed: *Shishoku Gankō*
woodblock, detached album plate, 264 x 388 mm
The British Museum, London (1972.7.24.017)

A couple are making love in a room. The woman has
mounted her male partner, who supports his head with a pil-
low. A discarded pipe lies next to the pillow. Kissing — as
they do here — was considered to be a very intimate form of
contact in Japan.

On the screen behind the couple is a poem, signed
Shishoku Gankō, that reads something like this: 'Those with
their eyes wide open have large openings, servants have
small openings, and chaste people have hairy openings.'

REFERENCE: Hayashi, 1968, pp. 101 ff

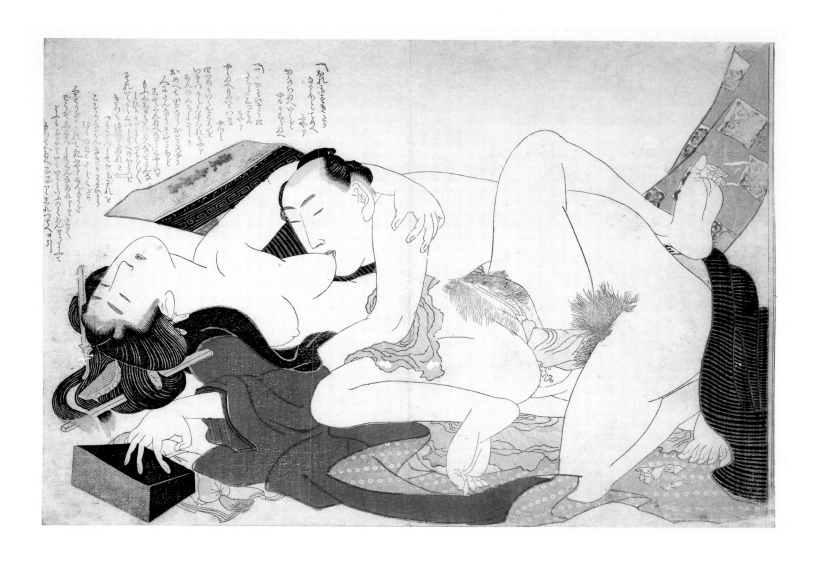

127 A COUPLE MAKING LOVE

from the anonymously published *Picture Album of Couples*
(*Ehon tsui no hinagata*), *c.* 1810–5

signed: *Shishoku Gankō*
woodblock, detached album plate, 252 x 364 mm
The British Museum, London (1972.7.24.019)

In this depiction of a couple making love the woman's state
of ecstasy is especially evident: her toes are curled, her hair is
in disarray and she struggles distractedly to reposition the
pillow under her head.

The signature *Shishoku Gankō* appears on the border of
the patterned cloth – possibly the woman's sash – beneath
them.

REFERENCE: Hayashi, 1968, pp. 101 ff

From the three-volume album *One Hundred Views of Mount Fuji* (*Fugaku hyakkei*) published by Nishimuraya Yohachi and Eirakuya Tōshirō in 1834 (volume 1), 1835 (volume 2) and *c.* 1842 (volume 3)

signed: *zen Hokusai Iitsu aratame Gakyōrōjin Manji hitsu* (volumes 1 and 2 only; volume 3 is unsigned), with seal: *Fuji no Yama*

128 A TREE-STUMP AND MOUNT FUJI

Mount Fuji in a Wintry Wind (Kogarashi no Fuji)

from volume 1

block-cutter: Yone[___] Kichi[___]
woodblock, album plate, 227 x 156 mm
Arthur M. Sackler Museum, Harvard University, Cambridge,
Massachusetts, Bequest of the Hofer Collection of the Arts of Asia
(85.610.TC.87.1971)

People are out on the road crossing some rice fields in a
strong wind. On the left are lines of bird-scarers strung from
upright sticks of bamboo.

In this design the outlines of a thatched shed and a tree-
stump reinforce the form of Mount Fuji's outline. A similar
composition, and one in which the effects of a strong wind

also figure prominently, can be seen in the *Thirty-six Views of
Mount Fuji* plate that shows the landscape near Ejiri (cat. 21).

129 BAMBOO AND MOUNT FUJI

Fuji of the Bamboo Grove (Chikurin no Fuji)

from volume 2

block-cutter: Egawa Sentarō
woodblock, album plate, 227 x 156 mm
The Chester Beatty Library and Gallery of Oriental Art, Dublin
(Ac. 179)

In this print Mount Fuji is prominently placed beyond a
screen of bamboo trees, some of the stems of which repeat
the mountain's curving silhouette.

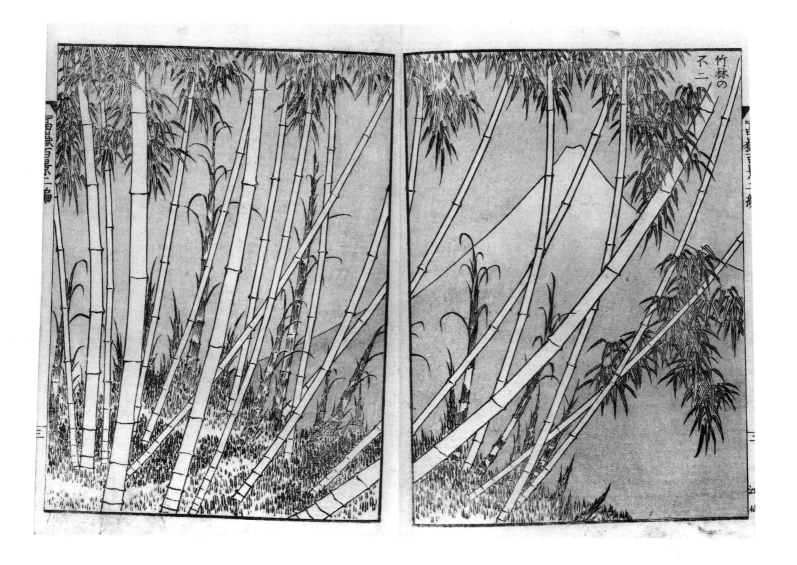

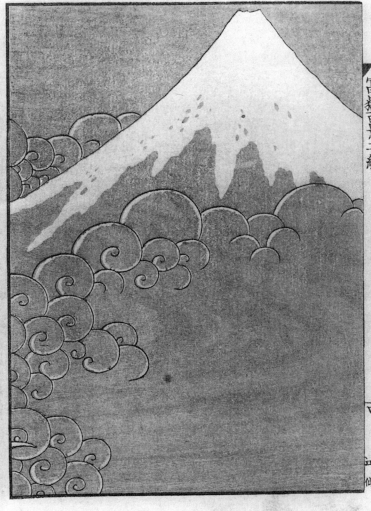

130 MOUNT FUJI AND A DRAGON

Fuji of the Ascending Dragon (Tōryū no Fuji)

from volume 2

block-cutters: Egawa Sentarō (right) and Yoshi[__] Tora[__] (left)
woodblock, album plate, 226 x 155 mm
National Museum of Ethnology, Leiden (1353–52)

At bottom left the head and claws of a dragon can be seen emerging from bubbling clouds below Mount Fuji. According to the popular superstitions of China and Japan, dragons were thought to inhabit both the waters and the sky, hence their suitability as messengers of the gods.

In the first impressions of this print the clouds were printed in soft grey hues right down to the bottom of the sheet. In later impressions, however, the lowest clouds were printed in black, which makes the dragon stand out more sharply. Confirmation that the suite of albums which includes this plate is one of the earlier impressions is provided by a correction that appears on the colophon (the final sheet) of every copy of this volume.

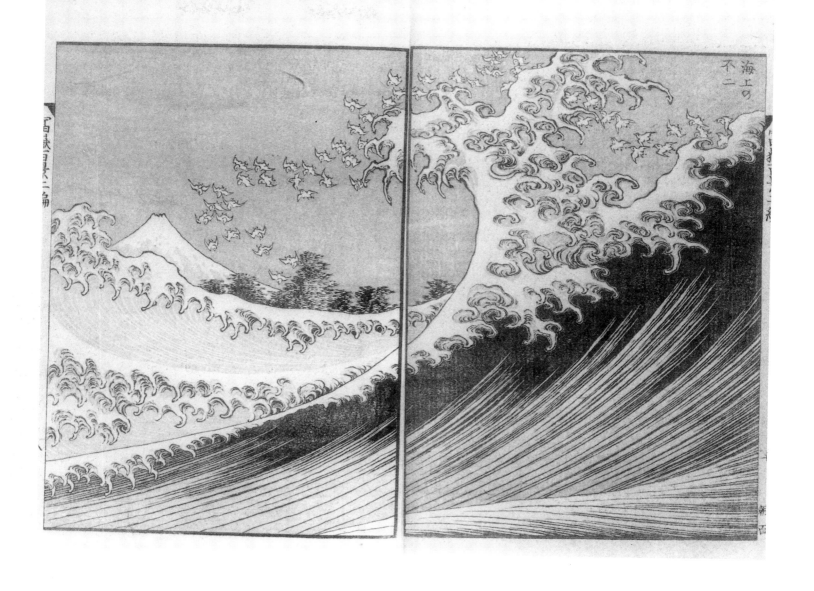

131　MOUNT FUJI SEEN ABOVE THE WAVES

Fuji Above the Sea (Kaijō no Fuji)

from volume 2

block-cutter: Asa [?kura] Hyaku[＿]
woodblock, album plate, 226 x 155 mm
National Museum of Ethnology, Leiden (1353–52)

Beyond a sea of churning waves is Mount Fuji. What at first glance seems to be large drops of water hurled from the crest of a rolling wave at top right is, in fact, a flock of sea birds skimming over the water.

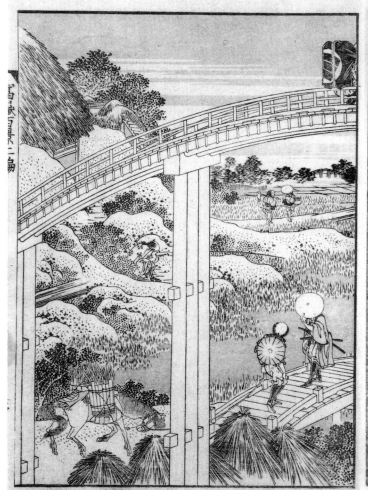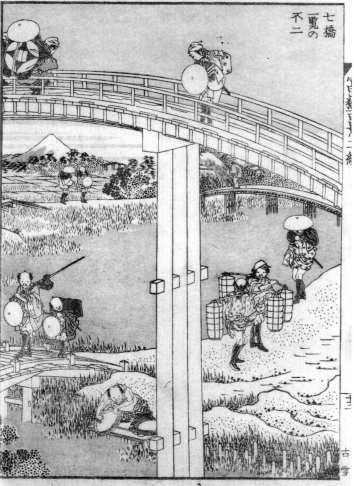

132 SEVEN BRIDGES IN ONE VIEW

*Seven Bridges in One View with Mount Fuji
(Nanabashi ichiran no Fuji)*

from volume 2

block-cutter: Ko/Furu[__] Yuki[__]
woodblock, album plate, 227 x 156 mm
Gerhard Pulverer Collection

Beyond the high-arched bridge that fills the foreground, the cone of Mount Fuji can be seen on the horizon. Below the bridge a number of smaller bridges bear a winding road through a marshy district. An assortment of porters and other travellers animates the scene.

Hokusai's fascination with bridges did not diminish after 1834, when the series of eleven prints of well-known ones was published as the *Remarkable Views of the Bridges in All Provinces* (cat. 34–8). This scene is clearly an imaginary one, however, and is related to Hokusai's dream-inspired *Landscape with a Hundred Bridges* (cat. 33).

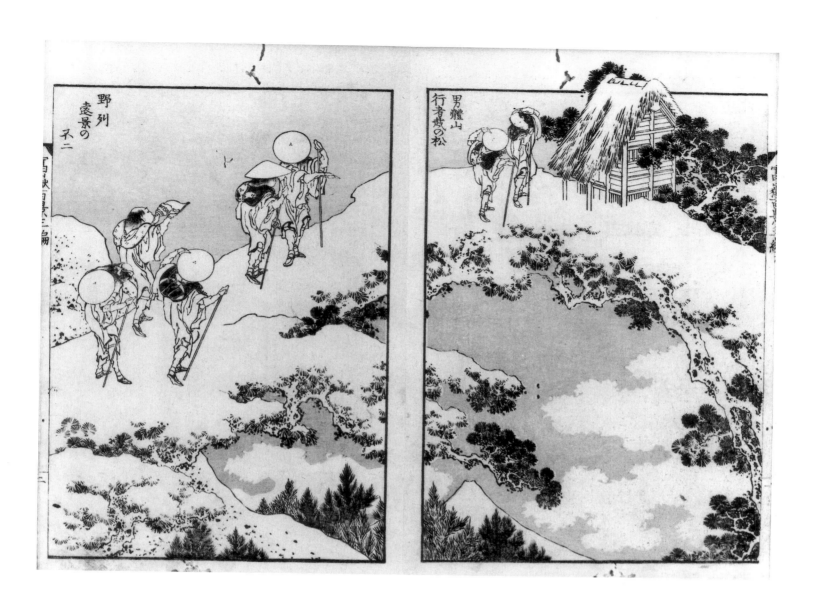

133 PILGRIMS ON A SNOW-COVERED BRIDGE

Pilgrims Crossing a Pine on Mount Nantaizan
(*Nantaizan gyōja koshi no matsu*) (right) and
A Distant View of Mount Fuji in the Province
of Shimotsuke (*Yashū enkei no Fuji*) (left)

from volume 3

block-cutter: Egawa Sentarō
woodblock, album plate, 227 x 155 mm
Gerhard Pulverer Collection

A group of pilgrims is crossing a bridge of arching pine to reach a small thatched shrine. One of them sounds their arrival by blowing on a large shell. The setting is near Mount Kurokami, a secondary peak forming part of Mount Nantaizan near Nikkō in present-day Tochigi prefecture. Near Kurokami is the Tōshōgū shrine of Nikkō, to which the pilgrims who paused at Kirifuri waterfall were travelling (cat. 39).

GLOSSARY

aiban
literally 'medium-large block', a size of paper used for prints that measures approximately 333 x 227 mm

aizurie
a type of print that is restricted to shades of non-fugitive blue

blindprinting
a printing technique that does not involve inks or pigments, in which a block is used to impress a textured pattern on the paper, frequently to add patterning to clothing or to enhance objects

bokashi
a process that involves interrupting the printing periodically in order to remove some of the ink or pigment from the block with a plug of cotton; the result is a gradated softening in the colour as it appears on the paper. Sometimes a damp cloth is used to achieve a streaked effect

Buddhism
a religion that originated in northern India and was introduced into Japan by way of China in the sixth century AD

chūban
literally 'medium block', a size of paper used for prints that measures approximately 270 x 195 mm

classical period
the sophisticated Heian period, which began in 785 when the imperial capital was established at the new city of Heiankyō (later Kyōto) and ended in 1185 with Minamoto no Yoritomo's seizure of power

colour block
a block used to print one shade of pigment on those areas of the paper already marked out for it by the line-block

daijin
a high-ranking minister

daimyō
a feudal provincial lord answerable to the shōgun

gafu
a picture book or album, usually the work of one artist only; a two-page introduction is often included

geisha
an accomplished female dancer, often a musician and singer

gradation
see *bokashi*

haiku
a genre of poem, consisting of seventeen syllables, on subjects linked to the seasons of the year

hosoban
literally 'narrow block', a size of paper used for prints that measures approximately 330 x 155 mm

impression
each print run from the same blocks constitutes an impression

kabuki
the popular theatre, largely devoted to plays on historical and domestic themes, whose plots were often freely adapted to suit the preferences or capabilities of individual actors

kakizome
'the first writing of the New Year', and, like most activities performed for the first time at each New Year, of special significance

kamuro
a child attendant to a courtesan

kiwame
literally 'approved', the censor's seal that appears on nearly all prints issued after 1790

kyōka
literally 'mad verses', a genre of comic poetry, consisting of thirty-one syllables, in which more weighty classical poems are often alluded to or mimicked

lacquerwork
lacquer, which derives from the sap of the lacquer tree (*Rhus verniciflua*), is applied in a series of thin coats to boxes, combs and various other *objets d'art* and furnishings. Its unique effect is the result of dust-size particles of colour or metal — usually gold or silver — having been blown on to a tacky undercoat that is then sealed in with further coats. Lacquerwork, which is finished to a high polish, was sometimes imitated in prints for local effects

line-block
the block that is cut from the copyist's finished drawing and used for printing the outlines. A sheet is always printed with the line-block before any colour blocks are applied

manga
literally 'random sketches', from which albums of prints were sometimes made

margins
the unprinted edges of a sheet. Margins were usually trimmed after printing – which sometimes left them partially intact – but the process frequently removed a millimetre or more of the printed paper. Prints were often further trimmed at a later date, for example on removal from albums in which they had

been pasted. The purpose behind drawing attention to the presence of a margin is to confirm that none of the original printing has been lost from that edge of the sheet

nagaban
literally 'long block', a size of paper used for prints that measures approximately 520 x 255 mm

netsuke
a toggle, decoratively carved from ivory, wood or other material, that is attached to the silk cord from which small containers — which take the place of pockets — are hung

Nō theatre
the classical theatre, which uses masks and fine clothing

ōban
literally 'large block', a size of paper used for prints that measures approximately 270 x 390 mm

oiran
a courtesan of the first rank

oxidation
a chemical process that takes place when certain agents in a pigment react with oxygen, which gradually darkens the shade of printed colour. Designers and printers

sometimes sought this effect deliberately, although since the process was difficult to control its results were unpredictable

rakan
a Buddhist monk who has attained Enlightenment

rōnin
literally 'wave men', samurai without a daimyō

samurai
members of the aristocratic military class serving their daimyō and, by extension, the shōgun

sennin
a mythical, semi-divine sage of Chinese origin

Shinto
the native pantheistic religion of Japan, which became known as Shinto, or the 'Way of the Gods'

shōgun
the military dictator of Japan, whose castle was at Edo. The shōgun was only nominally subservient to the emperor

shunga
literally 'Spring-time picture', any print, picture album or painting on an erotic subject

surimono
a privately issued presentation print, often of exceptional quality. *Surimono* were usually commissioned by wealthy merchants or poetry clubs to celebrate special events — especially the New Year — serving as invitations to dance, theatre or other types of performance; for these reasons they were invariably inscribed with *kyōka* poems or with details of the performance. Long and double long *surimono* are broad horizontal prints that were folded before being issued

title cartouche
the drawn or printed box, usually rectilinear, that appears on a print as a surround for the title

torii
a two-column gateway set up at the entrance to a Shinto shrine

uchiwa
literally 'fan', a size of paper used for prints that measures approximately 230 x 330 mm

ukiyoe
literally 'pictures of the floating [i. e. fleeting] world', these are genre prints, illustrated books and paintings of the good life, featuring the world of Edo's fashionable courtesans and actors

SELECT BIBLIOGRAPHY

BINYON & SEXTON, 1960
L. Binyon and J.J. O'Brien Sexton, *Japanese Colour Prints*, 1923, revd edn, London 1960

BOWIE, 1964
T. Bowie, *The Drawings of Hokusai*, Bloomington 1964

BOWIE, 1979
Art of the Surimono, exhibition catalogue ed. T. Bowie; Bloomington, Indiana University Art Museum; 1979

EDOGAKU JITEN, 1984
Edogaku jiten (Encyclopaedia of Edology), Tokyo 1984

EVETT, 1982
E. Evett, *The Critical Reception of Japanese Art in Late-Nineteenth-Century Europe*, Studies in the Fine Arts: The Avant-garde 36, Ann Arbor 1982

FENOLLOSA, 1901
E. F. Fenollosa, *Catalogue of the Exhibition of Paintings of Hokusai…at Uyeno Park, Tokyo 1900*, Tokyo 1901

FORRER, 1979
M. Forrer, *Egoyomi and Surimono: Their History and Development*, Uithoorn 1979

FORRER, 1982 (a)
M. Forrer, 'The Effects of the Tenpō Crisis upon the Publication of Illustrated Books by Hokusai and his School', *Andon*, II/8 (1982), pp. 31–7

FORRER, 1982 (b)
M. Forrer, 'Poetry Albums of the Kansei Period', in *Essays on Japanese Art Presented to Jack Hillier*, ed. M. Forrer, London 1982, pp. 41–55

FORRER, 1985
M. Forrer, *Eirakuya Tōshirō, Publisher at Nagoya*, Japonica Neerlandica 1, Amsterdam 1985

FORRER, 1988
M. Forrer, *Hokusai*, Paris and New York, 1988

FORRER & KEYES, 1979
M. Forrer and R. Keyes, 'Very Like a Whale? – Hokusai's Illustrations for the Genroku Poem Shells', in *A Sheaf of Japanese Papers, in Tribute to Heinz Kaempfer on his 75th Birthday*, ed. M. Forrer, W. R. van Gulik and J. Hillier, The Hague 1979

FORRER, VAN GULIK & KAEMPFER, 1982
Hokusai and his School: Paintings, Drawings and Illustrated Books, exhibition catalogue ed. M. Forrer, W. R. van Gulik and H. M. Kaempfer; Haarlem, Frans Halsmuseum; 1982

FRENCH, 1974
C. L. French, *Shiba Kokan: Artist, Innovator and Pioneer in the Westernization of Japan*, New York and Tokyo 1974

GONCOURT, 1896
E. de Goncourt, *Hokusaï*, Paris 1896

HAMADA, 1973
G. Hamada, *Edo bungaku chimei jiten* (Encyclopaedia of Edo place names in literature), Tokyo 1973

HAYASHI, 1968
Y. Hayashi, *Enpon kenkyū Hokusai* (A study of Hokusai's erotic books), Tokyo 1968

HILLIER, 1955
J. Hillier, *Hokusai: Paintings, Drawings and Woodcuts*, London 1955

HILLIER, 1966
J. Hillier, *Hokusai Drawings*, London 1966

HILLIER, 1970 (a)
J. Hillier, *Catalogue of the Japanese Paintings and Prints in the Collection of Mr & Mrs Richard P. Gale*, vol. 2, London 1970

HILLIER, 1970 (b)
J. Hillier, *The Harari Collection of Japanese Paintings and Drawings*, vol. 2, London 1970

HILLIER, 1980 (a)
J. Hillier, *The Art of Hokusai in Book Illustration*, London 1980

HILLIER, 1980 (b)
Japanese Drawings of the 18th and 19th Centuries, exhibition catalogue by J. Hillier; New York, Japan House Gallery; St. Louis, MO, Museum of Art; Portland, WA, Museum of Art; 1980

HILLIER, 1987
J. Hillier, *The Art of the Japanese Book*, 2 vols, London 1987

IIJIMA, 1893
K. (Hanjūrō) Iijima, *Katsushika Hokusai den* (An account of Hokusai's life), 2 vols, Tokyo 1893

HOKUSAITEN, 1988
Katsushika Hokusaiten: Piitaa Mōsu korekushon (Katsushika Hokusai: Peter Morse collection), exhibition catalogue; Tokyo, Ōta Memorial Museum of Art; 1988

HOKUSAITEN, 1990
Katsushika Hokusaiten, exhibition catalogue; Tsuwano, Katsushika Hokusai Museum; 1990

KEYES, 1985
R. Keyes, *The Art of Surimono: Privately Published Woodblock Prints and Books in the Chester Beatty Library, Dublin*, 2 vols, London 1985

KEYES & MORSE, 1972
R. Keyes and P. Morse, 'Hokusai's Waterfalls and a Set of Copies', *Oriental Art*, n. s. XVII/2 (1972), pp. 141–7

KOKUSHO SŌMOKUROKU
Kokusho sōmokuroku (A comprehensive bibliography of Japanese books), 8 vols, Tokyo 1963–77

LACAMBRE, 1988
G. Lacambre, 'Chronologie', *Le Japonisme*, exhibition catalogue; Paris, Grand Palais; 1988, pp. 59–123

LANE, 1989
R. Lane, *Hokusai: Life and Work*, London 1989

MORSE, 1989
P. Morse, *Hokusai: One Hundred Poets*, London 1989

MORSE & KEYES, 1972
P. Morse and R. Keyes, 'Checklist of the Prints of Hokusai', in *Katsushika Hokusai*, Zaigai hihō: Ō– Bei shūzō ukiyoe shūsei, 5 (Hidden treasures from foreign countries: Compilation of *ukiyoe* from European and American collections), Tokyo 1972

MURAYAMA, 1906
J. Murayama, ed., *Katsushika Hokusai nisshin jōmachō* (Katsushika Hokusai's daily exorcisms), Tokyo 1906

NAGATA, 1984
S. Nagata, *Hokusai*, Ukiyoe hakka 5 (Eight flowers of *ukiyoe* 5) Tokyo 1984

NAGATA, 1985 (a)
Katsushika Hokusaiten, exhibition catalogue by S. Nagata; Tokyo, Ōta Memorial Museum of Art; 1985

NAGATA, 1985 (b)
S. Nagata, *Katsushika Hokusai nenpu* (Hokusai chronology), Tokyo 1985

NAGATA, 1990
S. Nagata, *Hokusai Bijutsukan* (Hokusai Museum), 5 vols, Tokyo 1990

NARAZAKI, 1944
M. Narazaki, *Hokusai ron* (A treatise on Hokusai), Tokyo 1944

SCHACK, 1975
G. Schack, *Japanische Handzeichnungen*, Hamburg 1975

SCHACK, 1984
G. Schack, *Aus der fliessend-vergänglichen Welt*, exhibition catalogue, Baden-Baden 1984

SCHINDLER, 1985
Shindoraa korekushon ukiyoe meihinten (Masterpieces of *ukiyoe* prints from the Schindler collection), exhibition catalogue (touring); Tokyo 1985

SCHMIDT & KUWABARA, 1990
S. Schmidt and S. Kuwabara, *Surimono: Kostbare japanische Farbholzschnitte aus dem Museum für Ostasiatische Kunst, Berlin*, Berlin 1990

SUGA, 1936
C. Suga, *Kyōka shomoku shūsei* (Bibliography of *kyōka* anthologies), Kyōto 1936

SUZUKI, 1972
J. Suzuki, 'Hokusai nenpu', in *Katsushika Hokusai Zaigai hio Ō-Bei shūzō ukiyoe shūsei*, 5, Tokyo 1972

SUZUKI, 1979
J. Suzuki, *Ehon to ukiyoe: Edo shuppan bunka no kōsatsu* (Illustrated books and *ukiyoe* prints: Thoughts on the culture of Edo publishing), Tokyo 1979

SUZUKI, 1986
J. Suzuki, *Katsushika Hokusai Fugaku hyakkei* (Hokusai's Hundred Views of Fuji), Tokyo 1986

TODA, 1931
K. Toda, *Descriptive Catalogue of Japanese and Chinese Illustrated Books in the Ryerson Library of the Art Institute, Chicago*, Chicago 1931

TOMITA, 1957
K. Tomita, *Day and Night in the Four Seasons: Sketches by Hokusai 1760–1849*, Museum of Fine Arts Picture Books 14, Boston 1957

TSUJI, 1982
N. Tsuji, *Hokusai*, Book of Books 31, Tokyo 1982

UKIYOE TAIKEI
I. Oka, *Hokusai*, Tokyo 1975, vol. VIII of *Ukiyoe taikei*, Tokyo 1975–6

T. Kobayashi, *Fugaku sanjūrokkei*, Tokyo 1976, vol. XIII of *Ukiyoe taikei*, Tokyo 1975–6

S. Kikuchi, *Kisokaidō rokujūkyū tsugi*, Tokyo 1976, vol. XV of *Ukiyoe taikei*, Tokyo 1975–6

VIGNIER & INADA, 1913
Yeishi, Choki, Hokusaï: Estampes japonaises..., exhibition catalogue by C. Vignier, J. Lebel and H. Inada, Paris 1913

YŌFŪ HYŌGEN NO DONYŪ, 1985
Yōfū hyōgen no donyū (The development of Western realism in Japan), exhibition catalogue; Tokyo, National Museum of Modern Art; 1985

YOSHIDA, 1971
T. Yoshida, *Ukiyoe jiten*, 3 vols, Tokyo 1971

LENDERS TO THE EXHIBITION

EIRE
The Chester Beatty Library and Gallery of Oriental Art, Dublin:
18, 45, 86, 87, 93, 123, 129

FRANCE
Bibliothèque Nationale, Paris: 4
Huguette Berès Collection, Paris: 103, 105, 107, 108, 119
Janette Ostier Collection, Paris: 100
Musée National des Arts Asiatiques-Guimet, Paris: 13, 21, 48, 57,
59, 61, 67, 72, 85

GERMANY
Gerhard Pulverer Collection, Cologne: 24, 37, 52, 117, 124, 132,
133
Staatliche Museen Preussischer Kulturbesitz, Museum für
Ostasiatische Kunst, Berlin: 3, 99

GREAT BRITAIN
The British Museum, London: 1 a, 8, 12, 66, 76, 81, 112, 113, 125,
126, 127

JAPAN
David Caplan Collection, Tokyo: 10

THE NETHERLANDS
Bibliotheek der Rijksuniversiteit, Leiden: 7
Hotei Japanese Prints, Leiden: 42
Matthi Forrer Collection, Leiden: 91
National Museum of Ethnology (Rijksmuseum voor Volken-
kunde), Leiden: 22, 23, 104, 106, 110, 111, 122, 130, 131
Rijksmuseum, Amsterdam: 92, 98
Society of Friends of Asiatic Art, Amsterdam, on loan to the
Rijksmuseum, Amsterdam: 2

UNITED STATES OF AMERICA
Arthur M. Sackler Museum, Harvard University, Cambridge,
Massachusetts: 9, 97, 128
The Art Institute of Chicago, Chicago: 6, 30, 40, 41, 49, 54, 58, 60,
62, 68, 78, 83, 89, 90, 114, 120, 121
The Brooklyn Museum, New York: 17, 95
Honolulu Academy of Arts, Honolulu: 15, 27, 35, 36, 43, 46, 53,
64, 65, 69, 70, 73, 74, 79, 82, 84
L. B. Schlosser Collection, New York: 116
Mann Collection, Highland Park, Illinois: 19, 38, 39, 44, 55, 80
The Metropolitan Museum of Art, New York: 11, 16, 26, 28, 29, 75
Museum of Fine Arts, Boston, Massachusetts: 5, 101, 102
Museum of Fine Arts, Springfield, Massachusetts: 109
Peter Morse Collection, Hawaii: 14, 20, 25, 31, 32, 33, 34, 50, 51,
56, 96, 115

PHOTOGRAPHIC ACKNOWLEDGMENTS

The exhibition organisers would like to thank the following for making photographs available:

The Art Institute of Chicago (cat. 6, 19, 30, 38, 39, 40, 41, 44, 49, 54, 55, 58, 60, 62, 68, 78, 80, 83, 89, 90, 114, 120, 121)

The Arthur M. Sackler Museum, Harvard University, Cambridge, Mass. (cat. 9, 97, 128)

Bibliotheek der Rijksuniversiteit, Leiden (cat. 7)

Bibliothèque Nationale, Paris (cat. 4)

The British Museum, London (cat. 1a, 8, 12, 66, 76, 81, 112, 113, 125, 126, 127)

The Brooklyn Museum, New York (cat. 17, 95)

Gerhard Pulverer, Cologne (fig. 6; cat. 24, 37, 52, 117, 124, 132, 133)

Honolulu Academy of Arts (cat. 15, 27, 35, 36, 43, 46, 53, 64, 65, 69, 70, 73, 74, 79, 82, 84)

Hotei Japanese Prints, Leiden (cat. 42)

Huguette Berès, Paris (fig. 12; cat. 103, 105, 107, 108, 119)

Janette Ostier, Paris (cat. 100)

Kōbe City Museum (fig. 3)

Leonard Schlosser, New York (cat. 116)

The Metropolitan Museum of Art, New York (cat. 11, 16, 26, 28, 29, 75)

Musée National des Arts Asiatiques-Guimet, Paris (cat. 13, 21, 48, 57, 59, 61, 67, 72, 85)

Museum of Fine Arts, Boston, Mass. (fig. 1, 2; cat. 1b, 5, 101, 102)

Museum of Fine Arts, Springfield, Mass. (cat. 109)

National Museum of Ethnology (Rijksmuseum voor Volkenkunde), Leiden, Isaäc C. Brusse (fig. 4, 5, 7, 8, 9, 10, 11; cat. 22, 23, 91, 104, 106, 110, 111, 122, 130, 131)

Peter Morse, Hawaii (cat. 14, 20, 25, 31, 32, 33, 34, 50, 51, 56, 96, 115)

Pieterse-Davison International Ltd, Dublin (cat. 18, 45, 86, 87, 93, 123, 129)

Rijksmuseum-Stichting, Amsterdam (cat. 2, 93, 99)

Staatliche Museen Preussischer Kulturbesitz, Berlin (cat. 3, 99)

Studio 1, Tokyo (cat. 10)